THE SKETCH
ENCYCLOPEDIA

OVER 900 DRAWING PROJECTS

3dtotalPublishing

3dtotalPublishing

Correspondence: publishing@3dtotal.com
Website: www.3dtotal.com

The Sketch Encyclopedia © 2018, 3dtotal Publishing.

Every effort has been made to ensure the credits and contact information listed are present and correct. In the case of any errors that have occurred, the publisher respectfully directs readers to the www.3dtotalpublishing.com website for any updated information and/or corrections.

First published in the United Kingdom, 2018, by 3dtotal Publishing.

Address: 3dtotal.com Ltd, 29 Foregate Street, Worcester, WR1 1DS, United Kingdom.

Hardback ISBN: 978-1-909414-64-8

Printing and binding
Everbest Printing (China)
www.everbest.com

Visit www.3dtotalpublishing.com for a complete list of available book titles.

Editor: Annie Moss
Designer: Matthew Lewis

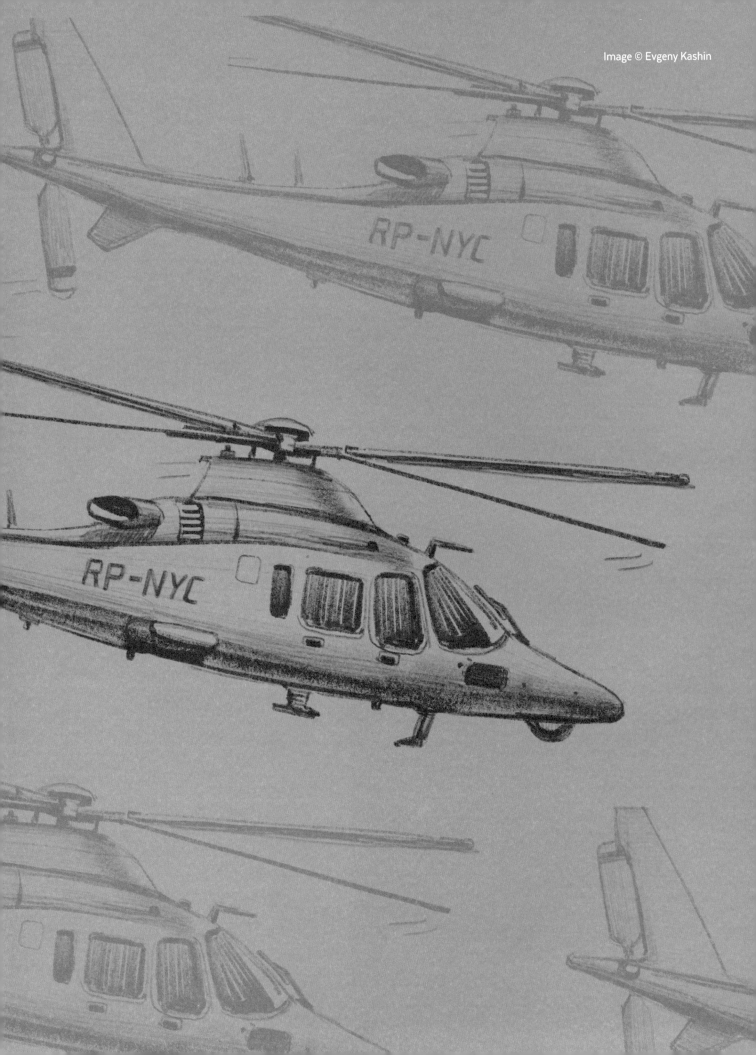

CONTENTS

YOUR JOURNEY INTO SKETCHING

Sketching is an art form that has been used for centuries, the results ranging from the quickest, loosest drawing to much more fully formed and detailed art. It continues to thrive today, being a versatile, portable technique that can be practiced not only at home or in the studio, but out and about, while travelling or just going about our daily lives.

Ask ten different people why they sketch, and you may receive ten different answers. Sketching for its own sake can be a relaxing hobby, allowing the artist to practice mindfulness in a fast-paced world. It is also a medium through which we can engage with our world. Observation in order to sketch is in itself rewarding, helping us to understand our place in the world and make sense of our surroundings. Sketching encourages us to take an interest in the world, and process what we find in a way that inspires us, and ignites the imaginations of others.

Many ideas start life as a simple sketch, this being the perfect medium with which to explore ideas, and draftsmanship sketching has long been used as a way to communicate ideas between creators. As a way to explore thoughts, intentions, and stories, sketching is an expressive and flexible medium. We may have a firm idea of what we want to create when beginning to draw, but the process itself could suggest different directions and possibilities we would not otherwise have considered. A sketch, by definition, is more of an idea and exploration, and it is up to us how far we want to take it.

Being able to accurately translate observations and ideas into a sketch using only paper and pencil is something that comes with repeated practice and focus, and this book allows you exactly that. Over 900 subjects are depicted as sketches in four key steps. Each one of these stages is clearly defined and allows you to identify and practice the build-up of a sketch. Practice is vital to mastering these steps, studying not only one particular subject, but working across a variety, from animals and nature to people, everyday objects, and buildings. As you improve and grow in confidence, having the versatility of being able to tackle different shapes, surfaces, and scales allows you to bring your ideas and images to life.

This book is intended to fulfil this aim - from learning about fundamental tools and techniques, to building a repertoire of styles and skills, everything you need is here. Turn to the How to use this book section for more details about what you will learn from each of the 900+ sketches, then begin your incredible journey into sketching.

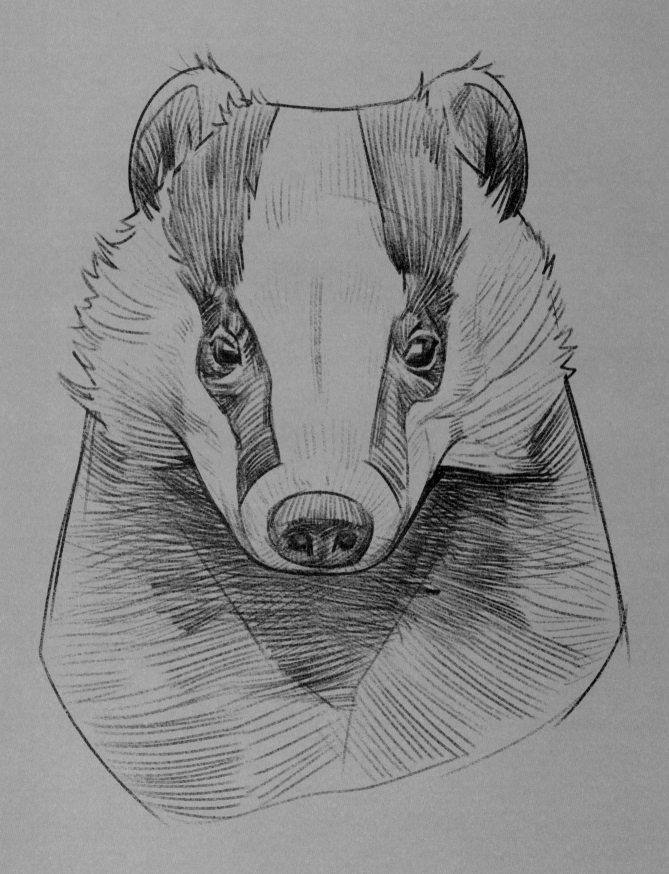

INTRODUCTION TO SKETCHING

BY BOBBY REBHOLZ

In this chapter you will learn the importance of fundamental art practices including perspective, line making, shape, light, and texture. An overview of drawing tools and materials is also included to help you select the best equipment for your needs. This introduction will prepare you for success with the drawing projects in this book and your own sketch compositions, even if this is your first time drawing.

IN THIS CHAPTER

TOOLS AND MATERIALS

Many new artists feel overwhelmed by the task of selecting the correct materials to buy for their needs. Even though this task can at first seem intimidating and loaded with importance, the tools are at your disposal. Remember that no matter how sophisticated these materials can be, they will not give you instant masterpieces so think of them as utensils and no more. A scribble with a B pencil can be as effective as one with an H pencil.

TYPES OF PENCIL AND LEAD

1: GRAPHITE PENCILS

Graphite pencils are wonderful to draw with because they allow for so many variations in tonal control and line weight. Your pencil strokes tend to be looser when sketching with a graphite pencil because the line width can fluctuate from narrow to wide with total control. Graphite pencils allow you to add value smoothly as they are easier to shade with than mechanical pencils. This is because more of the graphite lead is physically touching the paper when you change the angle of the sharpened edge against the page.

Many brands such as Kimberly, Derwent, and Faber-Castell produce good-quality graphite pencils in a variety of grades. I recommend using grades 4B-6B for the exercises in this book as you can cover a full range of dark to light using these three variants.

2: H AND B PENCIL LEADS

H and B pencils can be beneficial for different reasons. When I first meet my new students I always ask them if they have heavy or light hands. Heavy-handed

△ There are many different types of graphite pencils to experiment with

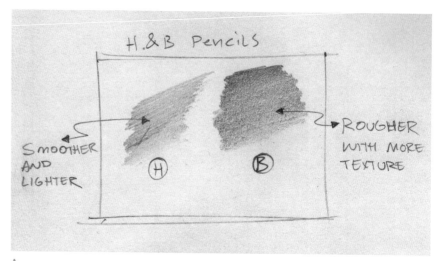

△ An H graphite lead will create harder markings whereas the markings of a B lead will be softer and darker

sketchers tend to push harder, which causes them to get frustrated when they need to sketch lightly. The opposite problem exists for light-handed sketchers who can have trouble making heavy lines.

H pencil leads are a harder form of graphite and the harder you push down with an H pencil, the shinier the markings look. B pencil leads are a softer form of graphite that allows you to produce darker markings,

△ Mechanical pencils offer very clean, fine lines

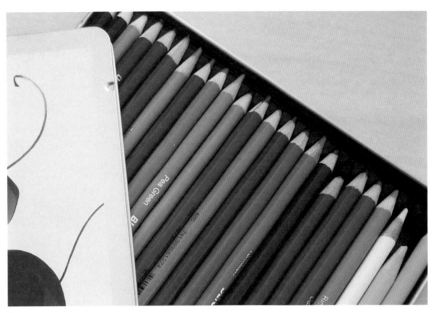

△ Different brands can give you different tones and textures

especially when using pencil grades beyond 6B. The numbers used alongside the H and B markers, such as 2B or 4H, form a scale that also refers to the hardness or softness of the lead and indicates subtler variations between the grades. The higher the number, the more extreme the variation is from the standard H or B lead hardness.

3: MECHANICAL PENCILS

Mechanical pencils are a special type of drawing tool limited to just one point size. Many young artists quickly become attached to their mechanical pencils because of the fantastic precision that can be achieved when using them. Because there is no need to sharpen them, mechanical pencils always give you a clean, fine line, regardless of the angle at which you tilt them. However, mechanical pencils are not recommended for shading large areas because, unlike the graphite pencil, the lead weight and line thickness cannot be easily changed at will.

4: COLORED PENCILS

Colored pencils can be used to create beautiful sketches, and are especially useful if you are familiar with color theory. These pencils behave in a similar manner to

graphite pencils; you can still create values ranging from dark to light but the colors will ultimately dictate how dark the tones can get. For example, blue would be darker than yellow, regardless of how heavily you apply the line. Colored pencils can be used to add subtle details or highlight areas of your sketch, and they also provide a quick way of working as the color is applied immediately. Using colored pencils is an enjoyable way to sketch and draw as you have the control of a pencil tip but a sense of creating a painting.

COLOR THEORY BASICS

Color theory is an interesting but sometimes complex topic that, although not necessary for the sketches covered in this book, is useful to research further as you develop your art skills.

One of the key lessons is to understand how different colors relate to one another. Typically one color will either contrast with another color (this can also be called a complementary color), or will harmonize to it. For example, blue will contrast with orange, but harmonize with purple. You can quickly identify whether one color will contrast or harmonize with another by looking at a basic color wheel. Contrasting colors are typically positioned opposite each other on the wheel; harmonizing colors will be grouped together. Contrasting and harmonizing colors can be equally effective in an artwork – contrasting colors create impact, while color harmony provides a subtle variation.

In addition, colors can also be grouped by whether they appear cool or warm. This relates strongly to warmth and coldness in real life, with colors such as red and yellow being considered warm and colors like blue and green thought of as cool. Using cool colors in your sketches can give your work an eerie look while warm colors are often uplifting or reassuring.

△ This image shows the vibrancy of a blue sketch

5: BLUE PENCILS

Blue pencils are excellent if you are into drafting or product sketching. They offer a very attractive look to your sketches, not only because the color blue is pleasing to the eye but it is also very readable and vibrant against most papers.

There is a certain dynamic that sketching in blue gives the viewer because it can help even the simplest sketch look professional. Blue pencil sketches also scan very well, which is why they are popular with product designers. Additionally, blue pencil sketches show up well in online and printed portfolios so these pencils are a good choice for artists wanting to include their sketches in a professional showcase.

6: CHARCOAL PENCILS

Charcoal drawings have been around for thousands of years, dating back to ancient cave paintings, and charcoal pencils are the ultimate tool for experimental drawing. They are often used for live figure drawing, landscape drawing, and live portraits. With these pencils you can achieve extremes of light and dark lines, which are easily removable using a putty eraser (see page 17, Erasers: Putty Erasers).

While they can get messy, especially when the charcoal stains your drawing surface, charcoal pencils offer wonderful

△ Charcoal pencils can be used for very dark tones but they can be messy

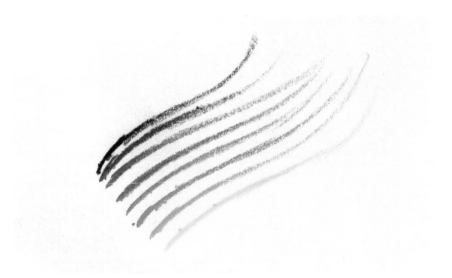

△ Pastel pencils are similar to colored pencils but softer to use

opportunities through blending using your finger. In addition to charcoal pencils you will find other types of charcoal that can also be used to draw. These include forms such as compressed (charcoal sticks shaped into thin blocks) and vine (long, thin sticks burned in a kiln), although these tend to be messier to use.

7: PASTEL PENCILS

Pastel pencils are a wonderful tool to use because you can achieve an amazing texture while having the familiarity of using colored pencils. Pastel pencils are slightly different from colored pencils, mainly because of the textured line that the pastel core creates.

Be careful, however, when erasing pastel pencils because you will only get about two tries before pigmentation is permanently set into the paper. The greatest aspect of using pastel pencils is that they are comfortable to use because we have been using pencils all of our lives. There is not the feeling of disconnect that can occur from the more unusual shape or hold of a pastel stick.

FINDING THE RIGHT TOOL FOR YOU

Now is the time for experimentation. Every artist, whether a beginner or advanced, has a comfort level with certain tools. Some artists stick with one preferred type of pencil or drawing tool for their entire career; others use many different kinds. It took me a long time and much testing of different drawing tools to realize that 4B is my favorite pencil to use.

If you are just starting out, ask yourself what interests you most in the sketches of others. Do you like to see color? Or maybe you prefer precision drawing? Do you enjoy loose and free drawings that are a little messy? Another question to ask yourself is what subject matter interests you the most. Certain tools do offer better outcomes depending on the subject matter you choose. For example, while landscapes drawn in graphite can be beautiful, color can cause major mood shifts and offer viewers an even deeper connection with the piece.

Start by picking a subject matter and sketching it a few times using different tools. You may want to sketch a self-portrait in the same lighting and pose, but with different tools to see which one you favor the effect of and what is most comfortable to use. This might take a lot of trial and error but experimentation is one of the most enjoyable aspects of art!

SHARPENING

WHY SHARP PENCILS CAN BE USEFUL

I am always telling my students that dull pencils make dull drawings. It is very important to sharpen your pencil if you want to maintain a line weight and keep your sketches precise. It is often the case that artists will let their pencils dull to a stump and then their drawings suffer because of it. The details just do not come through and the shading looks dissatisfactory, not allowing the tonal values to transition clearly.

Sharpening your pencil also allows you to keep your drawings clean! If you are sketching construction lines or basic shapes that later need to be erased, it is much easier to do this with a sharpened tip because the lines themselves are very thin and controlled.

WHY SHARPENING CAN BE PROBLEMATIC

There is a downside to sharpening your pencil that you should be aware of. I have found that by sharpening your pencil, it psychologically encourages you to grip the pencil closer to the sharpened graphite. This makes you want to add in details because you know that the graphite tip is in a perfect

△ A sharpened pencil such as this can go a long way toward helping you to create better lines

△ A sharp pencil encourages a focus on small details, which can be distracting

condition for this type of work. This, in turn, makes your sketches smaller and smaller and you may struggle to break out of the "tiny drawing" problem.

You will know if you suffer from this issue simply by looking at your sketchbook and seeing if you tend to draw in a small space

with a lot of white paper surrounding the drawing. If this is the case, try starting your work with a blunt pencil and make a conscious effort to use the available space. New artists should be particularly conscious of this as there is an urge to jump straight into details while ignoring the overall design and it takes practice to overcome this.

ERASERS

USING ERASERS TO DRAW

Using the eraser as a drawing tool is a special technique and one that is often overlooked. There is a difference between using the eraser as a tool and just erasing because you are frustrated. Frustrated erasing may ruin your drawing, and it can also make you feel that you are unable to complete a drawing without relying on it. It feeds your insecurities as an artist so that whenever you draw this is exactly what happens and your frustration grows. However, there is a different side to using the eraser.

Using the eraser to convey a light source is the most common technique used. It is a common mistake for new artists who are not experienced with studying light to forget to allow the tone of the paper to depict the light source. For example, if you are sketching a bowling ball and there is a strong highlight on the top of the ball, you can simply leave the white of the paper showing where that spot is and then shade the ball around it. If it is already shaded in or smudged, you can use an eraser to clean the spot where the highlight is to achieve the same effect.

Be careful with how you use this eraser technique though. No matter what paper you are using, they all have a special coating and erasing too much can remove this coating or damage it. When this occurs the erased area will look muddy and it will be virtually impossible to get the paper back to its original look.

1: RUBBER ERASERS

Rubber erasers are the most common erasers and are the type that can be found at the end of your pencil. You can also buy blocks of rubber erasers that are easier to use. Of the erasers you can buy they do not give the cleanest removal, but they are strong and will take off the majority of graphite put down.

Rubber erasers used to crumble easily until the 1800s when rubber began being vulcanized (a process of heating with sulfur that binds the molecules together), making them stronger and more durable. Since many rubber erasers are pink, you might notice a slight pinkish pigment when you use them. Do not be alarmed as this will not affect your drawing much, if at all.

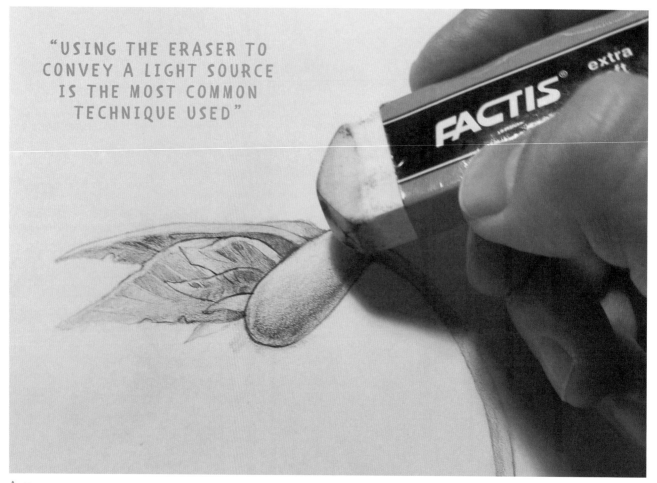

"USING THE ERASER TO CONVEY A LIGHT SOURCE IS THE MOST COMMON TECHNIQUE USED"

△ Use an eraser to wipe away graphite and create a faint highlight

△ This rubber eraser is not pink but it still achieves the same effect

△ The putty eraser is a great art tool and is very pliable

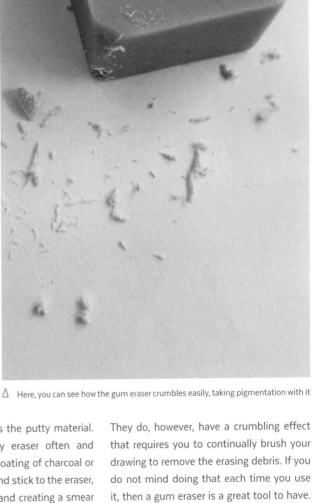

△ Here, you can see how the gum eraser crumbles easily, taking pigmentation with it

2: PUTTY ERASERS

Putty erasers, sometimes known as kneaded erasers, are wonderful to use if you sketch with charcoal or graphite. You might have a difficult time erasing dark lines with other erasers but the putty eraser gets the job done well. This type of eraser absorbs graphite, charcoal, and other drawing materials with ease. It is often helpful to pull putty erasers apart and shape them back together as this renews the putty material. If you use your putty eraser often and never stretch it out, a coating of charcoal or graphite can build up and stick to the eraser, hardening the outside and creating a smear on new drawings.

3: GUM ERASERS

Gum erasers are soft but very strong and can lift pigment off most paper types. They do, however, have a crumbling effect that requires you to continually brush your drawing to remove the erasing debris. If you do not mind doing that each time you use it, then a gum eraser is a great tool to have. However, the corners tend to wear down quickly so if you want to use the tip of an eraser to clear off a small area, putty erasers are usually a better option as they can be easily shaped.

TYPES OF PAPER

1: PRINTER PAPER

There is a soft spot in my heart for printer paper. It is readily available in most homes, schools, offices, and even libraries. When I was a child, I would take printer paper from any printer I could find just so I could draw on it. Printer paper is often A4 in size, which is a great size to start drawing at because it is not too big and not too small, and it has a very smooth texture. You can buy printer paper relatively cheaply at any office supply store and it comes in many different colors. If you use printer paper, collect your drawings and put them in a folder because it is great seeing your progress as an artist.

2: BRISTOL PAPER

Bristol paper is very durable and can be used for drawing, painting, markers, and collages. Bristol paper is great to use if you are studying figure drawing and need large sheets during a long drawing session. It is not as flimsy as printer paper and can withstand heavy impressions from a lot of different drawing tools. Bristol paper also comes with a smooth side and a rough side. The smooth side is great for more technical

△ A sketch of a reconnaissance probe on standard printer paper

△ Both sketches are drawn with a 4B pencil and a gray marker; the left sketch shows the effect of using the rough side of Bristol paper while the right shows the smooth side

△ Textured paper comes with many different surfaces that can improve your sketches

△ An example of what is possible with colored paper (right), using a pencil, fine-tipped pen, and white marker (left)

and precise drawing whereas the rough side is well suited to loose sketching, paint, and charcoal. The rough side also gives you added texture, which can result in a more dynamic finished piece.

3: TEXTURED PAPER

Textured paper may take more patience to work with because your lines will not be as smooth. You will need to practice hand control but once you get the hang of it, the outcome can be beautiful. You can only go so

far when shading and drawing in texture on your sketches, so having a textured surface to work on adds a whole new dimension and can make your work more appealing. You could even think of textured paper as a tool just like your pencil, especially if you want to draw dirt or a rough surface, as the texture you need may be there for you already.

4: COLORED PAPER

There are many advantages when drawing on colored paper. First of all, any object

you draw is immediately colored and that adds a new emotional dimension to your drawing. Secondly, adding highlights and shadows is much simpler. I like using white colored pencils to show highlights and black Prismacolor pencils to show shadows. You can experiment with any colors you like to see what impact they have on the colored surface. However, be careful when selecting colored papers if you are planning to work on a graphite sketch as graphite will not show up well unless the paper is light in tone.

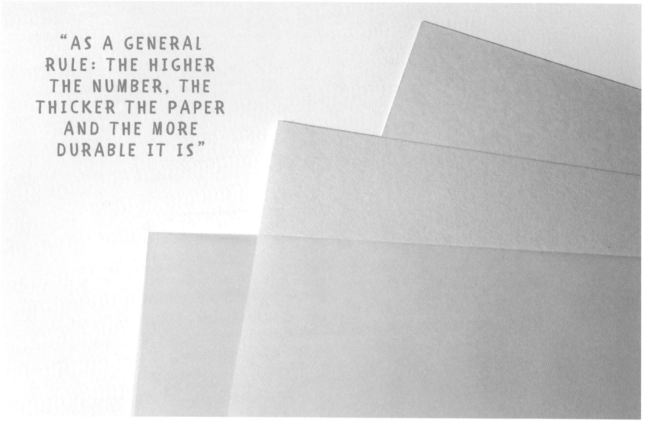

"AS A GENERAL RULE: THE HIGHER THE NUMBER, THE THICKER THE PAPER AND THE MORE DURABLE IT IS"

△ Here is a selection of papers with different weights

△ This particular sketch is drawn with graphite pencil on Graphics 360 marker paper

PAPER WEIGHTS

Paper comes in a wide variety of thicknesses known as "weights." Understanding paper weights can be quite confusing but as a general rule: the higher the number, the thicker the paper and the more durable it is. Internationally, paper weight is measured in grams per square meter (GSM) of paper but the US and Canada measure using the basis weight system that gives the paper weight, in pounds, of a 500 sheet ream of the paper.

A 25 lb paper is very thin, like tracing paper. Newsprint paper, at 30–35 lb, is a slightly thicker paper and is commonly used for very rough sketching. I recommend a 50-60 lb paper for standard sketching in graphite or charcoal but this paper weight is usually too thin for ink or most markers. A 70-80 lb paper weight is standard for drawing paper and can be great for finished work; whereas a paper of between 90–110 lb is a good choice for multimedia art. Bristol paper, for example, is a 90–110 lb material.

FINDING THE RIGHT PAPER FOR YOUR WORK

Take a look around you, whether you are at home, in your office, or in a classroom. Which materials would you grab immediately if you were to draw or create something? Whatever your gut instinct tells you is usually your favorite thing to use. Now, imagine buying paper to accommodate that tool. If you grabbed a trusty graphite pencil, the chances are you will do just fine working with printer paper or standard drawing paper such as those made by Strathmore Artist Papers or Canson.

There is also much room to experiment with tools and materials, especially if you are new to sketching. Try using a tool you have never tried before or mixing and matching different tools with different paper textures to see what effects they create. You may be surprised by some of the results you get. The tools and materials listed in this book are commonly used for drawing but that should not stop you exploring what effects you can create with more unusual options. Through experimentation you can find out which types of drawing you love to create and see what the most comfortable tools and materials for you to use are.

USE PENCIL AS A BEGINNER

As you become more experienced as an artist and acquire an intermediate level of skill, you can branch out and become familiar with many different tools. Do not worry about when this will happen as art should never be rushed and some people master techniques quicker than others. Go at your own pace; you are on your own journey and you do not owe it to anybody to improve quickly!

Using a graphite pencil as you first start learning to draw is a good way to break into the world of art. It is such an easy tool to use, there is no hassle with its shape or the type of paper that can be used, and there are many different brands to practice with.

Figure out if you are light or heavy handed at first as this will dictate whether you work better with H or B graphite pencils. As you become a more competent sketcher be sure to practice with both sets though, as you may find that using both is helpful. If you are truly stuck and do not know which pencil to choose from, start with a standard 2B, which is the lead grade used throughout this book. The graphite is soft enough to allow decent dark to light shading and it is hard enough for crisp lines.

△ Hold the pencil in a relaxed position with a loose, comfortable grip

BASIC SHAPES

This section will discuss the concept of construction using basic shapes and demonstrate why they are important when learning how to draw. Looking at familiar shapes like cubes, cones, cylinders, and spheres, this chapter will explore how simplified shapes like these make up the world around you. Although these basic shapes might not be immediately apparent when you see a finished drawing, you will learn how any drawing can be built from these simple shapes.

WHY USE BASIC SHAPES?

For a new artist, learning to draw a wide variety of subjects might at first feel like a daunting task. Do not be intimidated or put off by this, however, as studying basic shapes will show you that even incredibly complicated objects can be deconstructed quite easily into their basic shapes. When using basic shapes it is impossible to over-complicate their forms. This is very useful when sketching, but the approach can take time to learn as the human brain is very good at overthinking. Your brain interprets images through thousands of processes as it analyzes and interprets the information available. This causes you to overthink what is there and can easily create confusion when drawing.

In the early years of drawing, it is tempting to jump to the details as quickly as possible. To many, the details of a drawing are the best part. The outcome of this impatience is disproportionate-looking objects and very detailed figures that have little or even no shape underneath. By adding considerable detail to a drawing that is structurally incorrect the inaccuracy of the object becomes even more apparent.

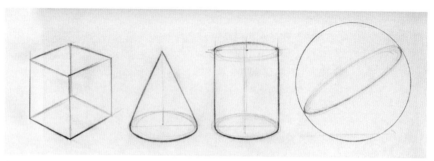

△ These four basic shapes in 3D form can give sketches a general structure

△ An example of how repeated, similar shapes can create more interesting forms © Richard Tilbury

As your skills develop you will see that all creatures, humans, and objects can be broken up into four basic shapes: a square, triangle, rectangle, and a circle. It is also useful to think of these basic shapes as three-dimensional forms, which in the case of these shapes are cubes, cones, cylinders, and spheres respectively. This practice helps you to better understand the forms when drawing in perspective or depicting light and shadow. Working with just these basic shapes initially, however, gives you an opportunity to relax into the process and think about the drawing without stressing over details.

Using basic shapes in the early stages of your work can also help to create believable subject matter because the viewer's eyes will relate the forms of your drawing to familiar shapes from the first glance. Regardless of whether you observe a landscape in real life or a painting of a landscape, your eyes will immediately pick up on the larger, simpler

forms and then move into the detailed areas. If a sketch or drawing has an effective composition those forms will be interpreted quickly and easily, and the overall piece will be more successful.

Learning how to draw and use basic shapes can also help with a theory known as "form language." A form language occurs when all of the shapes in your sketch relate to each other in some way, such as curves or sharp angles. It is also sometimes known as "a family of form." A drawing of puffy clouds, for example, could be characterized as a group of spheres and ovals to represent the naturally occurring form language of rounded shapes. Because of the repetition of these familiar shapes the image is more pleasing to the eye.

IDENTIFYING BASIC SHAPES

If you are sketching a complicated subject, try to imagine the subject's form in the most simplistic shape possible. For instance, if you are sketching a dragon, there will be organic qualities and complicated ridges to capture. The sketch will need wings, a long curved neck, scales, a tail, and so on. That is a lot to think about! However, you can break those complicated forms down into basic shapes. A dragon's neck is a cylindrical tube, so you could draw the outline of the neck as a cylinder that is curved to suit your idea. A dragon's head is often shown as an elongated shape and if viewed from the side, it can be broken into spheres and ovals of different sizes.

One way to practice identifying basic shapes is to think of an object familiar to you, such as a house, and try to work out how basic the shapes from which it is made can be before the subject becomes indistinguishable. The details of a house such as shingles, siding, brick, and glass help to solidify your understanding of the building. If you take a step back however, and squint, you can see that the house is mainly formed of a large

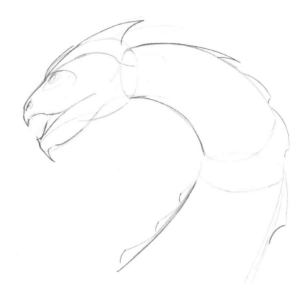

△ An organic form like a dragon's neck can be broken down into curved tubes and ovals © Richard Tilbury

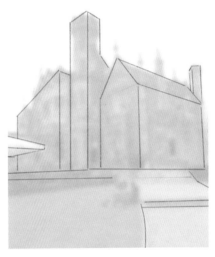

△ Even a detailed structure, such as an ornate building, can be reduced to basic shapes © Richard Tilbury

cube. This very basic shape is the first thing to focus on to create an accurate base for the rest of your drawing.

Another good way to practice identifying basic shapes is to study the room that you are sat in. What basic shapes can you see in the furniture and appliances around you? Is the light bulb a sphere? The room itself could be one large cube. More complicated forms such as a lamp, chair, and plant can be seen as cones, cubes, and cylinders.

If you are finding this practice difficult you could try to look first at the silhouette of the subject. The easiest way to recognize a silhouette is to study the very edge of the subject as a whole, which will help you determine the shape of the entire form. Squint your eyes and look at objects around you. Imagine those objects are purely black and have absolutely no detail. Pretend that the only thing you have to help you recognize the forms is the outermost shape. Now, think of the basic shapes: the cube,

△ Practice identifying basic shapes by imagining familiar objects in your home as block shapes © Richard Tilbury

cone, cylinder, and sphere. Which of these shapes are these object silhouettes most similar to? Whichever shape is most suited to the silhouette is the basic shape you can use to construct the object.

USING BASIC SHAPES

No matter what you draw, take a step back and think about the end goal of your sketch. Ask yourself what you want the viewer to see first. If you play video games or watch cartoons you will know that the most successful have memorable characters, creatures, and environments. If the colors and detail are taken away from those subjects you will find that the most readable, coherent silhouette tends to be the most memorable. When you look at a painting, your brain registers the large shapes first. Therefore, details are not initially important to enable you to understand an image. Objects, characters, and creatures are memorable because they use simplistic forms that are instantly recognizable.

As an exercise in using basic shapes, look again at how a simple house might be drawn. Take some paper and sketch a cube as this is the most basic shape that can be used to describe a house. Keep the lines of your sketch light and do not

△ Angular structures such as buildings are largely drawn with cubes and rectangles but can also require cylinders and circular forms © Richard Tilbury

worry about the perspective at this point. Next, add smaller squares or rectangles with very light construction lines to form windows. Immediately, you should get the sense of a house shape. Then, think about the roof and if it is flat or tapered. What shapes can convey this? Often, if you look at a house directly from the front, the roof looks like a triangle. Roofs can be many kinds of complicated and unusual shapes,

and these can be constructed using several overlapping shapes. Keep it simple for now with just a typical triangular roof.

Once you have the main forms of the building outlined you can begin to think about how to represent some of the details. Old-fashioned homes are usually constructed from stone blocks or brick. These stone blocks tend to appear to be square shapes but try to think

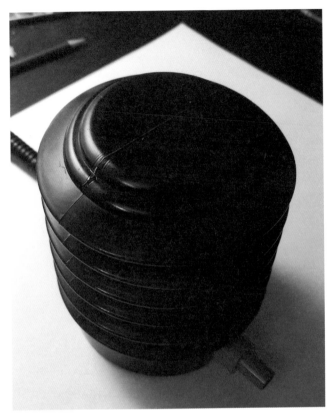

△ This simple air pump for an exercise ball can immediately be imagined as a cylinder © Richard Tilbury

about these squares as three-dimensional forms. They are simply an elongated cube. Using variations of the same basic shapes in different sizes and arrangements can easily develop into a more complicated image.

REDUCING FORMS

It is often thought that the simplest things to draw tend to be the most difficult to master. This is due to your brain naturally taking images and breaking them up, forcing you to rethink the construction of the subject from every angle, instead of seeing it for what it is. For example, when you look at a skyscraper, you may be in immediate awe of its size and height. However, if you were asked to draw that skyscraper, it would not be surprising if the first thing you tried to achieve was a sketch that clearly showed details such as windows, bricks, and ornate architectural elements. It is common to forget that what immediately captures your attention is the giant shape of the building itself.

It is also not always easy to think of images in terms of three dimensions. This requires you to see shapes in front of you and imagine how those shapes would appear if they were turned at different angles. Spend some time visualizing how the objects might look from a different angle and then study how accurate your imaginings are. Think about how you could reduce each of these forms into simple shapes when constructing your drawings.

To familiarize yourself with simple shapes, a good exercise to try is to study your surroundings carefully. We often see things without actually paying attention to how the objects around us really look. The basic cube, cone, cylinder, and sphere can be seen frequently in nature and in all human-made objects. Pick a very simple object like an eraser or water bottle and try to imagine that object floating in front of you. Mentally spin it around and imagine its different angles.

The more you practice this, the better you will become at using shapes to construct your drawings.

This method, however, cannot be done without thought. Some objects are complicated, such as a twisted tree. You first need to observe the tree and take notice of the largest shapes, and then decide which basic shape will most closely fill that large area. Tree branches and tree trunks tend to be tubular, so naturally a cylinder would work. However, there are also large knots and growths on the surface of the tree. You can use spheres and ovals for those particular shapes.

The next time you go out to a public place, take a moment to observe the world around you. What basic shapes do you see? Now is the time to sketch these basic shapes and then morph them into something you are used to seeing in your day-to-day routines.

BASIC SHAPES IN ACTION

1: OVAL SHAPES

In the sketch shown below, you can see how a bird can be constructed using repeated spheres. Since a bird is an organic shape, try not to think of it as a complicated subject to sketch, but rather a series of very basic shapes that overlap each other. At first, start with ovals that indicate the two large, round sections of a bird: the torso and the head. Using ovals can be very helpful because they quickly indicate areas with the most mass.

Once the first shapes are in place, you can branch off into the smaller areas of the subject's form that need ovals, such as joints and eyes. Even the longer feathers of the wings can be constructed with ovals. When the ovals are in place, connect them by sketching around the outline of the bird. Even when using a reference to guide your drawing, you can still have creative freedom with the organic shapes such as muscles,

and surface-level bumps and ridges. The outline helps the silhouette of the bird to appear and the sketch is now ready for more details to the inner forms such as the facial features and the wings. The final stage is then to apply gradients for shadows that give a sense of the three-dimensional volume of the shapes. I imagine that the light source in this example is directly above the bird, which means shade must be added to the underbelly and underneath the bird's neck and head where the light cannot reach.

2: TRIANGLES AND CONES

A cone is a useful shape to construct a static organic form from, such as a pine tree. Trees can seem very detailed because of their leaves, branches, and bark, but the pine tree fits neatly in a cone. First, sketch the cone with an elliptical base; an ellipse is a circle viewed in perspective which will give you a good frame for your rounded tree forms. Draw lines from either side of the ellipse until they meet above the center of the ellipse to form the rest of the cone shape.

Next, sketch the tree trunk as a smaller, thinner cone shape within your first cone. The cone is effective here because the trunk of a pine tree is wider at the base and tapers upwards toward the top of the tree.

The next stage is very important because the branches need to be thought of as a variety of thick and thin cones poking out from the side of the trunk, rather than the complicated organic shapes they at first appear to be. Choose locations for these cone branches carefully so they do not overlap in your sketch.

For the last phase of the sketch, you can begin to create more organic shapes, adding new branch and leaf shapes using reference images of pine trees. Using a reference is a good way to build up your mental library and gives you a better understanding of your subject matter. When you are more familiar with the forms you are drawing, it will become much easier to invent new, or stylized, tree shapes.

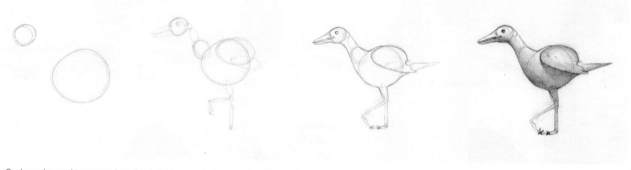

△ Ovals can be used to create a base for sketching organic forms such as birds and animals

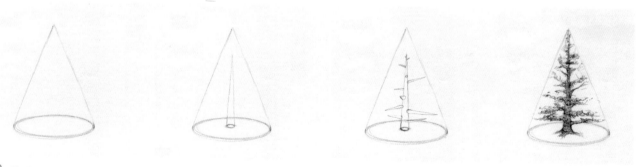

△ The key structure of a pine tree can be broken down into many variations of cones

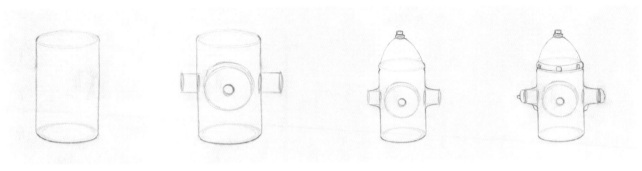

△ Cylinders are often helpful when drawing industrial subjects such as this fire hydrant

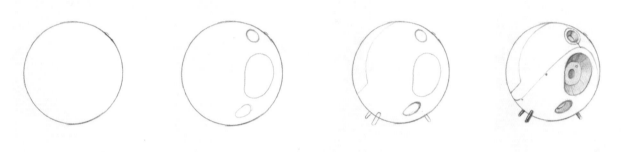

△ Spheres and rounded forms can be difficult to draw accurately so take your time practicing the circular motion

3: CYLINDERS

In the top drawing above you can see how a fire hydrant can be drawn with the use of a variety of simple cylindrical shapes. A cylinder can be found in a lot of diverse-looking objects such as drinking cups, smokestacks, and lava lamps. It is a common shape that is often taken for granted and neglected during study.

The first step in drawing a fire hydrant is to establish the main cylinder. This forms the main body of the hydrant. Next, sketch much smaller cylinders, turned on their sides, to represent the hydrant arms. There are many different types of fire hydrants and not all of them have four arms; some only have one. In this instance, a four-armed fire hydrant provides a good opportunity to practice and observe the different views of the cylinders.

To develop the sketch into a clearer image, draw the outline of the fire hydrant while ignoring the smaller, technical details that

you would find on a reference. Remember, you just want the silhouette so that you can see if your sketch is accurate so far.

When you are content with the general shapes, add those smaller details such as the lines across the body of the hydrant and the nuts and bolts that hold the structure together. Small details like these will help the sketch appear finished. Even though the nuts and bolts are small, they too can be constructed from cylinders. I find that it is better to work these shapes in slowly by making sure they are evenly placed and check they are correct by comparing your sketch against a reference image.

4: CIRCLES AND SPHERES

You can see above a sketch of a speaker constructed with a basic sphere. A sphere is a simple form to use as a base because there are no abrupt changes in shape and you also do not have to worry about placing it in perspective. The sphere, unlike a circle, remains rounded from all angles.

For the first step, sketch a circle. Try to avoid sketching the circle with a rotation of your wrist but instead move your whole arm in a circular motion, with your shoulder providing the main power source for the movement. It is okay to make multiple attempts when sketching the sphere because this will help you build a muscle memory for the shape. One of the key methods of keeping the same circular shape while sketching multiple circles is to lock your shoulder into the repetitive circular movement.

When you are happy with your base circle, begin sketching the speaker crevices on the surface of the speaker body with smaller circles. These smaller circles should be contorted to suit the rounded form of the main sphere. Make sure these shapes are drawn lightly as this allows them to be corrected later if needed. The lines that sit on a rounded surface can be difficult to draw so do not be disappointed if you need to make several attempts at these before you achieve the desired result.

PERSPECTIVE AND SCALE

In this section, you will learn the importance of perspective and scale when sketching and drawing. The most common types of perspective are one-, two-, and three-point perspective. Here you will find out how to recognize and construct them in your work. Knowing how to construct perspective is very important for beginners; without accurate perspective, your images will appear incorrect. No matter how much effort and detail you put into it, without perspective, the inaccurate perspective will be the focus.

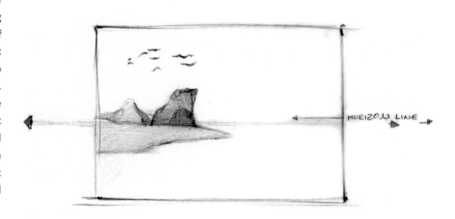

△ In this sketch of the ocean, the horizon line sits where the sky meets the water

THE HORIZON LINE

The horizon line of a view is the line, either visible or imaginary, where the sky meets the earth. This line is very important to drawing with accurate perspective because your other perspective markers will be placed in relation to it.

To practice identifying a horizon line, go outside and look into the distance of a clear space where nearby houses and trees are not blocking your view. Where the sky meets the ground is where you can see a real-life outdoor horizon line. If you are indoors, or surrounded by buildings blocking your view, look straight ahead instead. Whatever is directly at your eye level is the location of your horizon line. When you plan a drawing, look carefully at the subject and its surroundings to find the horizon line before you plan any other aspects of your drawing.

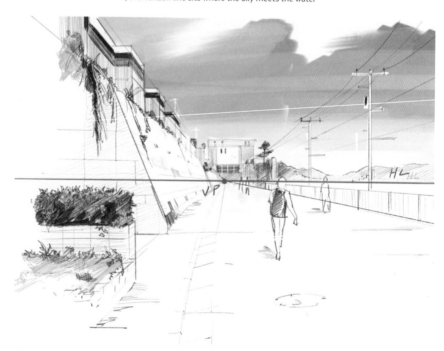

△ An example of a single vanishing point in a landscape © Richard Tilbury

VANISHING POINTS

Vanishing points are crucial for capturing accurate perspective. Without them your scene construction lines would float off into space without a destination to anchor the perspective. A vanishing point is a single point in the distance where all lines of an image converge. It occurs regardless of where you are or what you are drawing, and there can be multiple vanishing points depending on the type of perspective you use. A good way of locating your vanishing point is by looking at your surroundings at eye level as you may do to identify the horizon line. Whether you are sitting or standing, the vanishing point will still appear somewhere

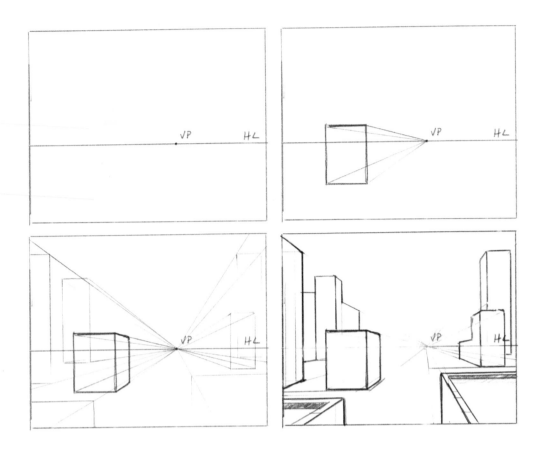

△ Cuboid shapes drawn with one-point perspective © Richard Tilbury

along the horizon line. If you look at the objects near you and further away, you will see that those objects have perspective applied to them regardless of what they are or where they are. This is because your eye perceives that the edges of the objects all converge to a single point. Perspective is so effective in art because it exists at all angles, no matter where you look.

TYPES OF PERSPECTIVE

1: ONE-POINT PERSPECTIVE

Sketching in perspective may be intimidating at first but it is much simpler than many think. One-point perspective is the most basic of the perspective types. In one-point perspective, there is a single vanishing point on a flat piece of paper. This single vanishing

point acts as an anchor for the perspective and all the lines in your drawing will converge to this point. Using the vanishing point means that you do not have to worry about the direction of your lines as the point they flow to is set.

Beginners can use a ruler to mark out lines in the direction of the vanishing point as it will train your eye to recognize where lines need to go in every drawing. Rulers also help you to keep your work clean until the line quality improves. As you become more confident with drawing the direction of the vanishing point, using a ruler in this way will become unnecessary.

To construct a one-point perspective, begin by making a single dot on the page. This dot

will be your vanishing point. Next, sketch a flat rectangle on the page with your ruler, making sure that the two pairs of edges are the same length. This rectangle should sit away from the vanishing point by at least three or four inches. You do not want the rectangle to sit over the dot for this exercise. Take your ruler and lightly draw a line between one corner of the rectangle and the vanishing point. Repeat this for the other three corners. You should now have a prism that you can use to create a cube or cuboid by drawing another rectangle further down the line. If your drawing looks like the example above, you have successfully drawn using one-point perspective. Practice this method with different hard-edged shapes and make sure that the construction lines all flow back to that single point.

Once you are confident with this type of perspective, draw a dot on a new sheet of paper, then sketch several cuboids of different sizes at different places on the page. Carefully connect the corners of all the rectangles to that single vanishing point. Soon a page of flat rectangles will transform into three-dimensional shapes. Take your time when doing this; there is no rush when it comes to learning fundamentals.

2: TWO-POINT PERSPECTIVE

Two-point perspective is similar to one-point perspective in that you have a horizon line, but for this type of perspective there are two vanishing points. You will find it easier to use two-point perspective if the vanishing points are spread far apart on the horizon line. This helps to prevent the object you are bringing into perspective from looking forced or squeezed.

To draw in two-point perspective, sketch a straight line across your paper to form the horizon line. Next, draw a small dot near to each end of that line to create two vanishing points. Try placing each dot at slightly different distances from each end of the horizon line to add more interest to the finished composition.

After the two vanishing points are applied, you can choose any area on the paper for your object to sit. Until you are familiar with two-point perspective it is better to keep the objects at, or near, the center of the paper. Next, draw a straight line from each vanishing point so that the lines intersect somewhere on the page. This crossover point will be the starting position for a cuboid in two-point perspective. The cuboid is a good

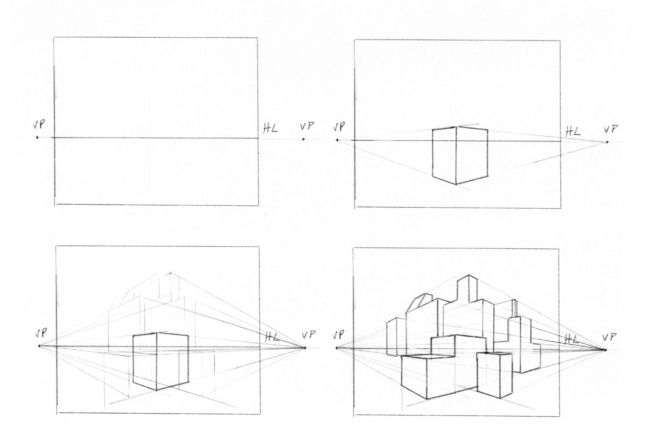

△ Apply two vanishing points far apart on the horizon line when using two-point perspective © Richard Tilbury

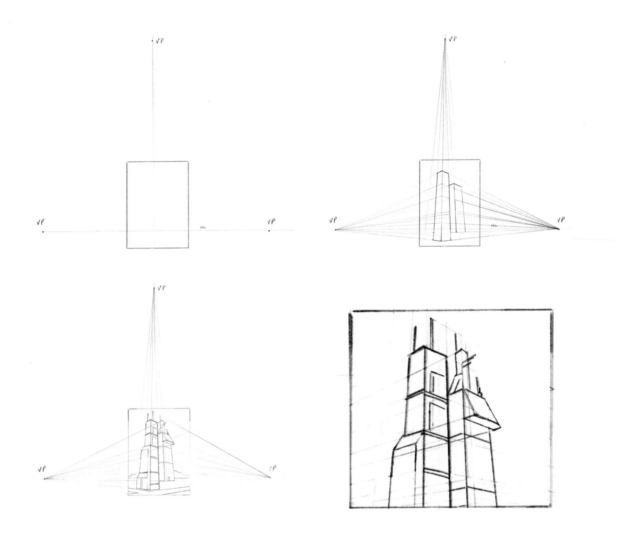

△ Three-point perspective is very useful for drawing tall buildings © Richard Tilbury

shape to practice with as all of the edges are straight and you do not have to worry about organic curves.

The useful thing about sketching vanishing points with a horizon line drawn in is that no matter how confused you might get with drawing these shapes in perspective, all lines that are not vertical will lead to one of the two points. Trying to imagine how the cube will float in 3D space as you work will also help. Just remember that in two-point perspective, keep the vanishing points far apart to prevent your drawing becoming squeezed and misshapen.

3: THREE-POINT PERSPECTIVE

Three-point perspective is more advanced but fun to sketch! It is particularly good for drawing tall buildings accurately. The easiest way to construct three-point perspective is to have your horizon line followed by two vanishing points spread far apart on that line, as you do with two-point perspective.

The next step is adding a third vanishing point placed between the other two points but moved to the opposite end of the paper from the horizon line. Draw a straight line from each of those points and make those lines intersect somewhere on the paper.

This crossover will be the starting point for sketching a skyscraper in three-point perspective. Again, it is better to keep the objects at or near the center of the paper so aim for your third point to sit fairly centrally. Try to imagine how a building looks if you are standing on the sidewalk looking up, or on the roof looking down at a building across the street. As with two-point perspective, keeping the vanishing points far apart will help prevent your drawing becoming stretched. However, there is an exception to this in three-point perspective; if you are looking down on something far below, the base will look unusually small and pointy.

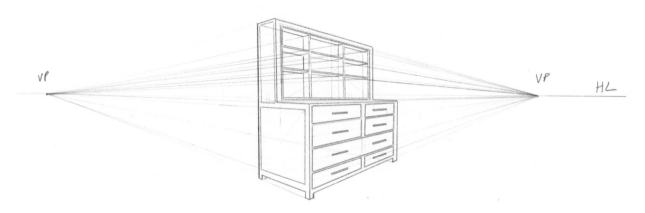

△ Most objects viewed at eye level, such as household furniture, can be drawn in two-point perspective © Richard Tilbury

DEFINING A PERSPECTIVE FOR YOUR DRAWING

Before you start sketching, you need to know what it is that you are aiming to draw. As bad perspective can be spotted almost instantly it is important to spend time getting this right. Beginning a project with a plan already in place will help you succeed with the perspective and overall execution.

There is one key factor you need to look at when determining which perspective to use for a drawing: the angle at which you are viewing the subject from. When you have decided which angle you want to draw from, you can then establish whether one-point, two-point, or three-point perspective is most suitable.

The most common angle to draw from is eye level. Generally we view the world around us in two-point perspective; either slightly above or slightly below the subject with a hint of perspective in two different directions. Therefore subjects viewed at eye level can most often be drawn with two-point perspective.

If you are drawing an object that has a flat face and you are looking directly at the flat surface, one-point perspective will be the most appropriate perspective to use. Imagine, however, that you are in an airplane looking down over a city. What

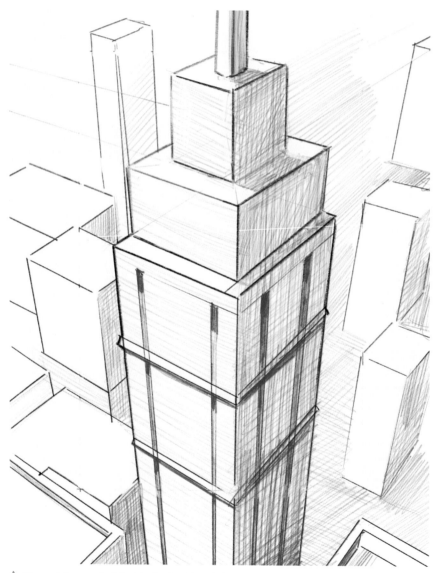

△ Three-point perspective is best for drawing objects far below the viewer © Richard Tilbury

△ It is often easiest to use one-point perspective when drawing a flat-faced object at eye level © Richard Tilbury

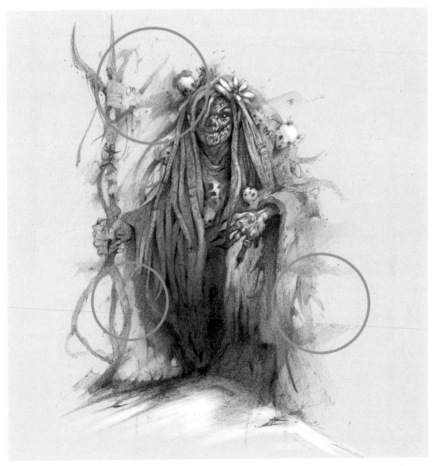

△ Smoke and mist effects (circled) help to develop atmospheric perspective with less detail around the edges

"ATMOSPHERIC PERSPECTIVE IS THE REASON WHY A NATURALLY GREEN LANDSCAPE, FOR EXAMPLE, MAY HAVE FADED BLUE TONES WHEN VIEWED FROM A DISTANCE"

perspective would you use if you wanted to sketch a skyscraper tower? Three-point perspective is the best option in this case because it is a tall subject viewed from high above, and therefore the third vanishing point is far below you. Often, if you are sketching something very large and tall, like a skyscraper, three-point perspective is the best option to use.

ATMOSPHERIC PERSPECTIVE

Atmospheric perspective (sometimes called aerial perspective) is the perceived dissolution of light and color of objects when they are viewed at a distance. It is caused by the air particles between your eyes and the object interrupting the passage of light. Atmospheric perspective is the reason why a naturally green landscape, for example, may have faded blue tones when viewed from a distance. This type of perspective can add a whole new sense of depth to your drawing as your object fading into the background gives more realism and even a sense of movement to your work.

An easy way to achieve atmospheric perspective is to leave some areas of your drawing less detailed. To be effective, the detailed parts should be in the foreground and the rougher parts should be in the distance. As atmospheric perspective is created by the disruption of light through air, I like to add an impression of pockets of mist or smoke with eraser smudges, to give the illusion of different atmospheric pressures.

DRAWING 3D FORMS

When drawing 3D forms, it is important to remember that you can draw through the forms to make guides. By lightly sketching the entire form with construction lines passing through the object you can ensure the perspective is correct and get a better understanding of the object as a 3D form. If you are drawing a speaker, for example, make sure to sketch what the components might look like on the side you cannot see. Imagine that these objects are floating in front of you and you have Xray vision to see through them.

To go into more detail, let's observe a simple table. A table is easy to draw as it has a flat top and usually four legs attached. Using your imagination, think about this form in 3D, floating it in front of you, and slowly turn it around in space to view it from different angles. Identify the parts that would be hidden when the table is viewed statically, such as the join between the table top and the legs on the far side, and how you could mark them on a sketch. This will help you check the accuracy of your image and ensure that it is in perspective.

3D forms need clarity when sketching them because they must be identifiable and understood by the viewer to be successful. We need a strong idea of what all edges of an object are doing while in perspective to get a realistic vision for the object.

SCALE

Scale is the practice of identifying the size of an object by putting it in context with something else. It is important when drawing because viewers need to see your subject in comparison to other objects to fully understand what it is, and how that relates to the size of an average human. This helps clarify a lot of questions from the outset, such as how realistic or stylized the sketch is and what genre your subject might belong to.

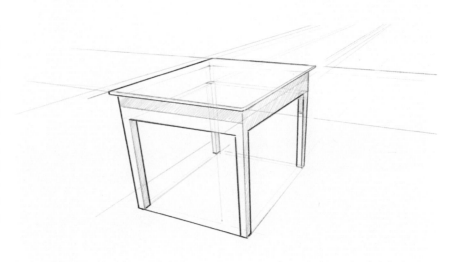

△ Use simple objects such as a table to practice drawing 3D forms © Richard Tilbury

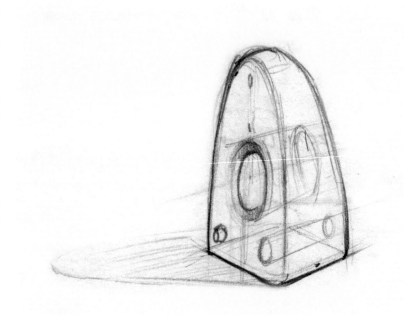

△ A sketch showing construction lines through a speaker so the opposite side can be visualized

Scale can also be used to add drama and storytelling to your image. For example, when sketching a large creature it may be clear to you, the artist, that the creature is enormous. However, anyone who looks at the sketch has no idea how big it is. If your creature or object is sixty feet tall you need to include something that will help the viewer understand the scale. Adding a character,

trees, street fixtures, or vehicles will create scale as these have easily recognizable sizes that are common in our daily lives.

USING SCALE IN YOUR SKETCHING

When you sketch a scene or object, it is good to include a human or something with an easily identifiable size to create a sense

of scale. If you use a human figure, try to make them anatomically correct and avoid the temptation to scribble a loose shape that will not provide the viewer with enough information. A realistic-looking human will be identified much more quickly than a rough impression and encourages the viewer to understand the scene from that figure's position, making them more emotionally attached to your drawing.

One scenario where using human scale to explain your drawing is very important is during a presentation, particularly if this is for school or a client. Through all my years of teaching, I have noticed that one common flaw made by students in final presentations is that they simply forget to add a sense of human scale into their piece. The viewer is left guessing how big the subject of the artwork is as a result.

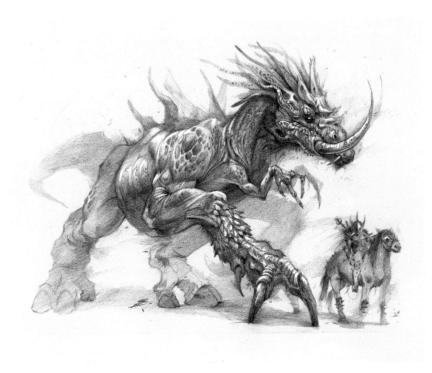

△ Adding a human on a horse for scale makes it clear that this beast is gigantic

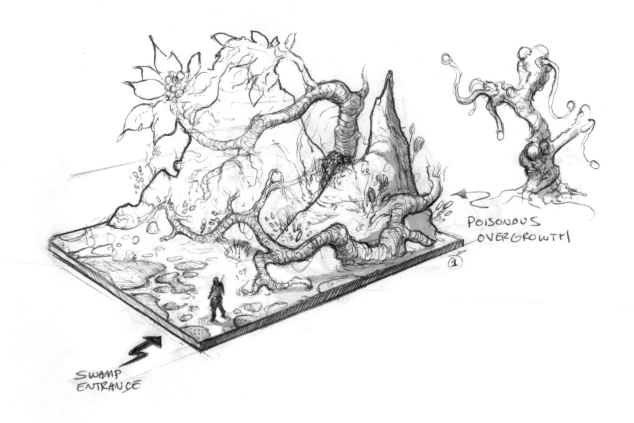

POISONOUS OVERGROWTH

①

SWAMP ENTRANCE

△ A human figure with accurate proportions gives scale to this sketch of a swamp

LIGHT AND SHADE

In this section we will be discussing light and the importance it has in drawing. We will also look at tonal value and how to achieve tonal control in your sketches. Lighting is a fundamental aspect of drawing and therefore it is very important that it is not overlooked in your work. Our eyes use light to see on a daily basis, so light will affect every sketch or drawing you make and be a significant influence on how your art is perceived.

WHAT ARE VALUES?

Values mark the tonal strength of an image, informing the viewer of whether an object is darker or lighter than the objects around it. When a variety of light and dark values are used in an image it creates contrast, which makes the image more interesting to look at. It is important to learn how to use values before you work with color because colors also have a dark to light range and this can cause confusion when color is introduced prematurely. If you can master the value range of your image in grayscale first, you will know how and where to transition from dark to light tones and applying color will become much easier.

Values are not limited to black and white but are instead made up of a wide range of grays, each of which has a slightly different tonal strength. It is this grayscale that gives you the ability to transition from black to white, making an object appear believable. This is especially important if you want to show how the object is affected by light. A great way to practice seeing value is by taking pictures with your cell phone and converting them to black and white. You could also try taking pictures outdoors in different lighting scenarios to see how the light affects the

△ Conversion into grayscale reveals the different values between the hillside, cliff, sea, and sky © Richard Tilbury

△ Building up lines can create midtones while pencil pressure is used for dark values © Richard Tilbury

light and dark values of the surroundings and landscape. Alternatively, take a picture of an object with only one light hitting it, convert the image to grayscale, and study how and where the transition from dark to light happens.

HOW TO DRAW VALUE

Drawing different values will take some patience but it is definitely achievable and worth the effort. The simplest method is to sharpen your graphite pencil (preferably a 4B–6B) and draw a single line. When you first put the pencil to paper, press firmly but take care not to break the tip. Then slowly release the pressure as you sketch until your graphite pencil hovers just above the paper. This method can also be used in mark-making to create interesting lines (see page 42, Lines and Mark-making: Line Weight). However in this case the method can be used to quickly show how pencil pressure can affect dark to light values.

A great way to build tonal differences in your image through value is to apply multiple layers of lines, in different directions, with varying pressure. First, lightly sketch an even coating of graphite across an object, ignoring the line art details at this stage. Find a section of your image that you want to have a midtone value and draw over it again two further times, changing the direction of your lines each time. Even without adding pressure to the lines, you will begin to see the area fill up with a darker, even value. Then, if you want part of your image to have a very dark value you can apply darker tones using pencil pressure or a softer graphite lead. This will give you an image that has multiple values and, as a result, is more visually appealing.

USING GRADIENTS

Similar to the sketching process used above to create a value range, gradients are achieved by applying very smooth transitions from dark to light. As values are

△ Practice drawing a smooth gradient by varying your pencil pressure and layering light marks © Richard Tilbury

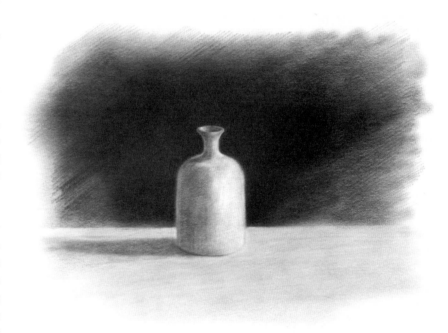

△ Use simple scenes with only one light source to practice drawing gradients © Richard Tilbury

used to show contrast in an image and help you make a composition more interesting, gradients allow our eyes to observe a gradual increase in light. Gradients can be used in almost any drawing depicting a light source.

To practice applying a gradient, lightly sketch a long rectangle on your paper. Next, apply a light coating of value across the rectangle, allowing it to transition into the pure white of the paper at one end by very gently fading the graphite as you sketch. Starting at the opposite side of the rectangle from the white, begin shading again, this time with more pressure to create a dark tone. As you

work across the shape toward the white of the paper try fading the dark tone into the coating of graphite, either by building up lighter tones or varying the pressure. It is important that you do not use your finger to blend the tones. Although blending with your finger can produce a similar effect, you will not learn how to create a smooth gradient that can be adapted for your sketches. When you are confident in your technique, move on to practice drawing gradients on 3D forms. Choose basic objects at first using one light source to create areas of light and dark, before attempting more complicated compositions.

TYPES OF LIGHT SOURCE

1: STRONG NATURAL LIGHT

Strong natural light often comes from direct sunlight. Natural light can be lightly colored, although at its strongest it will appear to be pure white. It is not unusual to use a pale yellow or orange color in the midtone values to suggest the scattering of natural light as it hits an object. As natural light travels a great distance through the atmosphere it creates a secondary light from the sky, which in turn creates a fainter bounce light on objects.

The shadow caused by a strong natural light is usually well defined, with the shadow stretched depending on the time of day.

2: WEAK NATURAL LIGHT

Weak natural light usually occurs at dawn and at dusk, or when the sky is very overcast with cloud. Without the beam of strong sunlight, there is no need to show a white spotlight, and the warm colored tones can be more pronounced and spread more widely over the object. The secondary light of the atmosphere still has an effect on the object but the difference between areas of

light and shade are much less clear. The shadow that is created under a weak natural light is faded with blurred edges.

3: ELECTRIC LIGHT

Electric light, such as the light caused by lightning or an electric light bulb, is caused by light particles being heated very quickly. The strength of the light that is created can vary greatly, but if the electric light is strong it tends to have an intense white or white-blue color that will fade out over a large surface area. A dark, clearly defined shadow is created by such a strong light.

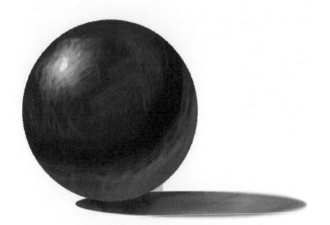

△ The effect of strong daytime sunlight

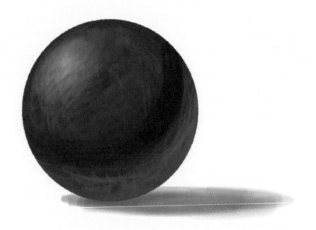

△ The effect of weak natural light

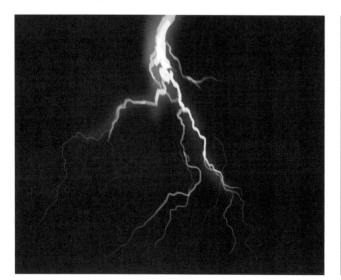

△ Lightning produces a strong electric light

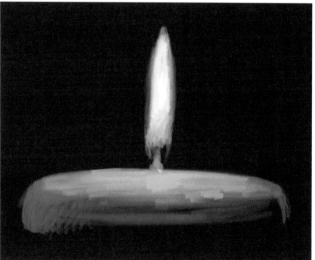

△ Candle flames produce a muted, colored light

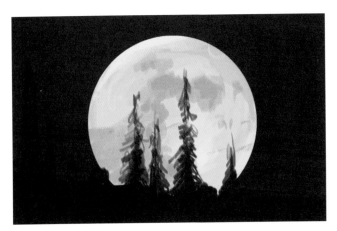

△ Moonlight produces a warm, muted light

△ A spot light positioned slightly above and to the right casts an ominous shadow

If the electric light is weaker it will have an orange or yellow glow, and illuminate a smaller area. The shadows created by weaker electric lights will have relatively lighter values and appear to be blurred.

4: CANDLELIGHT

Candlelight or firelight is bright when viewed up close, but generally it produces a muted effect, varying with the flame's intensity. This can add mystery and drama to your art as the light has a very short reach, leaving objects partially hidden. Usually positioned at a lower angle than other light sources, candlelight can create interesting shadows.

5: MOONLIGHT

Moonlight is beautiful to look at and is typically muted, even on a perfectly clear night. It is not as illuminating as sunlight as the moon is only bouncing the light from the sun off its surface. Despite popular belief, moon light is not blue. It actually has a warm hue to it. The shadows it produces are often very weak, especially in cities where there is artificial light conflicting with the moonlight.

TYPES OF SHADOW AND HIGHLIGHT

1: SPOTLIGHT

A spotlight is a harsh, single light shining directly on an object. It can be natural or artificial and is frequently used to draw the

△ Edge lighting separates the figure from the background and draws focus to the figure © Richard Tilbury

viewer's gaze to a single focal point in an image. A spotlight can also be used to create interesting shadows in a single location in a scene. The more interference from other light sources there is in the scene, the less effective the spotlight becomes.

2: EDGE LIGHTING

When an object is placed between the viewer and a light source a thin illumination appears around the edge of the object; this effect is called edge lighting, or rim lighting. Edge lighting is a wonderful way to tease the viewer by separating an object or figure from the background, but it does not necessarily reveal the details of the object to the viewer. Edge lighting is therefore a great method of creating atmosphere and mood when drawing. This lighting effect is also very useful when creating portraits as it draws focus onto the figure itself in an interesting and unusual way.

3: CAST SHADOW

When a light source shines on an object, a shadow is cast across the surfaces surrounding the object. This is referred to as a cast shadow. The length of the cast shadow depends on the angle of the light source. The clarity of the shadow is dictated by the intensity of light and the surface the shadow is projected onto. Multiple light sources at different angles can create overlapping cast shadows of different value.

4: CORE SHADOW

Core shadow in art is the blocking of light around a form. When a light is shining on one side of an object, it is blocked from reaching the other side, creating a shadow. The darkest part of this shadow is called the core shadow (sometimes known as form shadow). It is often softer than cast shadow as it is muted by the ambient light of the light source and gives the viewer a greater sense of the object's 3D form.

IDENTIFYING LIGHT SOURCES

To identify the light source in an image, look at the location of the highlights first and then observe where the shadows are in relation to the highlights. This gives a good indication of where the light source can be located in space and the direction the light is traveling across the image. Studying directional light from images is a great way to learn how to apply it to your drawings. If there are multiple light sources in a scene it may be hard to identify the conflicting directional light. This calls for even more studying and attention to detail when translating it into a sketch. Practice sketching light using reference images that you have already identified as having a single light source before tackling scenes with multiple light sources.

USING DIFFERENT LIGHT SOURCES

Using only one light source can keep your sketching process simple as you do not have to worry about the complex value structures

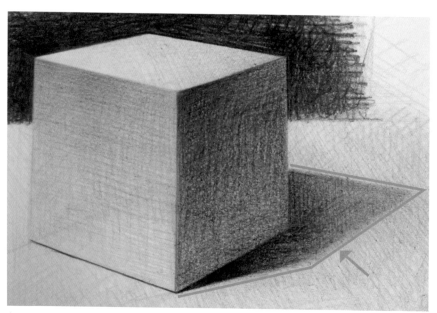

△ The basic cast shadow of a cube

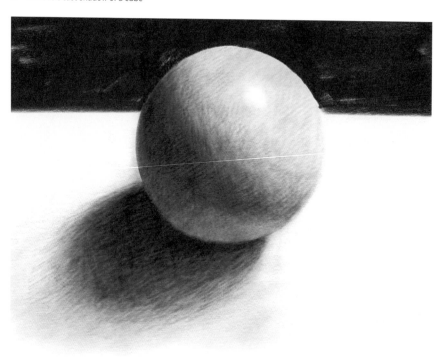

△ Core shadow on a sphere © Richard Tilbury

of multiple lights or the creation of multiple shadows. Using a single light still offers some options for dramatic effects. This is especially true if the light source is intense, as it can create a stark contrast between light and dark areas. When sketching a single light source, take advantage of the natural color of your paper. Indicate with a small dot where you want the brightest highlight to be and if you are drawing on white paper, leave that area white with no shading at all. Less is more when sketching a light source, so this is the perfect time to use the color of your paper to your advantage!

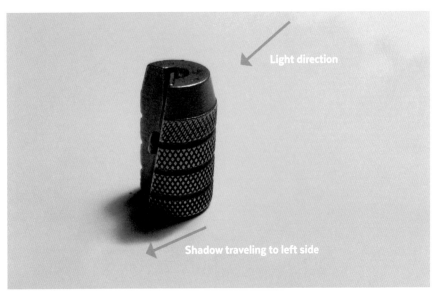

Light direction

Shadow traveling to left side

△ In this photograph a light source from above right casts a shadow to the left of the pencil sharpener

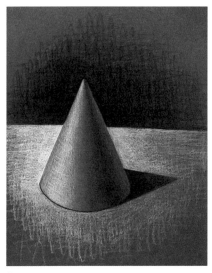

△ The single light at the upper left of the cone is causes a strong, dramatic cast shadow

Sketching light when there are multiple light sources can be tricky. You have to look at the intensity that each individual light is giving off and the direction of those light sources will determine how the shadows fade. As a general rule though, the stronger and closer a light source is to an object, the harder edged that cast shadow will be on the ground or surface that the object is on. Tackle each light source one at a time to ensure you fully understand them.

BOUNCE LIGHT

Bounce light, or reflected light, is indirect light bouncing off the surface an object or the ground onto another nearby surface. This can often be seen when several objects are placed close together. Bounce light is weaker than other light effects and can be hard to identify. If one of the objects is in shadow, or a single object is producing a strong cast shadow, the reflected light that hits it can be seen more clearly because of the contrast it creates.

This type of lighting is challenging but you can master bounce light by eliminating confusion. Set up several objects with different materials such as glass, rubber, and plastic. Next, take a picture of this set-

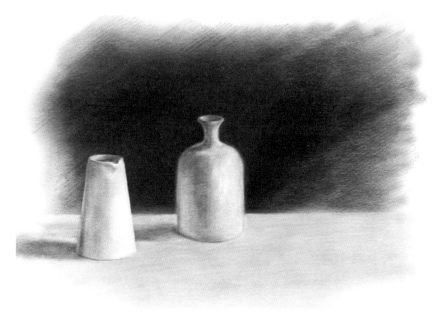

△ In this image light reflects off the ground and white jug onto the left side of the bottle © Richard Tilbury

up and convert that image to grayscale. Now that you can see it in black and white, those reflections can be seen without the confusion of color.

To effectively sketch bounce light, your object needs to be a midtone. This means not too light and not too dark. Bounce light will mostly occur on the bottom of an object

because the light is directed from above and bounces upwards off a surface, usually hitting the underbelly of an object. The area where the bounce light is hitting should be of a lighter tone than the midtone you used for the whole object. Place less graphite and shading inside the area where the bounce light will occur to prevent unnecessary erasing of the lighter area.

41

LINE AND MARK-MAKING

Creating a mark or line is the backbone of all that is drawing and practicing different techniques will help you become more comfortable when working on a drawing. In this section, we will be discussing the many mark-making techniques, including hatching, stippling, and negative mark-making, that can be used to make your sketching more creative and intuitive.

LINE WEIGHT

Line weight is the relative strength of a line compared to its background and surrounding lines. In sketching, line weight is often caused by the pressure with which the pencil is pressed on to the paper or by changing the mark-making tool (such as switching from pencil to pen). Line weight works best when it shows the graduation from thick to thin in a single drawn line and it is extremely important to create depth and interest when sketching to vary your line weight. Sketches that have the same line weight throughout often look very flat. Being able to draw with varying line weights is a very useful skill to have if you want to show depth without shading your sketch.

HATCHING

Hatching is a series of repeated diagonal lines all drawn in a single direction. This particular technique is very effective when filling an area with shading or shadow. When it is done correctly, hatching can have a beautiful effect on your drawings from a minimalist standpoint. When you are sketching and want to use hatching in an area, make sure you have all the shadows planned out first so that the hatching can act as a shadow substitute. Then mark off all the areas which you know are going to need a lot of shading with a simple, light outline. Next, pick the direction you want to make the hatching lines and fill that area in. It is very important to make sure the lines are evenly spaced as you move across the paper, as this will give a consistent impression of shade in your drawing.

△ Different line weights add depth to a sketch © Richard Tilbury

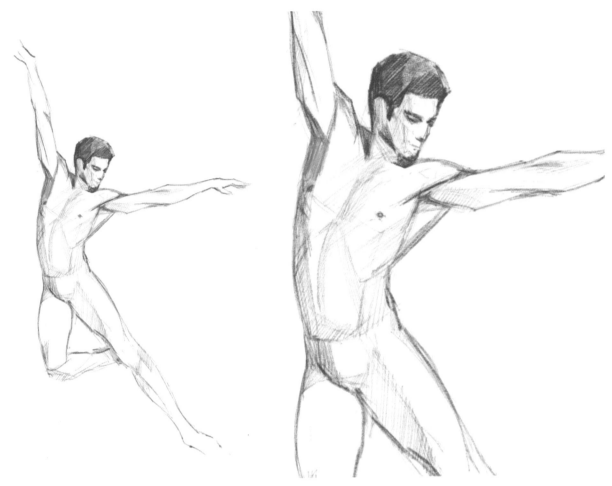

△ Hatching is a series of diagonal lines that can be used to add shade © Richard Tilbury

△ A combination of hatching and cross-hatching can add depth to sketches © Richard Tilbury

CROSS-HATCHING

Cross-hatching is a technique that takes regular hatching a step further. You can cross-hatch by adding another layer of lines in a different direction over your original hatching lines. Whatever direction you have chosen for each layer of lines, make sure that the lines themselves remain parallel to each other. This will make your hatching technique look more professional.

Since cross-hatching is a more advanced form of hatching, you can use it to draw your own hand with a strong light source shining on it. Look at the shadows that the light creates on your hand. Take a picture of your hand in this position and convert it to grayscale. Sketch your hand and cross-hatch wherever shadows appear.

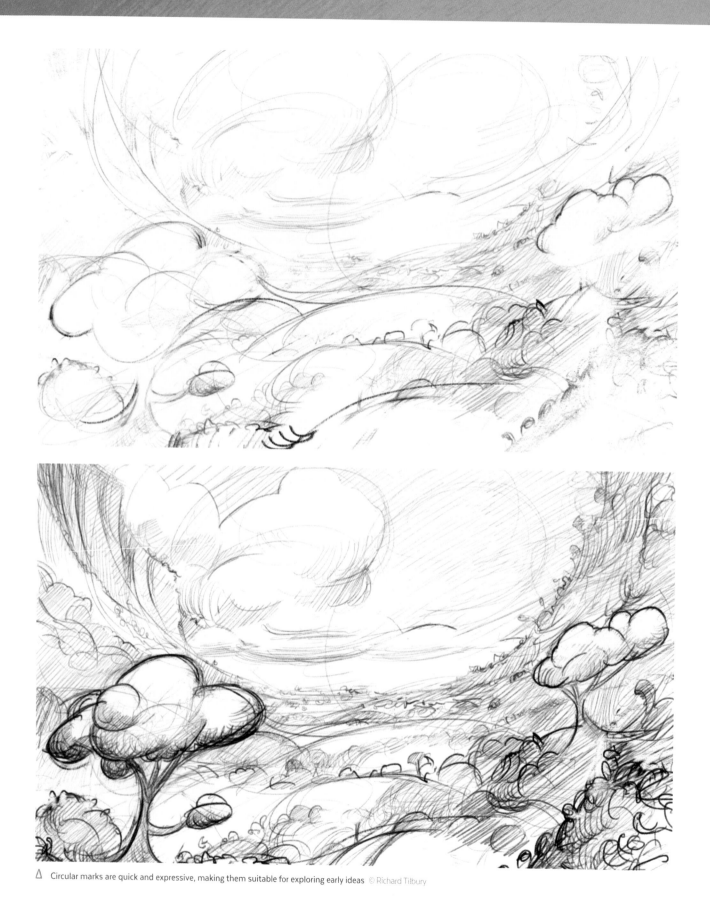

△ Circular marks are quick and expressive, making them suitable for exploring early ideas © Richard Tilbury

△ Scribble marks can be used to speedily draft an image © Richard Tilbury

△ Irregular marks can be used as the starting point for an image and create exciting variations © Richard Tilbury

CIRCULAR MARK-MAKING

Circular mark-making is a unique technique in that rounded marks are made to convey shading. Circular marks are best used when you are in the ideation phase of your sketch as it is a very free form of mark-making and it allows you to stay loose in your work. Keep your arm and wrist flexible as you draw as this will give you better results. When you are using circular marks in a sketch, group smaller circular marks together to create dense areas and use large sweeping circular marks to indicate open areas.

SCRIBBLING

Scribbling is often considered to be something only children do when drawing but there is power in scribbling. This technique is mainly used in thumbnail sketching (small practice sketches) or in draft work. Using a collection of random lines together and intertwining them can quickly create the image you have in your mind without the need for refinement. Furthermore, if you are having trouble thinking of something to draw, you can scribble lines together and then see if there are interesting shapes within the scribble that you can use.

IRREGULAR LINES AND MARKS

Irregular lines and marks are unpredictable lines that can change direction suddenly, making the viewer study the sketch harder as they interpret it. As an artist, using irregular lines can also keep your mind fresh and offer new opportunities when sketching. Take your drawing tools and explore how they can be used differently. An interesting effect could be created by holding a pencil at a very low angle or rubbing a charcoal stick on its side over the page. Irregular marks can also be created by placing your paper over different textured surfaces as you draw. Think of your drawing as a spontaneous eruption of lines and marks with no order or pre-planned idea and see how they can be worked into a composition.

45

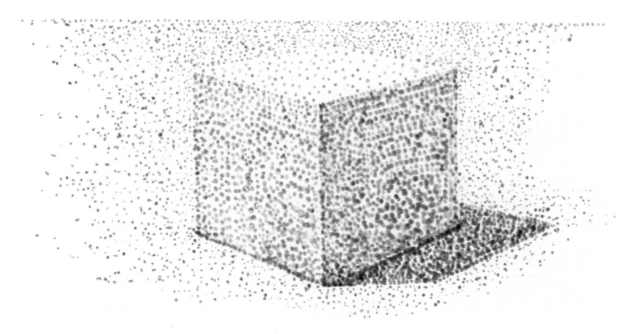

△ Stippling dots can be grouped to show solid form and shade © Richard Tilbury

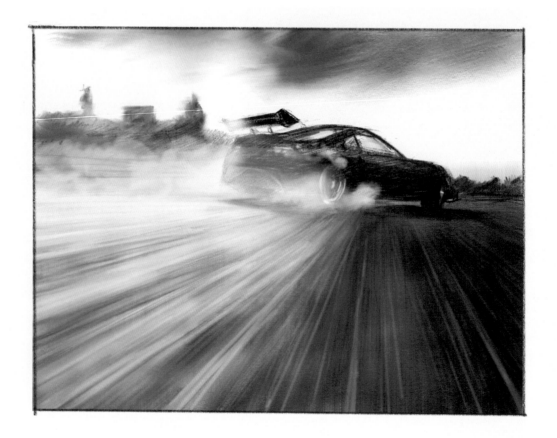

△ An eraser is rubbed across the thick coating of graphite here to create a motion blur © Richard Tilbury

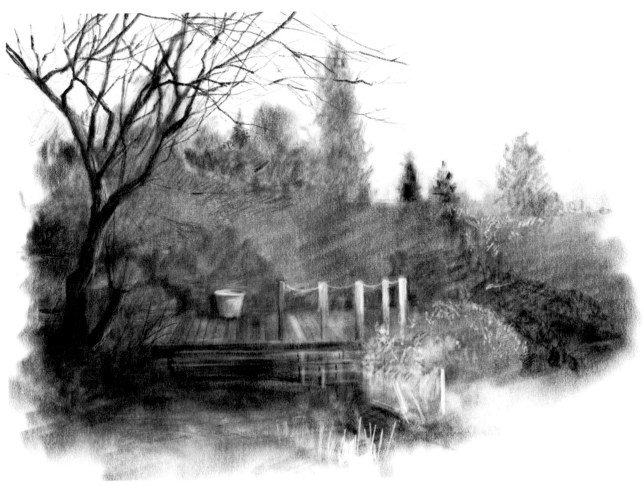

△ Apply the eraser slowly with force to take up the graphite and create a negative space © Richard Tilbury

STIPPLING

Stippling is done by making many tiny dots in a disordered manner. These dots can be grouped and spaced to suit the sketch. It is a beautiful technique that can be used to construct entire drawings, regardless of the subject matter. Stippling is also useful for shaded areas. It helps to know how gradients work when using this technique for shading because the dots need to be grouped together for darker areas and spread farther apart as areas become lighter.

ERASER BLUR

Erasers can be incredibly useful when sketching, and they can be used for more than removing mistakes. Sometimes, shading a certain area will not give you the effect you desire. For example, it is very difficult to convey fast movement on a flat piece of paper with pencil strokes. Trying to shade an object that is blurred due to quick movement can be challenging too. Eraser blur is a technique of fading marks and shade so they have less definition and appear to be moving quickly. To achieve this effect, take an eraser and gently slide it across the edges of the object, causing the marks to become evenly smudged. This creates a blur effect similar to the motion blur seen in games and movies. It can take practice to achieve but it is a handy technique to learn.

NEGATIVE MARKS

Negative mark-making is the removal of marks to create areas of space in a sketch. This technique is a good way to show bright light and can be very effective on images that have very dark values. This is another technique where the eraser is very helpful. To create a highlight with negative marks, carefully erase away graphite from the area in a slow, purposeful motion. However, the ease at which the graphite can be removed will depend on how dark or thick the coating of graphite is on the paper. A dark coating with a clear highlight can be effective to look at but it is hard to keep the highlight clean. A negative mark on a lightly shaded image is less effective but easier to create.

47

TEXTURE

In this section, we will be discussing how texture works and its importance in achieving realism in your sketches. Translating what you see with your eyes onto paper can be challenging, but here are the most influential factors to consider when representing textures with basic graphite pencils.

WHY TEXTURE IS IMPORTANT

Texture, the detailed impression of a surface, informs the viewer what materials a form is made of. It can make a dull drawing come to life. As simple as a pencil is, sometimes that is all you need when trying to make a surface appear believable. It is important to show surface texture because a drawing can become redundant and repetitive without some sign of material variety in a scene. Textures can help break up those surfaces and make an image more interesting.

For example, a scene featuring a wolf needs to show the different textures of the wolf's short and long fur, and textures of bark and grass will also give the image more interest. Using different textural techniques, such as the ones that can be found in the Texture Library, will help the viewer's eye to differentiate between the surfaces.

MATERIALS AND LIGHT

Materials reflect and diffuse light differently, mainly because of their surface makeup, which dictates whether the light reflects off the surface or scatters erratically, dulling the light. A smooth surface tends to reflect light clearly and usually at the same angle that the light hits the object. For example, a beam of light hitting the shiny metal of a car will bounce back at the same angle and seem as bright as the original light source.

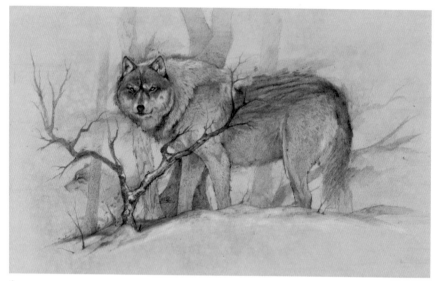

△ Layering multiple fur textures brings this wolf to life

△ Fibrous materials have a rough texture that does not reflect light as well as smooth surfaces © Richard Tilbury

On a rough surface, the light is diffused so the reflection of light is scattered. This is because the surface texture is uneven and therefore the light is more unpredictable. Materials that are very fibrous, such as a plank of wood or a cotton shirt, only show a very soft reflection of light because the fractured surface causes the light to scatter.

CAPTURING TEXTURES

Identifying textures can easily be practiced at home through observation of the textures around you or by taking pictures of different objects and materials. Study a wide variety of metals, wood, plastic, dirt, and so on to build up your mental library. Having a thorough understanding of how different textures

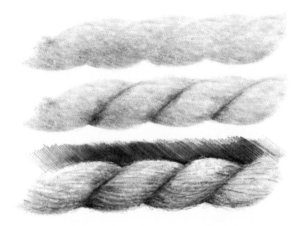

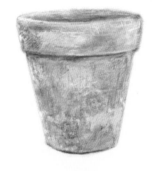

△ Begin any texture by making light marks and build the values as needed © Richard Tilbury

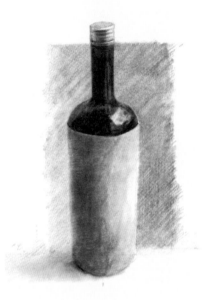

△ Very smooth surfaces such as metal or formed plastic can be shown with light shading on white paper

△ The plant pot's flat texture has little impact but the wine bottle is more effective as the textures are wrapped around the 3D form © Richard Tilbury

look in real life and how they respond to light will help you when sketching these textures.

Translating those textures onto paper effectively takes practice and unfortunately there really is no shortcut to becoming proficient. Do not let this discourage you however, as exploring different textures can be fun and will also help you improve your mark-making skills.

In the next section of this book you will find a Texture Library with sketching tips that can be worked through to practice a wide variety of textures. Regardless of the texture you are

trying to draw, start very lightly and build up your values. Have the Texture Library or an image of the texture next to you at all times for reference.

WRAPPING TEXTURE AROUND 3D FORMS

As the subjects of your sketches are 3D forms, a flat texture drawn over the shapes will always look odd. To make the texture more convincing, it must be wrapped around the forms and, if the subject is in motion, follow the gestural flow of the forms. Wrapping texture around a 3D form can be done if you imagine what that texture

does when turned in space, as you did when depicting the 3D shapes. If you are looking at a woven material, study the lines of material. Are they perfectly straight or do they warp or bend around the shape?

Pick up a piece of rough paper and wrap it around a can or bottle. Study how the paper bumps look as they travel around the cylindrical shape. Now look at the materials; what are the reflections doing? How do they change from one area of the cylinder to another? Again, wrapping texture around a 3D form takes practice but it is very important to creating an identifiable sketch.

49

TEXTURE LIBRARY

There are hundreds of different surface textures, both organic and synthetic, that can be captured beautifully through sketching to give an image detail, realism, or context. As you will see in the processes presented in this encyclopedia, texture plays in important part in polishing a sketch. Here you can find quick tips to guide you in the recreation of the most commonly used textures.

△ Cloud

CLOUD

· Draw clouds with a light hand

· Hatch a light coating of graphite over the cloud shape

· Make repeated irregular marks in places to build dark areas

· The paper color or negative eraser marks can be used for the lightest values

CURVED GLASS

· Use a glass bowl or cup as a reference

· Sketch the outline shape and lightly mark any reflections you can see

· Apply a light cross-hatch layer of graphite, leaving the areas of highlight blank

· Mark small areas of dark value in lines following the curve of the glass

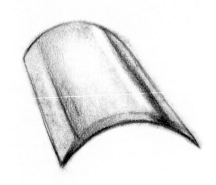

△ Curved glass

FEATHER (FLUFFY)

· Use a freshly sharpened graphite pencil

· Angle the pencil so that you draw with the side of the lead

· Apply very light individual strokes

· Layer the pencil strokes to create irregular areas of shade

△ Feather (fluffy)

△ Fish scales (plain)

△ Flat glass

FISH SCALES (PLAIN)

• Draw rows of curves spreading horizontally

• Apply a light cross-hatch layer of graphite over the scales as a base

• Add definition around several of the curves to show shade between the scales

• Use small, irregular dark marks to suggest grit and imperfections

△ Mirror

△ Reptile scales

FLAT GLASS

• Making minimal marks is the key to drawing glass effectively

• Sketch a very light hatch layer of graphite

• Add slightly darker values for reflections of any nearby objects with additional layers of hatching

• As the glass is flat, the reflections will be stretched and drawn in long streaks

MIRROR

• The texture of mirror is similar to that of flat glass but opaque

• Use minimal lines to show the shiny surface

• Reflections are only distorted if the mirror is at a sharp angle

• Use very light hatching strokes to suggest a few streaks of shade

REPTILE SCALES

• Have reference photos of reptile scales readily available

• Draw a single rounded scale

• Duplicate the scale shape side by side, introducing irregularities

• Lightly shade individual scales with hatching, following the direction of the light

51

SHINY PLASTIC

· Use a freshly sharpened graphite pencil

· Apply a very light cross-hatch coating of graphite in a minimum of three directions

· Repeat the cross-hatching, adding more pencil pressure to create darker values

· Leave the white of the paper visible in areas that need highlights

△ Shiny plastic

SILKY FUR

· Silky fur is layered, with hair laying in clumps

· Draw a series of clumps with irregular lines making sure some individual strands of hair are visible

· Add detail to the ends of hairs by drawing extra irregular lines

· Increase darker values around clumps with added pencil pressure to show shade

△ Silky fur △ Smoke

SMOKE

· Make sure your pencil is sharp to create precise marks

· Apply a light, wispy layer of graphite in an upward motion

· Add horizontal markings with circular movements

· When working on colored paper use a white or light gray colored pencil

△ Smooth rubber

SMOOTH RUBBER

· Smooth rubber has very gradual changes in values

· Use a darker graphite pencil, such as 6B, or a black Prismacolor pencil

· Smoothly build up values from light to dark with cross-hatching

· Keeping the pencil sharp will make the values darker and smoother

△ Tree bark

△ Wrinkles

△ Straight hair

STRAIGHT HAIR

- Straight hair typically does not show every individual strand

- Clump the hair together and apply a thin coating of graphite

- Move the pencil in a light sweeping vertical motion when sketching

- Carefully place shadows by shading between some of the strands

TREE BARK

- Tree bark is very random and has a lot of organic shapes

- Quickly scribble small markings together

- Overlap marks to create an organic effect

- Increase scribbles in areas of shade

△ Undulating metallic surface

UNDULATING METALLIC SURFACE

- Apply a light cross-hatch coating of graphite over the shape

- Sketch evenly spaced darker vertical lines to suggest indents

- Add small, randomly placed horizontal marks to suggest ridges

- The edges of the shape should be wavy to show the undulating surface

WRINKLES

- Apply an even cross-hatch coating of graphite as a smooth base

- Sketch darker uneven lines in one direction to form creases

- Use an eraser to mark raised areas of highlight between the creases

- Add darker value to smaller sections of shade, following the crease lines

AGED WOOD

- Sketch a cross-hatch coating of graphite to create a light value

- Small wear and tear markings can be sketched lightly over this base texture

- Mark growth rings in a circular motion with increased pencil pressure

- Use a darker graphite, such as a 6B, for the shadows inside the broken wood

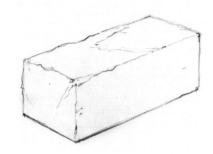

△ Aged wood

CLOTHING WRINKLES

- Treat each wrinkle in the fabric as if it is isolated to avoid distraction

- Roughly mark the individual wrinkles with simple lines

- Observe how the light hits each wrinkle and leave the lightest areas blank

- Use soft cross-hatching to create areas of shade, suggesting the body underneath

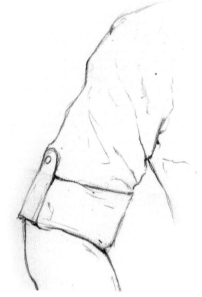

△ Clothing wrinkles

COARSE FUR

- Short, coarse fur can be drawn with quick, light lines

- Slightly lean the lines in different directions to create a coarseness

- Coarse fur is thick, so make sure hairs are clumped together

- Increase the dark values toward the tips to give emphasis

△ Coarse fur

△ Feather (smooth)

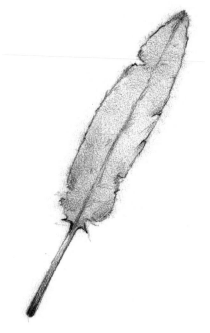

△ Fish scales (patterned)

FEATHER (SMOOTH)

- Angle the pencil to draw with the side of your sharpened graphite

- Make the feather strands split apart at random near the ends

- Lightly coat the entire feather with cross-hatching

- Add shade on the quill and indents with increased pencil pressure

FISH SCALES (PATTERNED)

- Outline the scales as a series of overlapping circles or arches

- Apply an even cross-hatch layer of light graphite across the scales

- Mark patterns with dark values and highlights using references

- Keep the pattern simple at first to avoid any inconsistencies

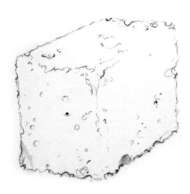

ANIMAL MARKINGS

When learning how to sketch creatures with scales, fur, and feathers, it is always helpful to have photographs of these with different markings and patterns for reference. As you practice more and more, building up your confidence, technique and visual library, you won't need the references.

FOAM

- Sketch a small block with irregular edges

- Mark holes using basic lines

- Apply the shadows on each face with even cross-hatch coats of graphite

- Press the pencil harder in the holes to make the surface appear porous

△ Foam

55

△ House brick

△ Large brick

HOUSE BRICK

- House bricks are rough and uneven in texture

- Create a very light, rough graphite base with quick cross-hatching

- Sketch multiple layers of gradients in patches

- Scribble small marks to suggest the surface has tiny bumps

LARGE BRICK

- Larger bricks tend to have bigger marks on the surface than house bricks

- Mark out crevices and ridges on the brick with simple lines

- Quickly cross-hatch several layers of graphite in different directions

- Use added pencil pressure to show the marks and bumps

△ Light hair

LIGHT HAIR

- Sketch light hair in large, smooth clumps

- Keep your markings very light and use the natural paper color for the lightest areas

- Apply only a thin coating of graphite value with hatching

- Add minimal shadows by shading a few strands at the ends of hair clumps

PATTERNED FUR

• Mark an outline for the fur, suggesting layers if necessary

• Clump hair in areas likely to have pattern

• Cross-hatch an even layer of graphite to give a base texture

• Add patches of darker value in a rhythmic pattern

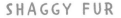
△ Patterned fur

SHAGGY FUR

• Shaggy fur is messy and irregular

• Draw hair with a hanging effect and avoid curling the strands too much

• Scribble random, unpredictable lines across the surface

• Add shade in irregular patches that also hang down

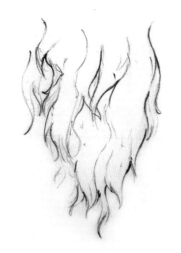

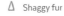
△ Shaggy fur

SMOOTH WOOD

• Mark the wood grain with light lines across the surface

• Keep your pencil sharp and apply light layers of graphite with cross-hatching

• Add extra layers of hatching to create darker values for the details of the grain of the wood.

• Smooth wood has a semi-shiny surface so use the bare white paper to convey any reflections

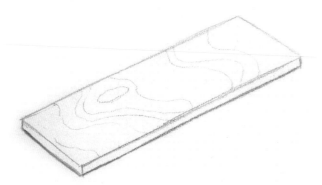

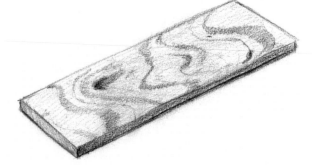

△ Smooth wood

TREE KNOT

- Look at the overall organic shape of the knot, ignoring the details

- Build up values lightly with cross-hatching

- Add irregular scribble marks to suggest a bark texture

- Use rounded sweeping movements to shade the spherical knot

BARK
See also the technique for drawing Tree Bark texture to achieve the most authentic results

△ Tree knot

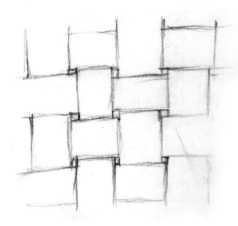

△ Woven fabric

△ Claws

△ Curly hair

WOVEN FABRIC

• Mark out the woven fabric, showing how the fibers cross over

• Fill the image with a light hatch coating of graphite, including the gaps

• Increase shade around the edges of the woven fabric

• Add very dark values to small gaps and points of crossed fibers

CLAWS

• Claws are commonly sharp and curved

• Outline the shape and then apply a light hatching to the surface

• Add very dark values with further cross-hatching around the edge and base of the curved claw

• Leave curved streaks of white from the paper to convey reflections

CURLY HAIR

• Group the hair together in curls

• Apply a thin coating of cross-hatch value

• Keep your markings light and even

• Shade the grouped curls in a curved motion to indicate movement

△ Dark hair

△ Rough rock

DARK HAIR

· Draw an outline showing the hair as a single flowing clump

· Hatch graphite over the hair, keeping the markings light at first

· Repeat the hatching several more times to give an even, dark value

· Lift some graphite from the page with an eraser to show a glossy shine

ROUGH ROCK

· Sketch a light jagged outline of the rock shape first

· Apply a smooth light value with one layer of cross-hatching

· Hatch shade into crevices along the jagged edge

· Add smaller details with sharp pencil marks

SHELL (PATTERNED)

· Cross-hatch a light, even coating of graphite over the surface as a base

· Use a sharp pencil to apply ridges across the surface in a sweeping motion

· Lightly add an extra layer of hatching to areas of shade

· Mark on patterns with a sharp pencil, following the curve and ridges of the shell

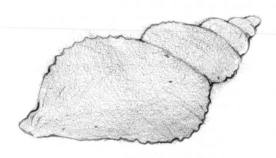

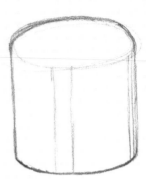

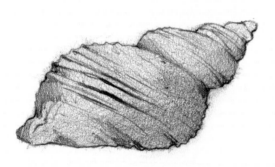

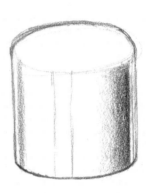

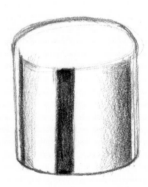

△ Shell (patterned)

△ Shiny metallic surface

SHINY METALLIC SURFACE

- Highlights on a metallic surface are usually specular and concentrated

- Mark small areas of light shade using upward strokes

- Leave large areas of the page blank to show concentrated light reflection

- Add streaks of very dark value in an upward motion to indicate the reflection of other objects in the metal

SPECULAR HIGHLIGHTS

Specular highlights on metal typically happen where the surface is most curved, with lightwaves reflecting as they would from a mirror

HOW TO USE THIS BOOK

As you have learned in the previous chapters, there is so much more to creating an interesting sketch than marking a quick outline. In the following pages you will find sketch processes of over 900 subjects depicted in four key steps. These key steps signify crucial turning points in a drawing: the basic shapes, line art, light and shade, and texture details. They bring into focus the most commonly misinterpreted points of each sketch and show how the subject matter can be tackled successfully. Noted below is an explanation of the four key steps and how they work to guide you through your own sketches.

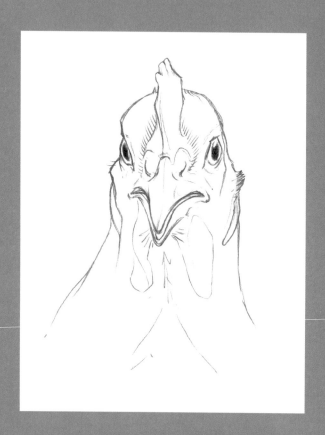

1. BASIC SHAPES

As discussed in the Basic Shapes section, these are very simple shapes that even the most complex objects and figures can be reduced to. By working out the basic shapes of a sketch subject you provide yourself with a strong, clear base for the rest of your sketch. When starting with basic shapes you also have much more freedom to experiment with the pose and perspective of your subject as the shapes can be easily altered or removed before you get into the more detailed parts of the process.

2. LINE ART

With the basic shapes in place you can now focus on drawing a clean and orderly version of the subject, showing the main outline and any significant internal lines or markings. The line art stage is where the subject first becomes recognizable but it is not yet detailed, so this is a good step to refine any areas of the sketch that look incorrect. Some people may choose to leave their sketch at this point in its evolution, especially if it is only intended as a rough draft for another artwork. However, to achieve a higher level of finish in your sketch, attention to the next two steps is essential.

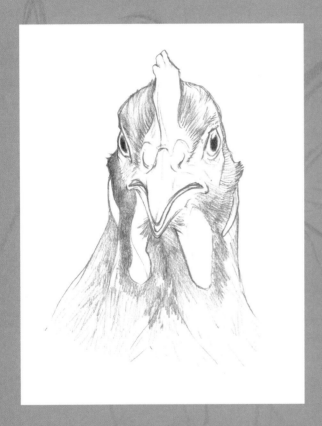

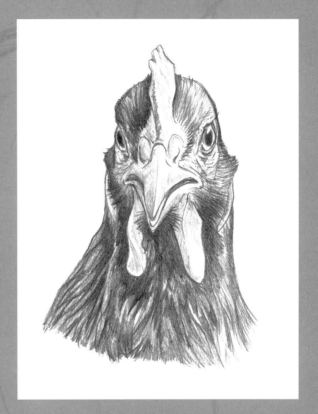

3. LIGHT AND SHADING

Light, and how it is depicted, has an important effect on any artwork, regardless of whether it is a finished painting or a quick sketch. It is a strong indicator of the sketch subject's place in an environment or scene and it can have a great impact on the viewer's perception of a sketch. In the processes shown in this book the light is largely depicted from a single source positioned high above the subject, to either the right or left side. The cast shadows this creates show the three-dimensional forms of the subject and, combined with the brightening effects of the light itself, add a sense of depth to an otherwise flat sketch.

4. TEXTURE

In the final drawing for each process, you will see that surface texture is added to give the sketch greater realism and to add further interest. For accomplished artists, light effects and texture will often be tackled at the same point in the process. However, as texture has its own challenges and nuances, it is helpful to have the light and shade effects preemptively marked out to ensure a sense of depth is maintained as the sketch gains detail. You will find a wide range of texture details in this book so we strongly recommend that you look at the Line and Mark-making section and consult the Texture Library as you explore suitable textures for your subjects.

NATURE

Drawing from nature provides an excellent opportunity to explore the diversity of shape and structure that can be found in organic forms. In this section you will find a wide range of plant life and natural forms to draw plus demonstrations of nature affected by different weather elements. You can use the nature projects in this chapter to practice drawing botanical art or detailed areas of a landscape.

IN THIS CHAPTER

. .

FLOWERING PLANTS

FRUITING AND EDIBLE PLANTS

GREENERY

TREES

SEA ELEMENTS

NATURAL STRUCTURES

WEATHER

ALSTROEMERIA

ANTHURIUM

BIRD OF PARADISE

BLUEBELL

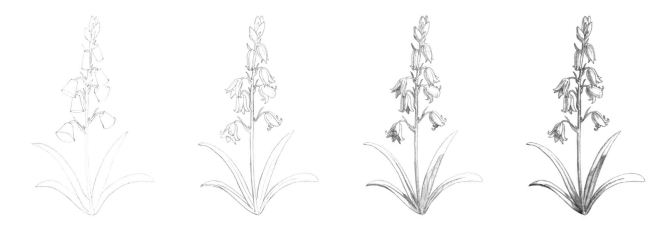

CARNATION

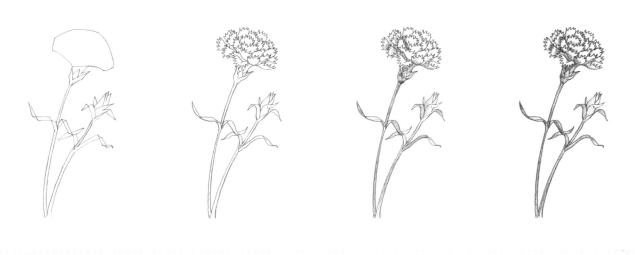

CHRYSANTHEMUM

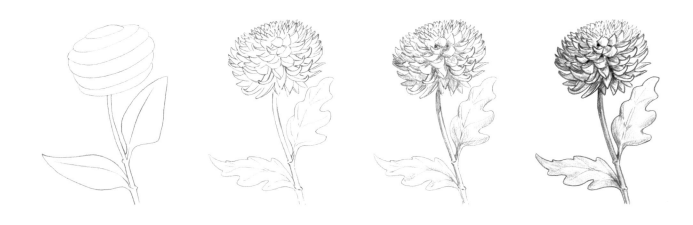

CLEMATIS

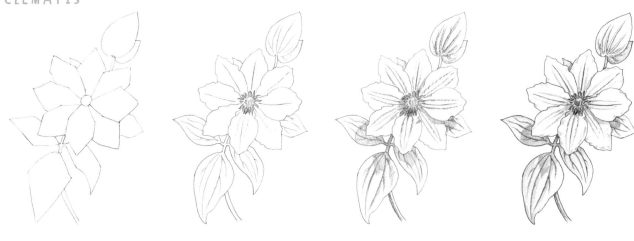

DAISY

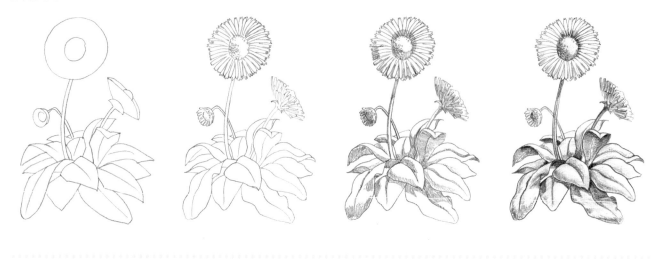

FOXGLOVE

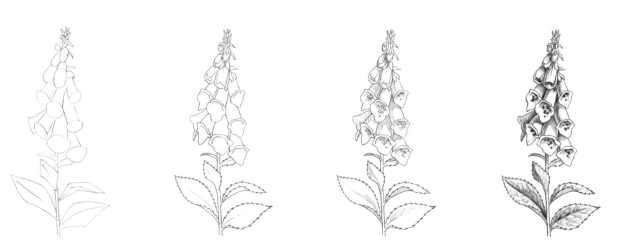

FREESIA

 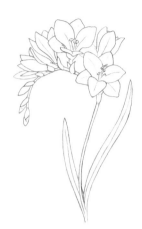

HYDRANGEA

 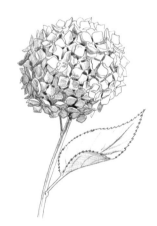 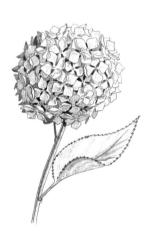

IRIS

 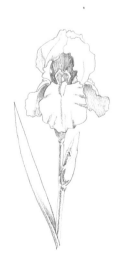 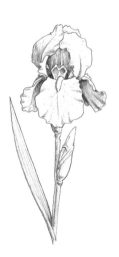

LILY

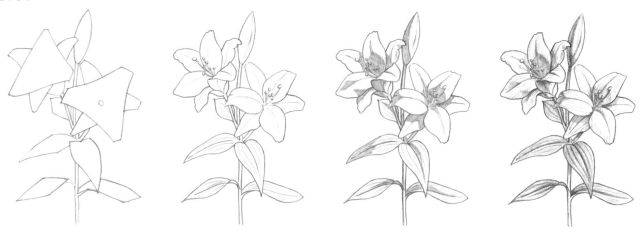

ORCHID

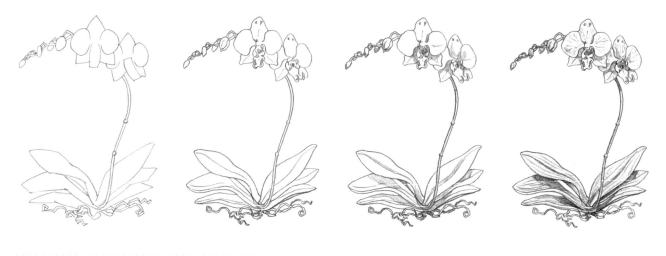

PANSY

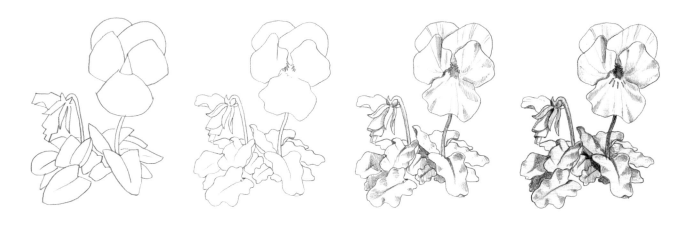

PEONY

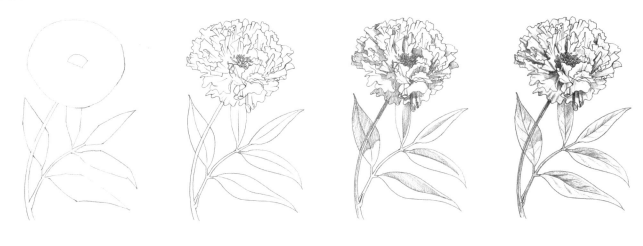

POPPY

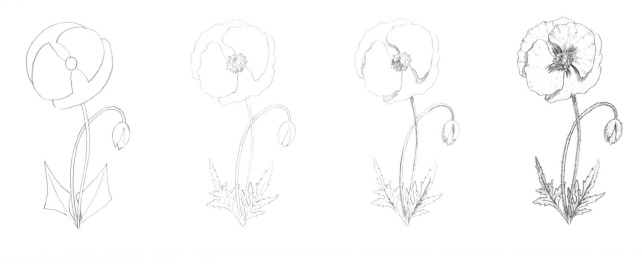

RAFFLESIA

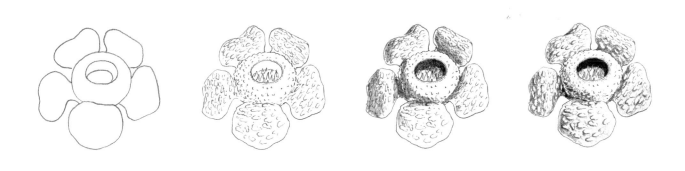

ROSE

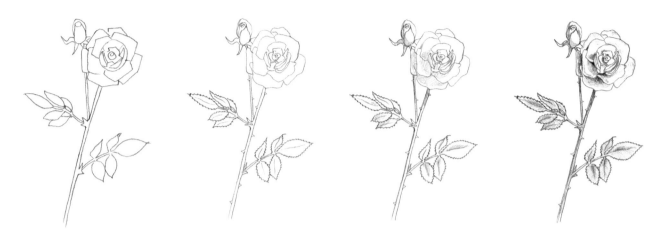

SNOWDROP

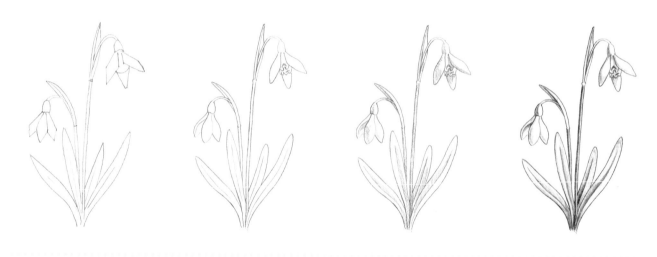

SUNFLOWER

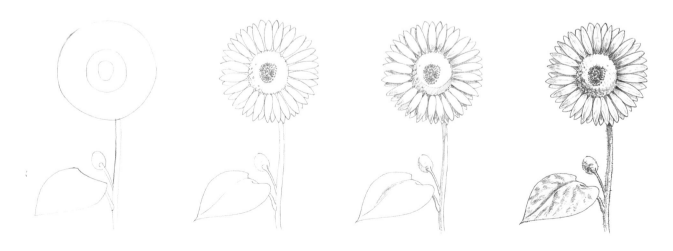

TITAN ARUM

TRICHOCEREUS

TULIP

 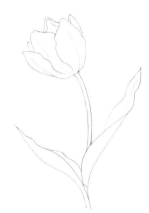 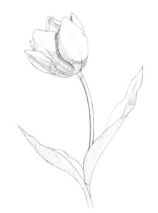 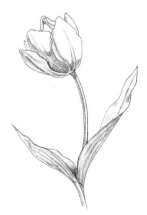

CHILI PEPPER

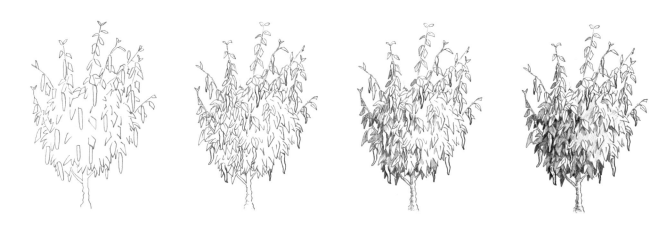

CHIVE

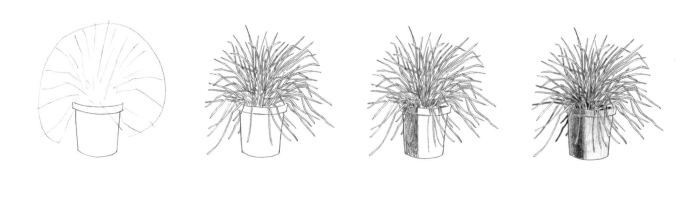

EGGPLANT

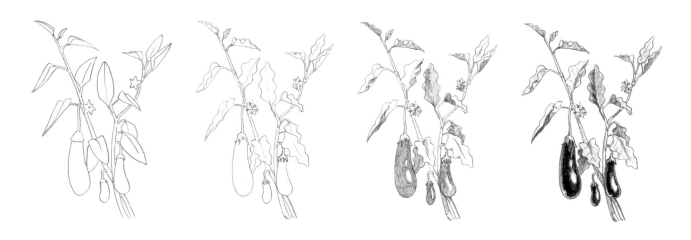

GRAPE VINE

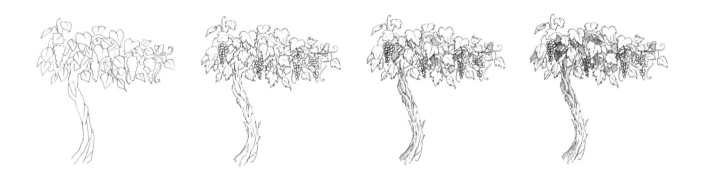

MINT

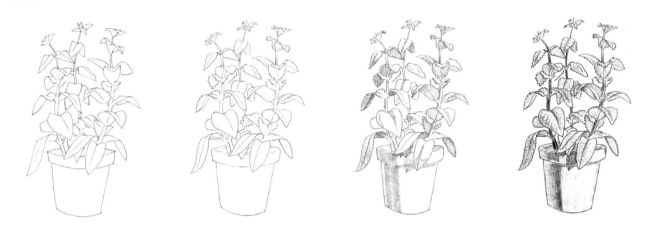

PARSLEY

ROSEMARY

RUNNER BEAN

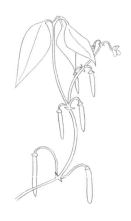 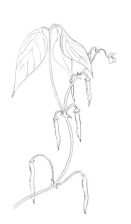 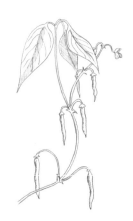

SWEET CORN

ALOE VERA

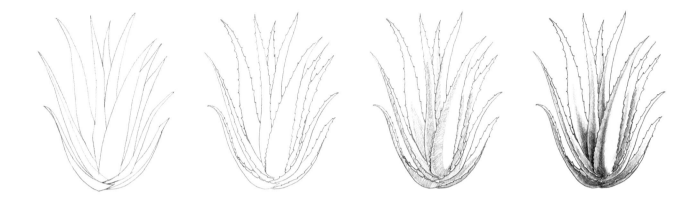

ASPIDISTRA

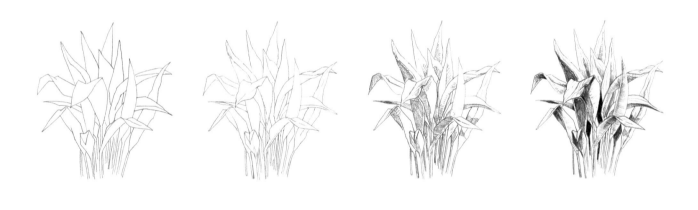

BAMBOO

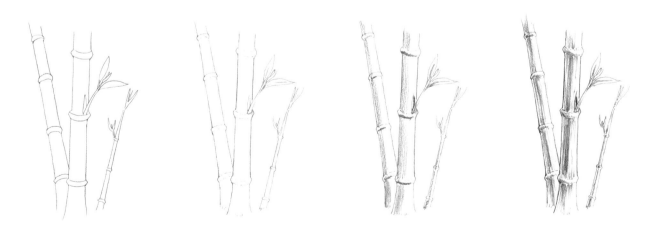

CACTUS

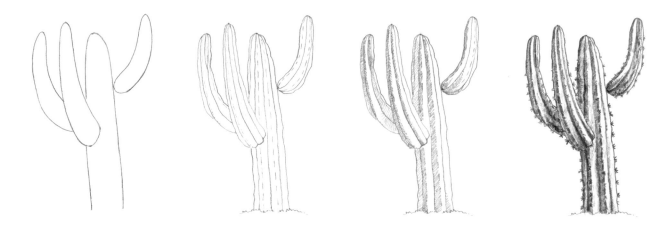

FERN

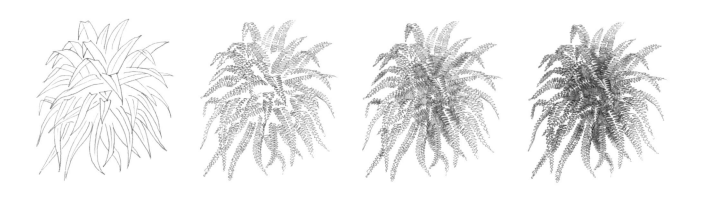

FLYTRAP

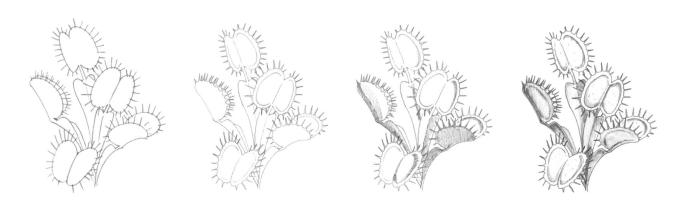

IVY

RUBBER TREE PLANT

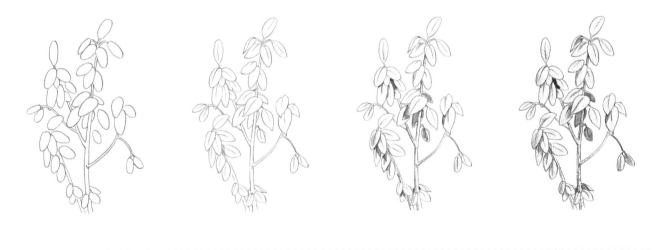

SUCCULENT

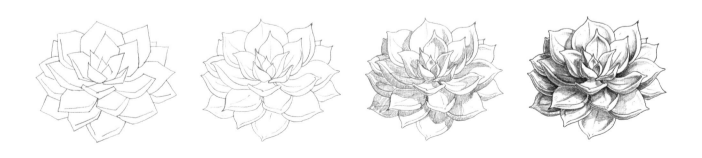

APPLE

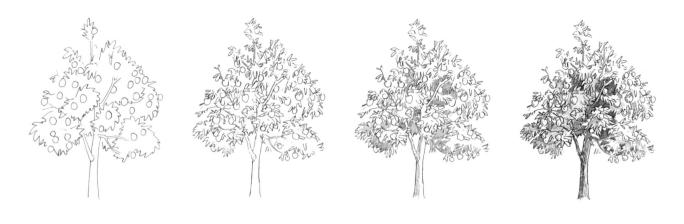

AVOCADO

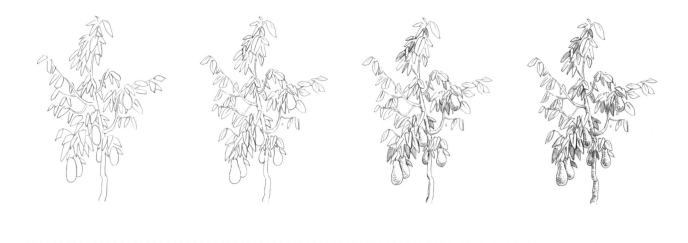

BLOSSOM

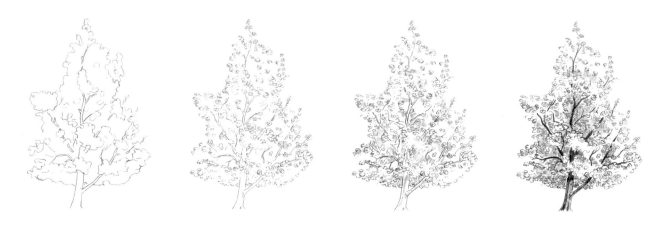

BONSAI

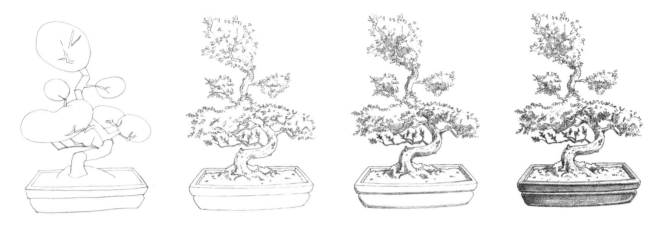

CHRISTMAS

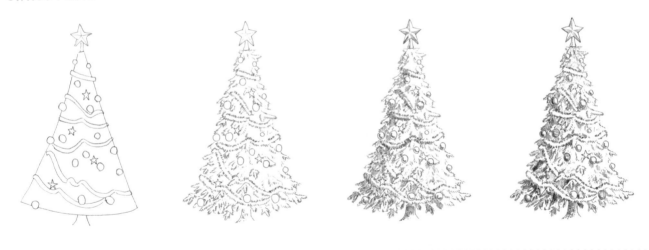

CONIFER

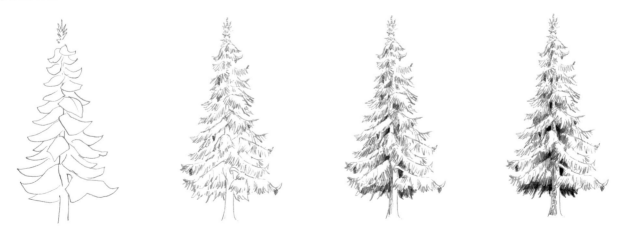

JUNGLE VINE

LEAVES (DRIED)

LEAVES (WET)

LEMON

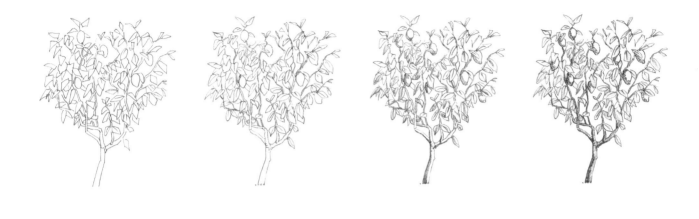

MONKEY PUZZLE

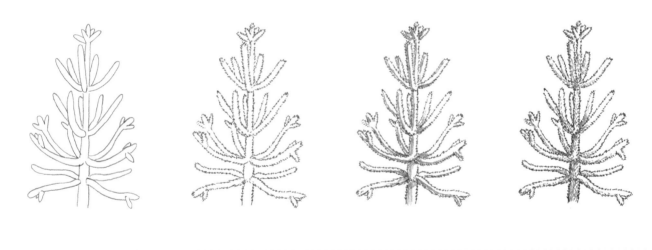

OAK

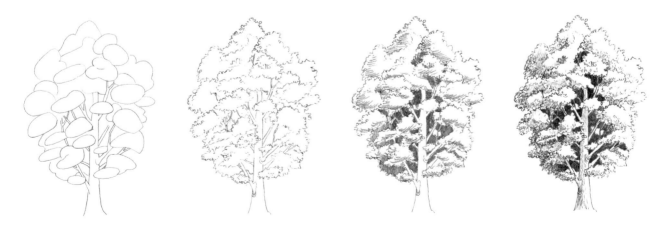

PALM

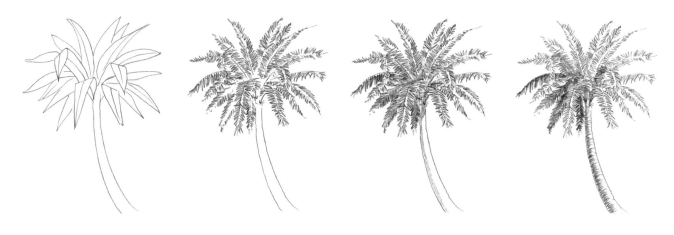

TWISTED TREE TRUNK

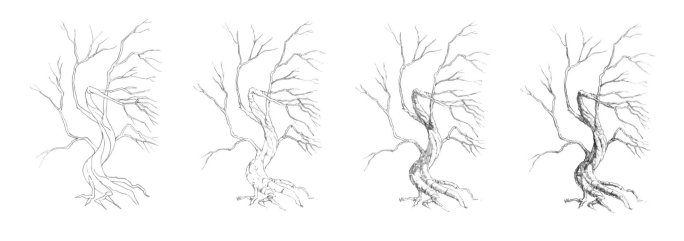

WILLOW

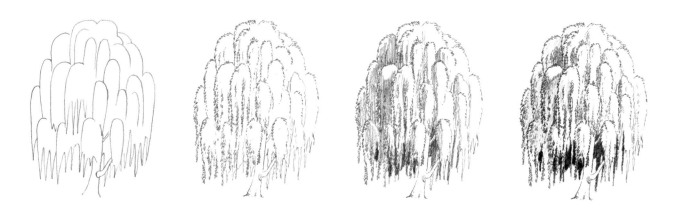

CORAL

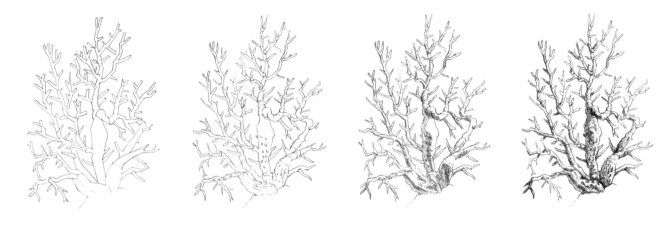

SEASHELL

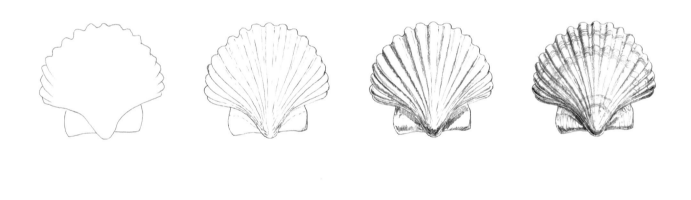

SEAWEED

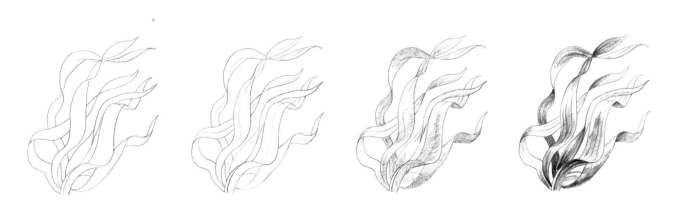

ANT HEAP

BEEHIVE

BIRD NEST

CHRYSALIS

COBWEB

COBWEB (FROZEN)

 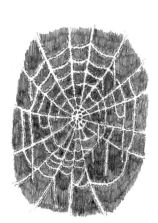

CONKER SHELL

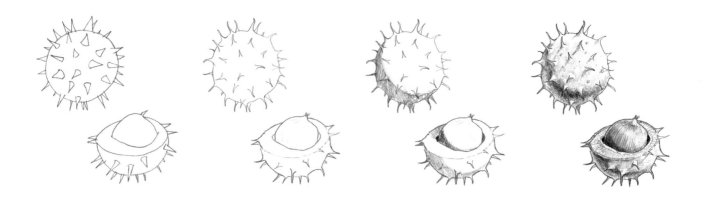

FEATHER

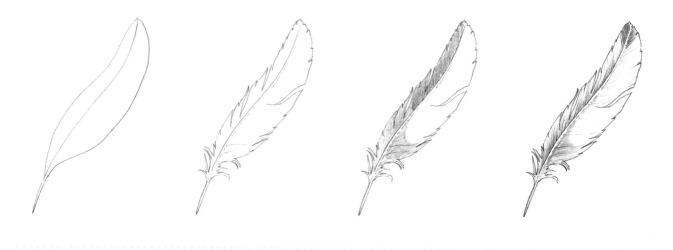

FOSSIL

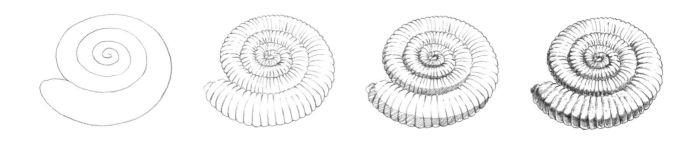

TERMITE MOUND

VOLCANO

WASP NEST

CLOUD

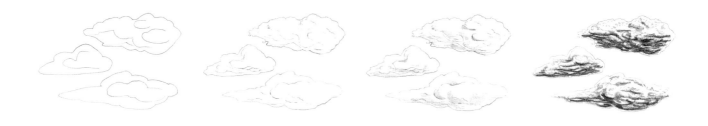

FROST (ON LEAVES)

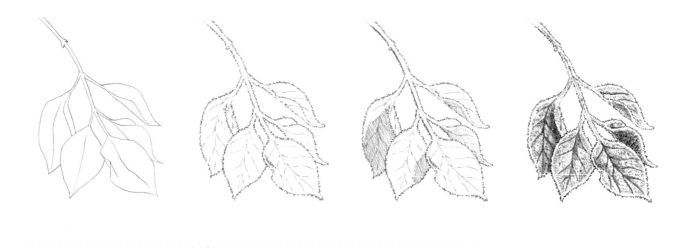

HAIL ON A HARD SURFACE

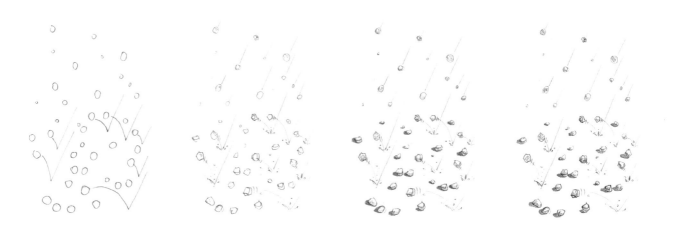

HAIL ON WATER

LIGHTNING

RAIN ON A HARD SURFACE

RAIN ON WATER

RAIN PUDDLES

SNOW

TORNADO

WHIRLWIND

WIND

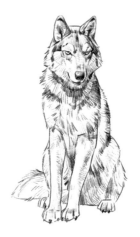

CREATURES

∙∙

Animals, insects, sea life, and birds present a wide range of diverse textures which are fascinating to explore through sketches and drawing. As active subjects there is also often a need to show the subjects in multiple poses. Therefore, in this section, you will find many of the creatures have additional poses or a close-up view of the creature's head in addition to a basic full body pose.

IN THIS CHAPTER

............................

ARCTIC ANIMALS

BIG CATS

BIRDS

BIRDS IN FLIGHT

DESERT ANIMALS AND MARSUPIALS

DINOSAURS

INSECTS AND MINIBEASTS

MOUNTAIN AND GRASSLAND ANIMALS

PRIMATES

REPTILES

RODENTS

SAFARI ANIMALS

SEA LIFE

WATERSIDE ANIMALS

WOODLAND AND JUNGLE ANIMALS

WORKING AND FARM ANIMALS

ARCTIC FOX

ARCTIC FOX (SITTING)

ARCTIC FOX (FACE DETAIL)

ARCTIC HARE

ARCTIC HARE (SITTING)

ARCTIC HARE (FACE DETAIL)

 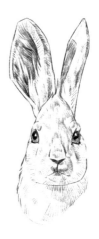

POLAR BEAR

POLAR BEAR (SITTING)

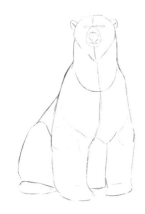 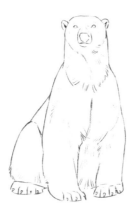 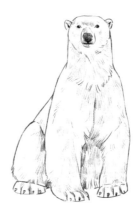 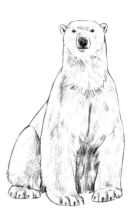

POLAR BEAR (FACE DETAIL)

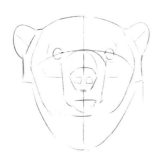 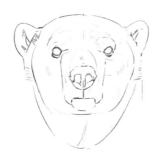 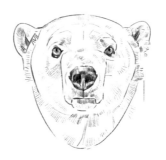 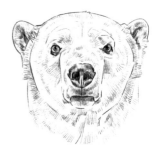

REINDEER

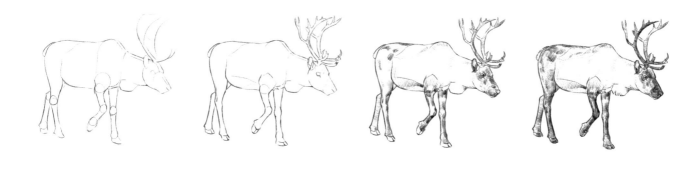

REINDEER BULL (FACE DETAIL)

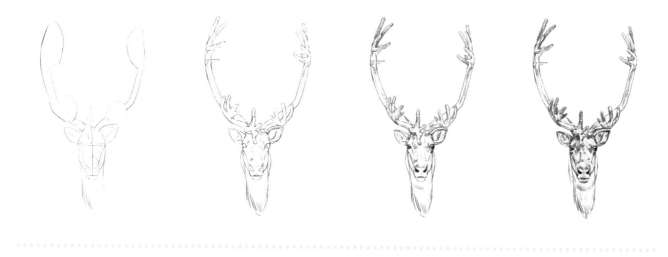

REINDEER COW (FACE DETAIL)

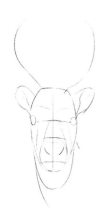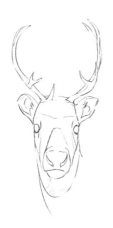

CHEETAH

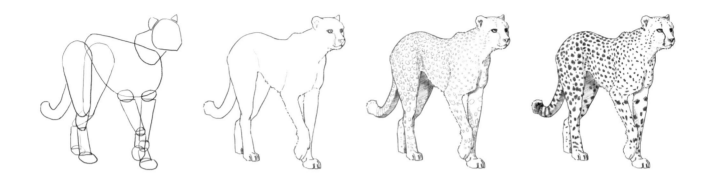

CHEETAH (SITTING)

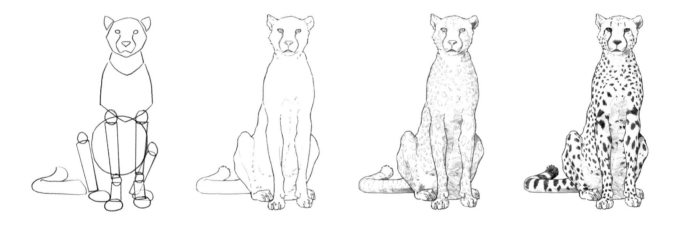

CHEETAH (FACE DETAIL)

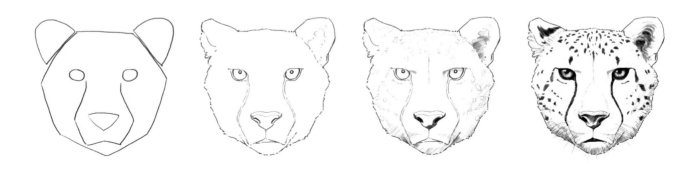

CHEETAH CUB (FACE DETAIL)

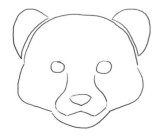 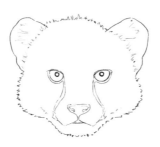 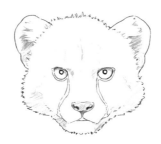

LEOPARD

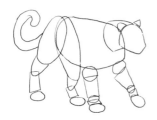 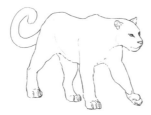 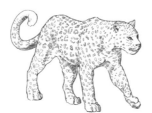 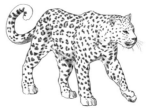

LEOPARD (SITTING)

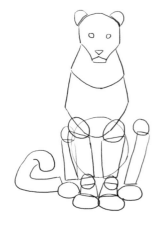 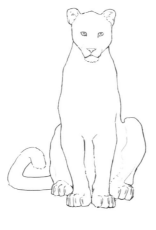 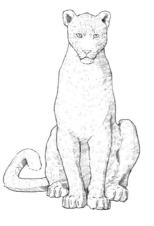 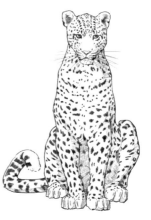

LEOPARD (FACE DETAIL)

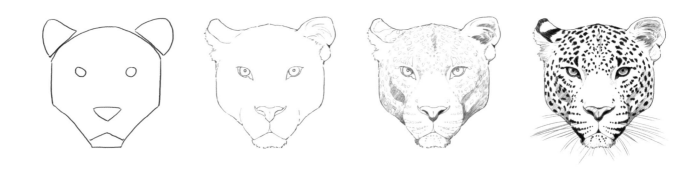

LEOPARD CUB

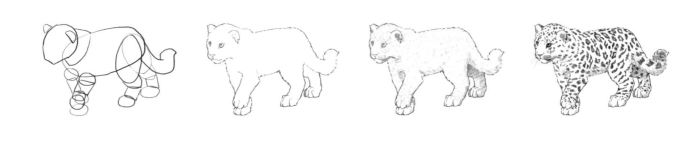

LEOPARD CUB (FACE DETAIL)

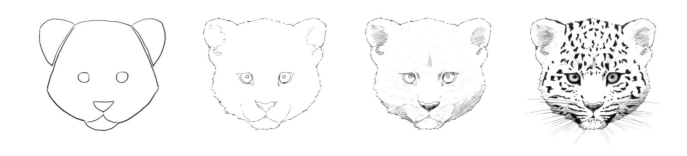

LION

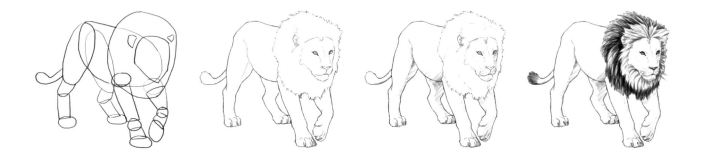

LION (SITTING)

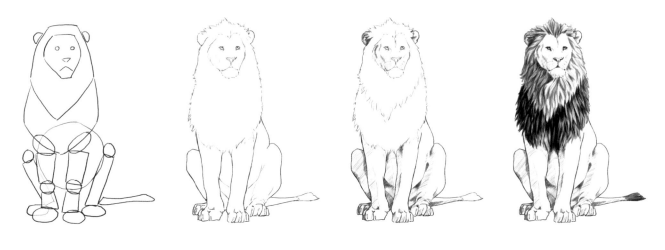

LION (FACE DETAIL)

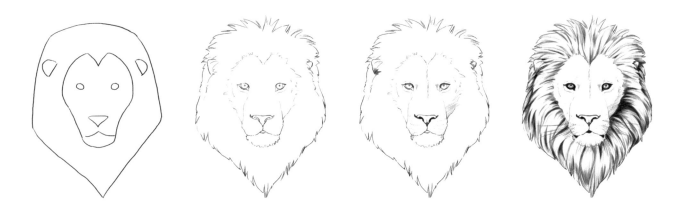

LIONESS (FACE DETAIL)

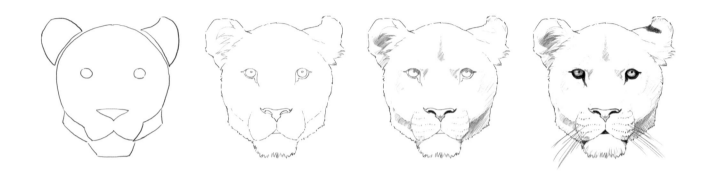

LION CUB

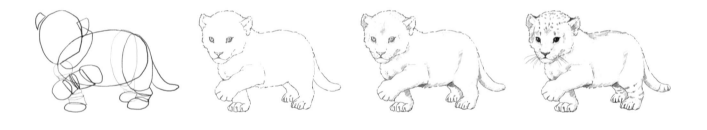

LION CUB (FACE DETAIL)

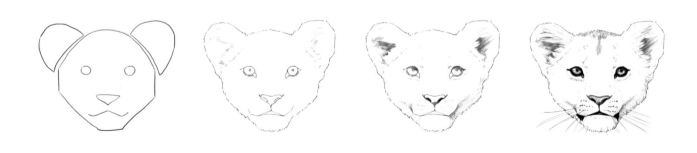

SNOW LEOPARD

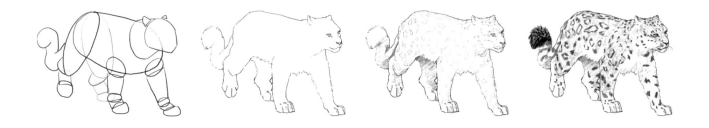

SNOW LEOPARD (SITTING)

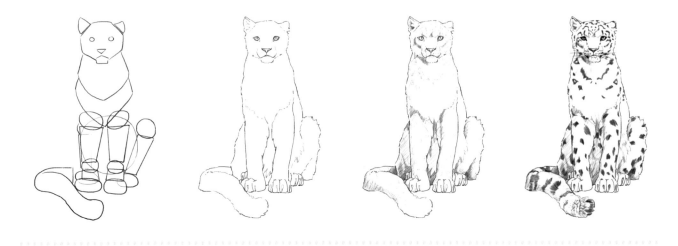

SNOW LEOPARD (FACE DETAIL)

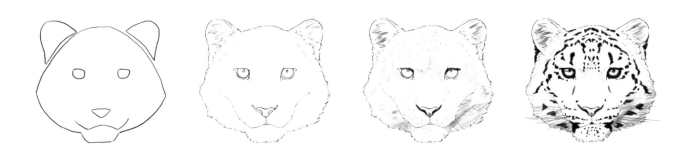

SNOW LEOPARD CUB (FACE DETAIL)

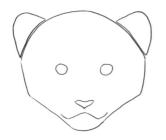 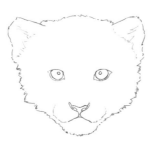 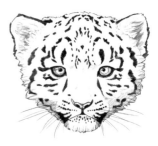

TIGER

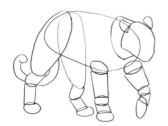 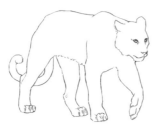 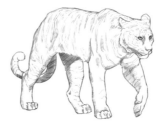

TIGER (SITTING)

TIGER (FACE DETAIL)

 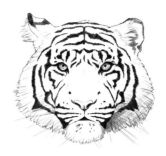

TIGER CUB

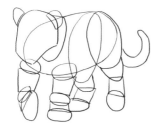 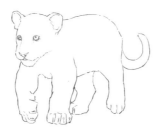 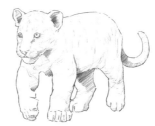

TIGER CUB (FACE DETAIL)

 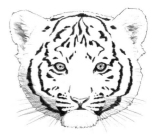

CHICK

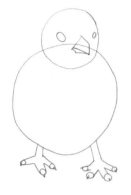 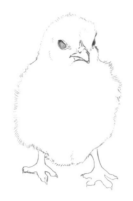 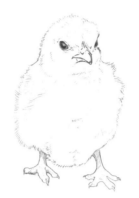 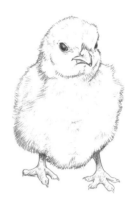

CHICK (WALKING)

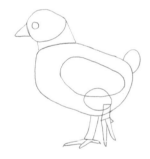 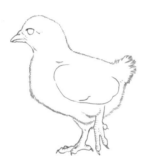 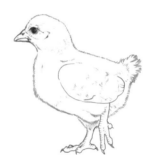

CHICK (FACE DETAIL)

CHICKEN

 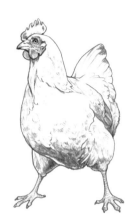

CHICKEN (PECKING)

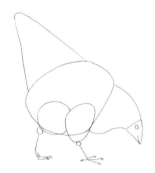 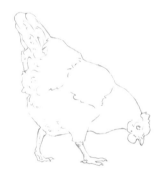 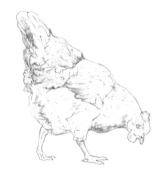 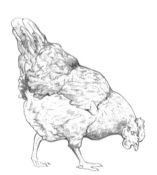

CHICKEN (FACE DETAIL)

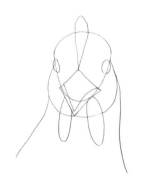 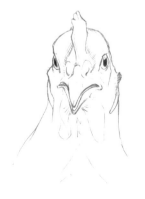 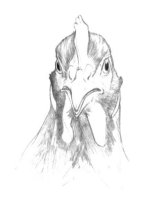 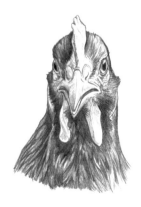

CONDOR

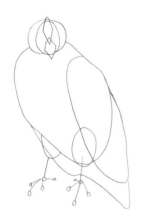 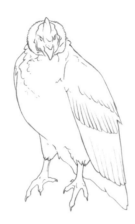 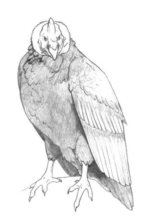 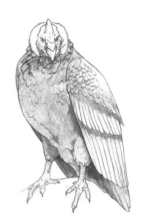

CONDOR (FACE DETAIL)

DOVE

 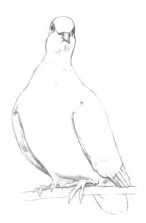

DOVE (FACE DETAIL)

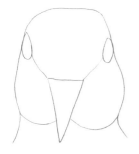 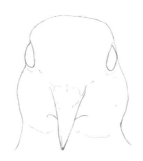 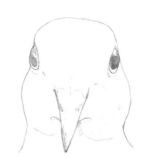

DUCK

 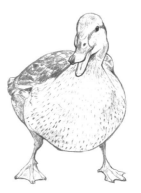

DUCK (SWIMMING)

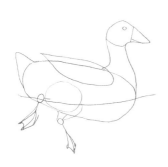 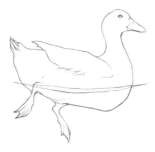 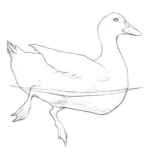

DUCK (FACE DETAIL)

DUCKLING

 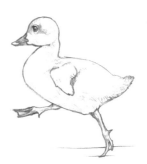

DUCKLING (FACE DETAIL)

EAGLE

 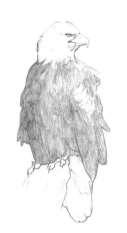 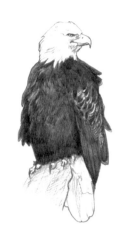

EAGLE (FACE DETAIL)

 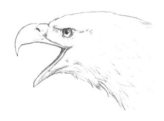

FLAMINGO

 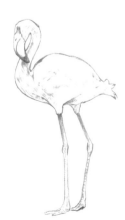

FLAMINGO (FACE DETAIL)

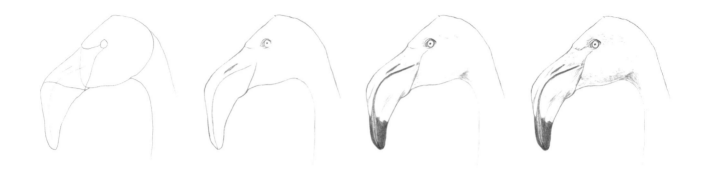

GULL

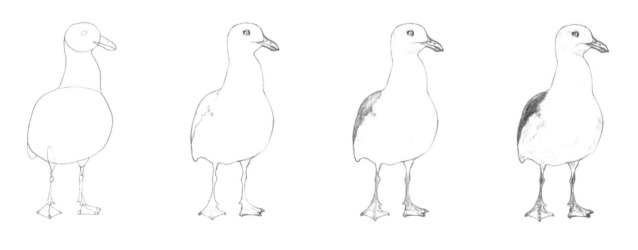

GULL (FACE DETAIL)

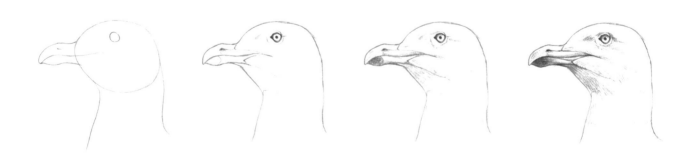

HAWK

HAWK (FACE DETAIL)

HUMMINGBIRD

HUMMINGBIRD (FACE DETAIL)

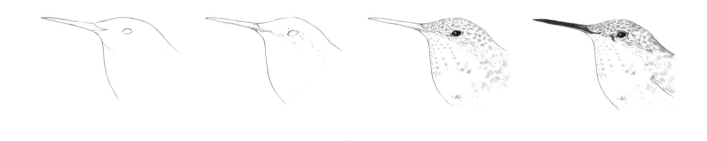

KIWI

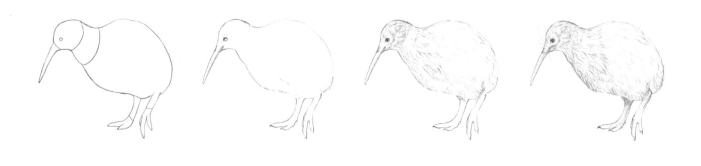

OSTRICH

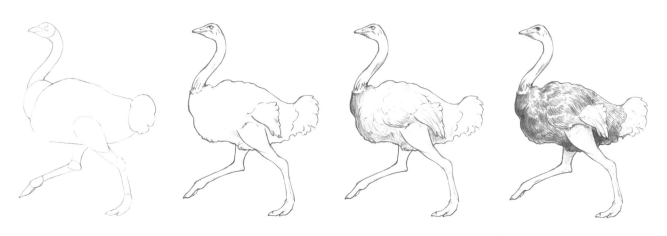

OSTRICH (FACE DETAIL)

OWL

 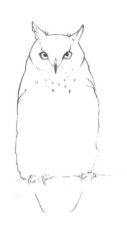 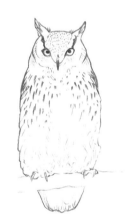 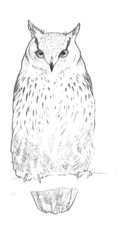

OWL (FACE DETAIL)

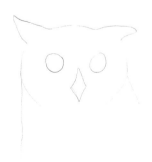 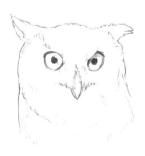 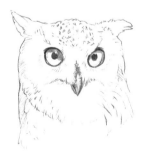 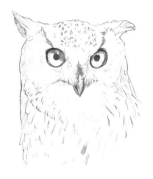

PARROT

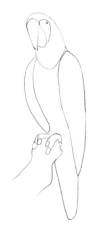

PARROT (FACE DETAIL)

 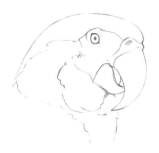 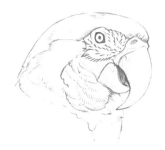 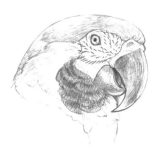

PENGUIN

 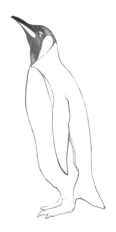 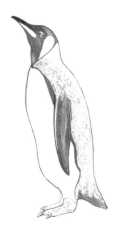 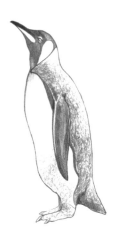

PENGUIN (WINGS RAISED)

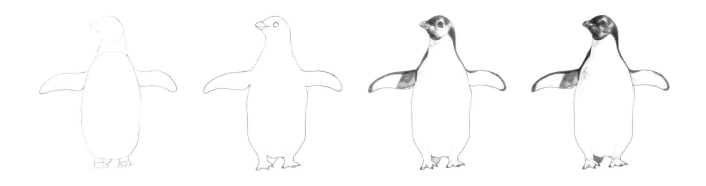

PENGUIN (FACE DETAIL)

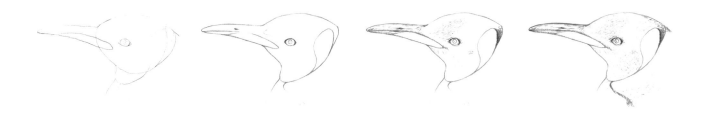

PIGEON

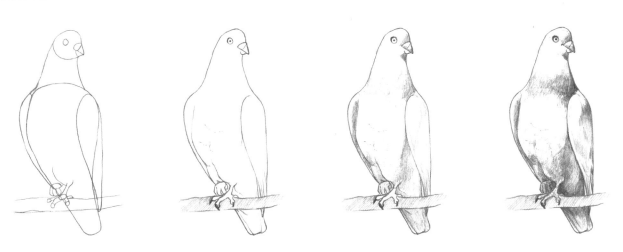

PIGEON (PECKING)

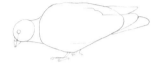

PUFFIN

 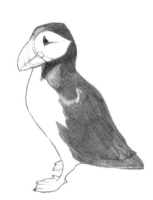 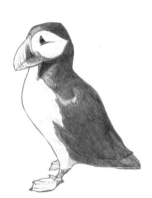

PUFFIN (FACE DETAIL)

ROOSTER

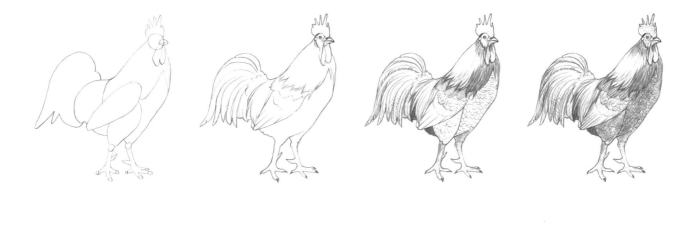

ROOSTER (FACE DETAIL)

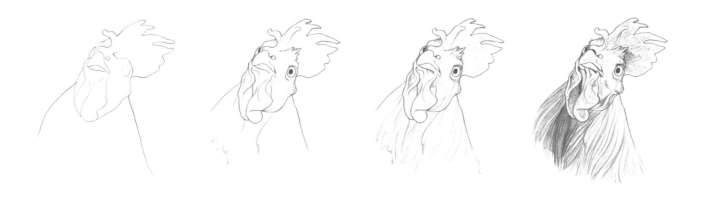

SPARROW

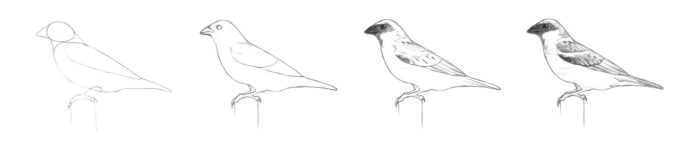

SWAN

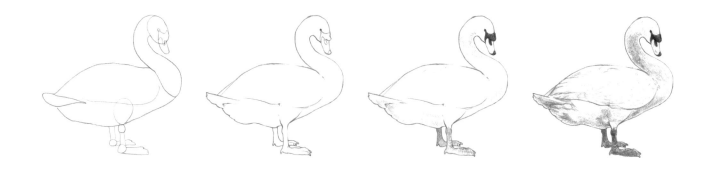

SWAN (SWIMMING)

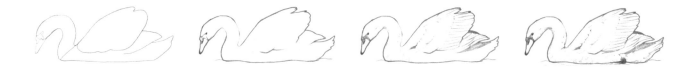

SWAN (FACE DETAIL)

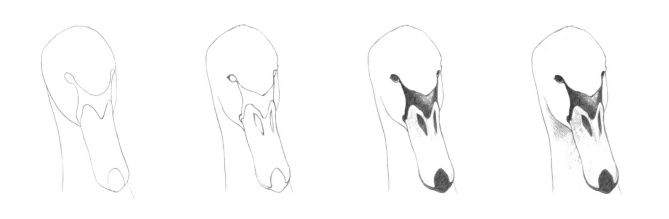

TOUCAN

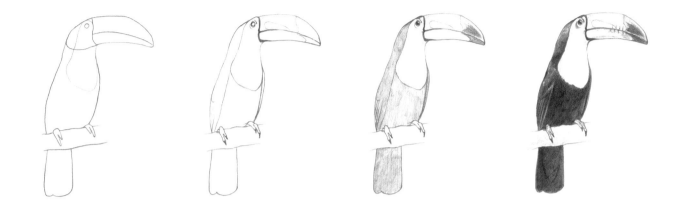

TOUCAN (FACE DETAIL)

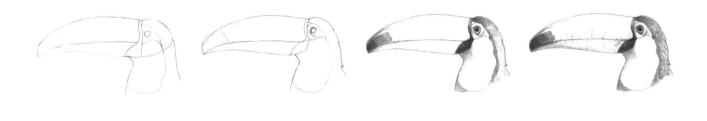

TURKEY

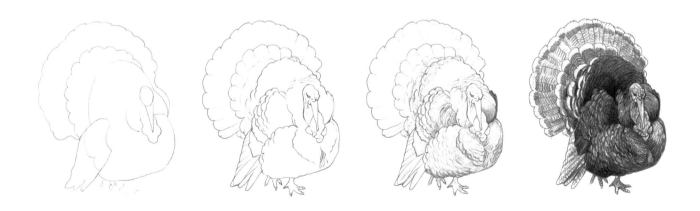

TURKEY (FACE DETAIL)

 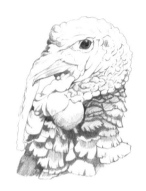 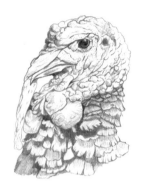

VULTURE

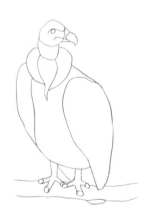 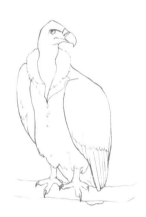 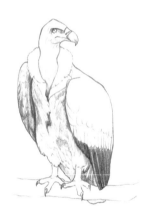 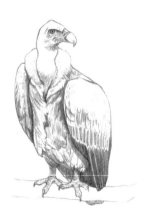

VULTURE (FACE DETAIL)

ALBATROSS

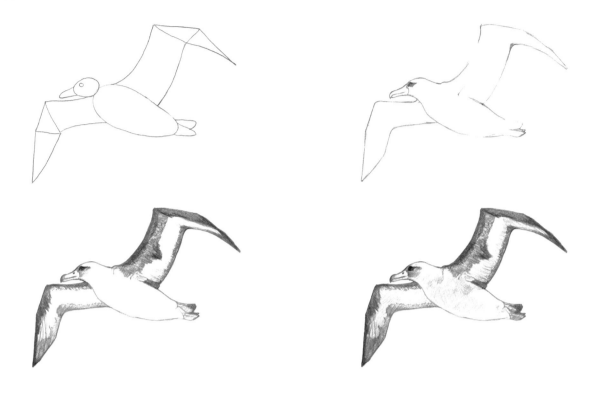

CONDOR

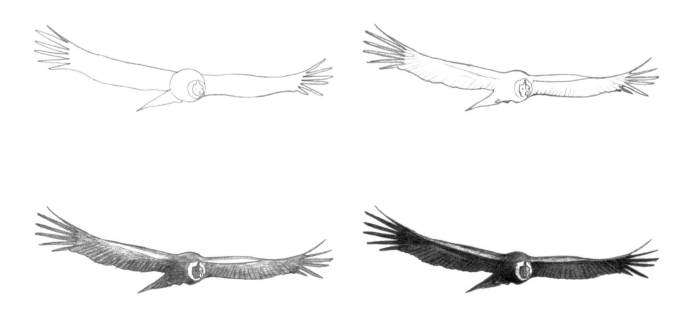

DOVE

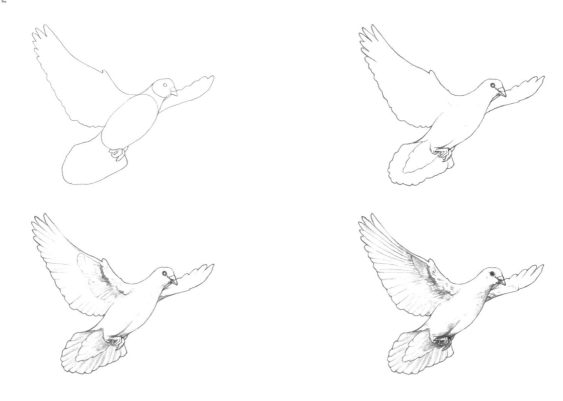

EAGLE

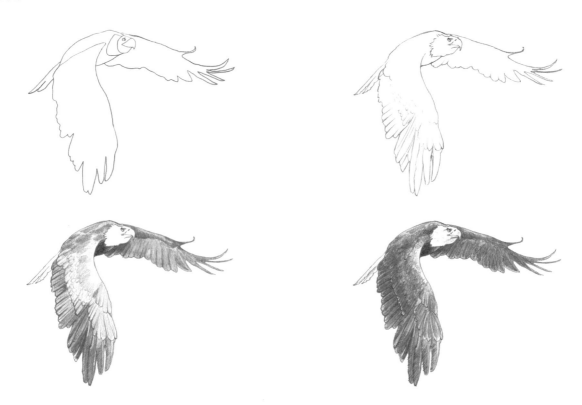

FLAMINGO

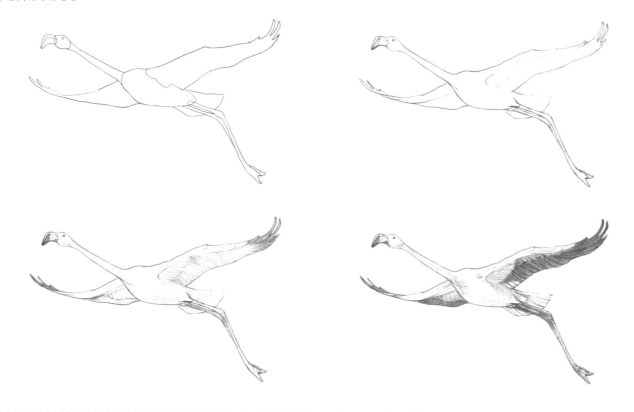

GULL

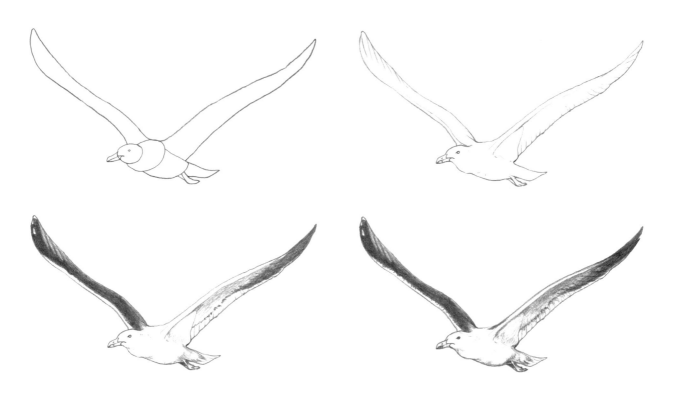

HAWK

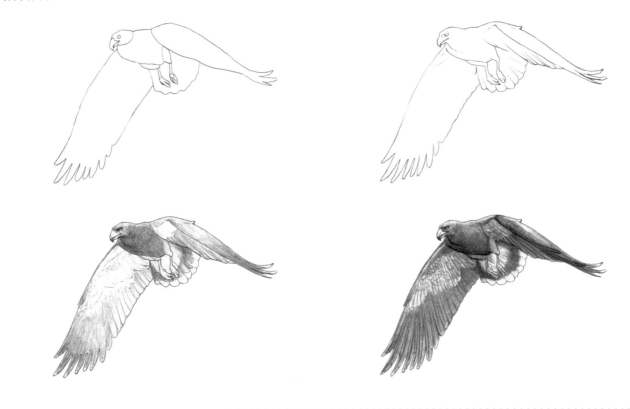

OWL

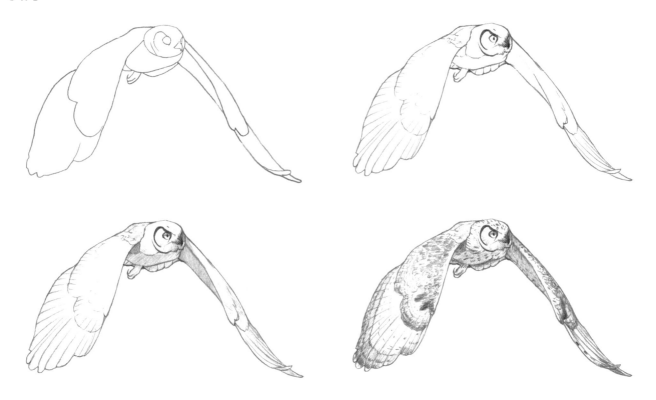

PARROT

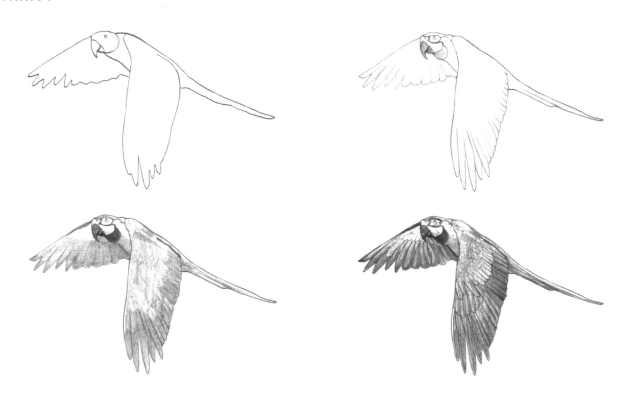

PIGEON

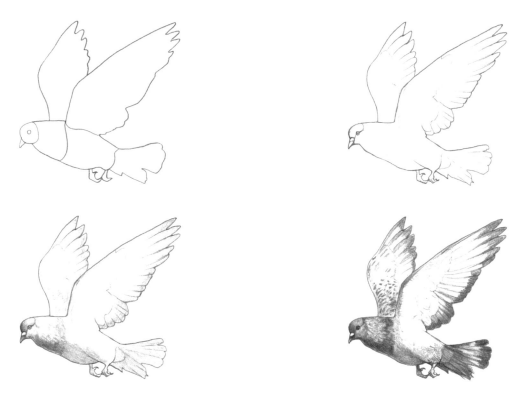

PUFFIN

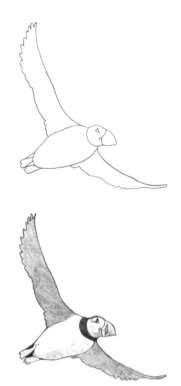
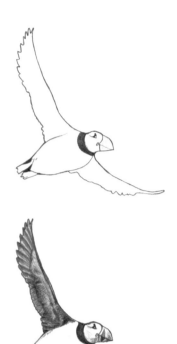

SPARROW

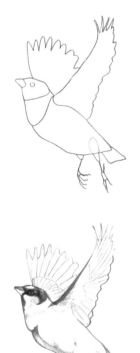

TOUCAN

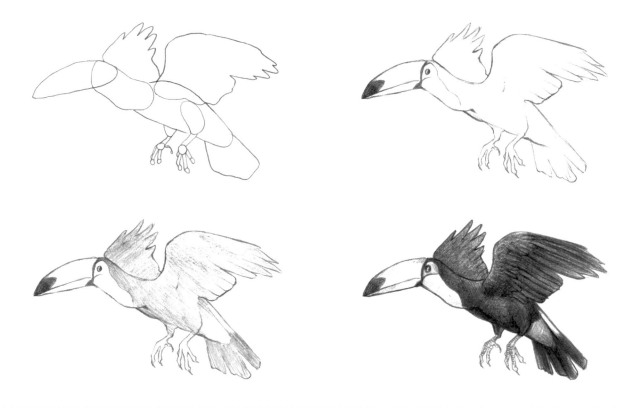

VULTURE

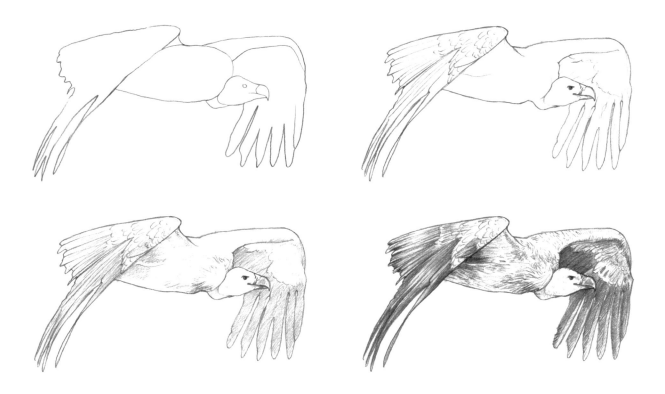

FENNEC FOX

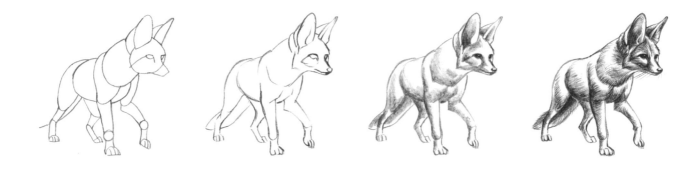

FENNEC FOX (FACE DETAIL)

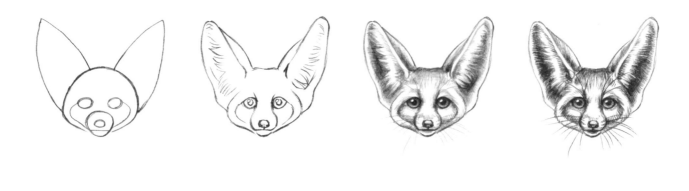

KANGAROO (FACE DETAIL)

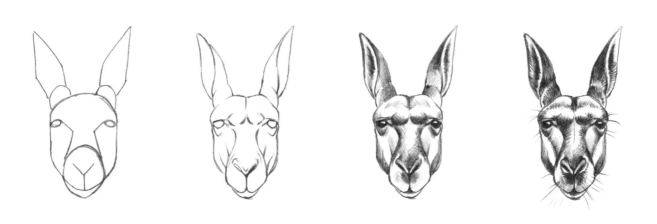

KOALA

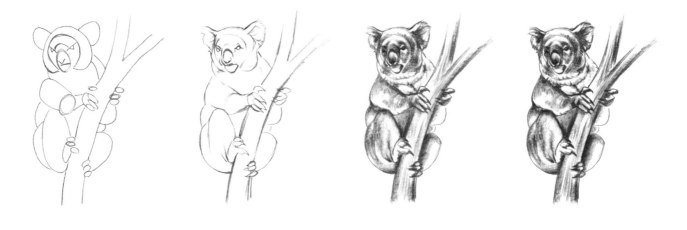

KOALA (FACE DETAIL)

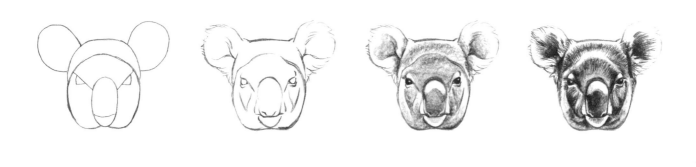

MEERKAT

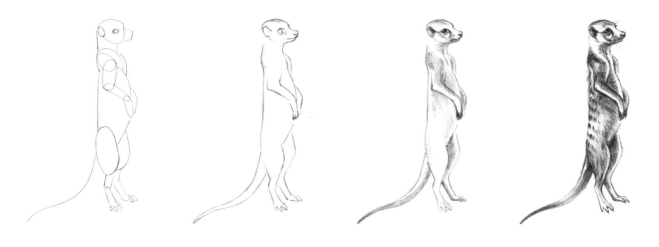

MEERKAT (FACE DETAIL)

 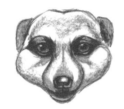 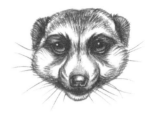

POSSUM

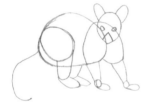 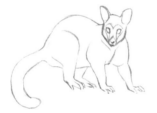 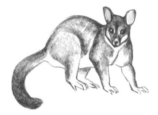 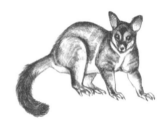

POSSUM (FACE DETAIL)

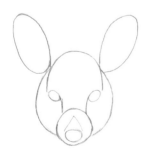 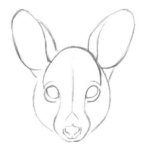

CAMEL

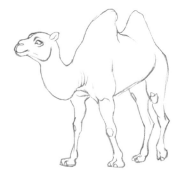

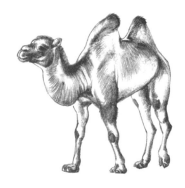

KANGAROO

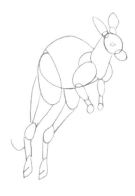
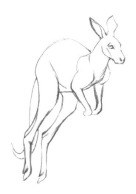
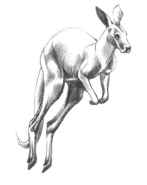
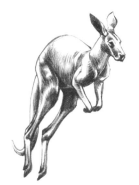

BRACHIOSAURUS

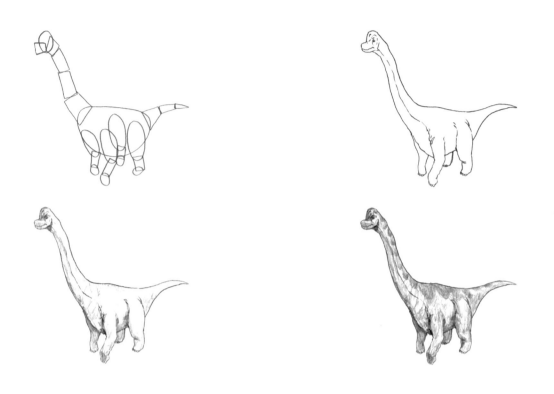

DIPLODOCUS

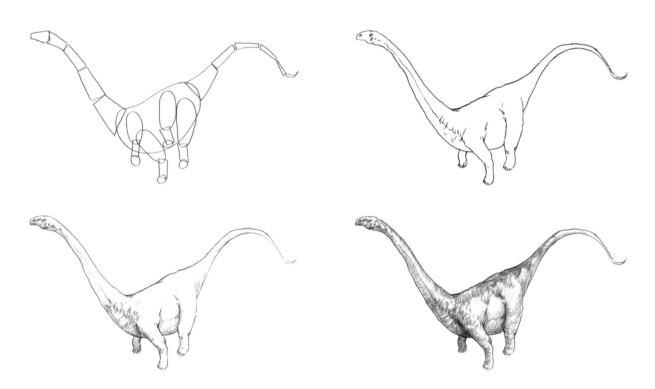

GALLIMIMUS

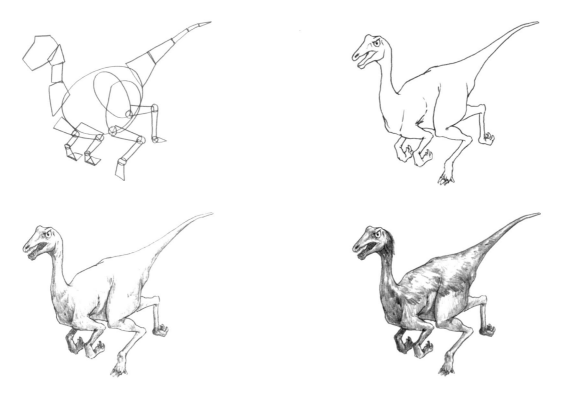

ICHTHYOSAUR

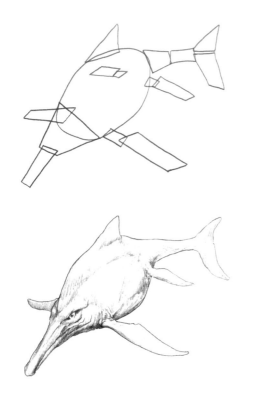

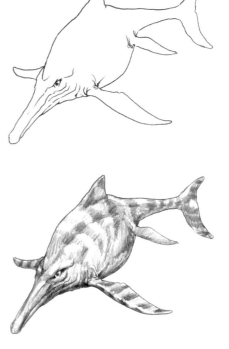

PTERODACTYL

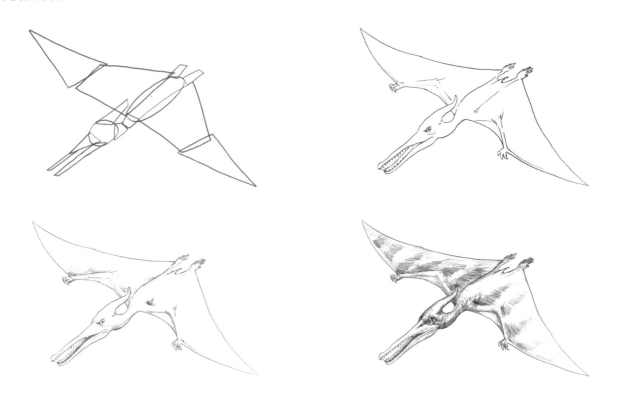

STEGOSAURUS

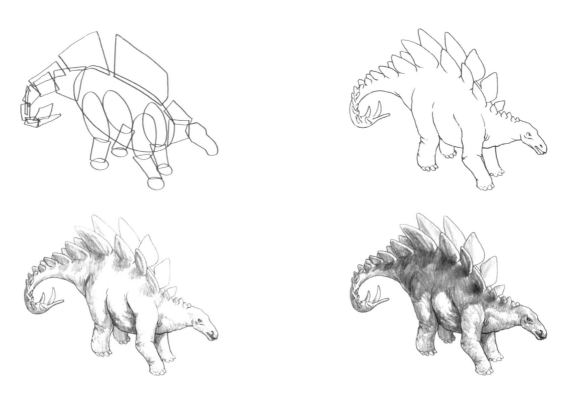

TRICERATOPS

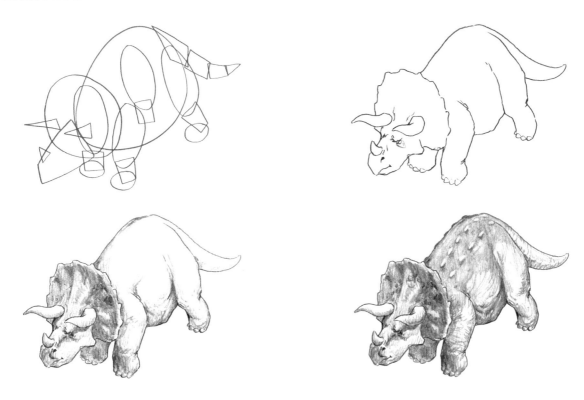

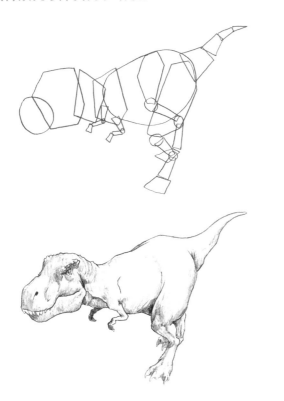

TYRANNOSAURUS REX

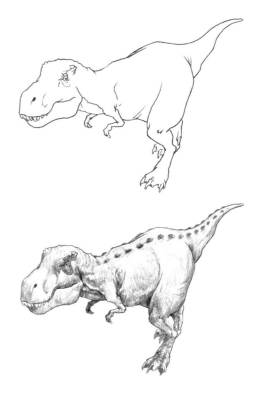

BRACHIOSAURUS (FACE DETAIL)

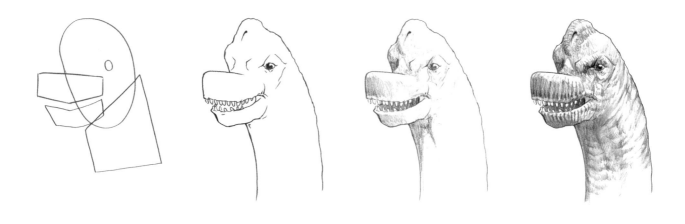

DIPLODOCUS (FACE DETAIL)

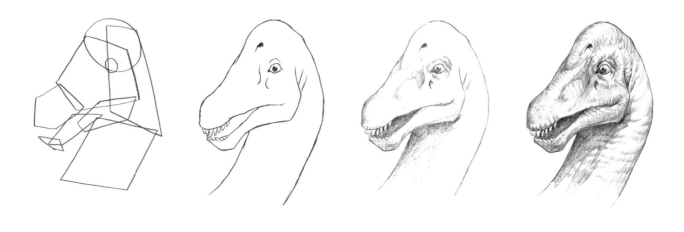

GALLIMIMUS (FACE DETAIL)

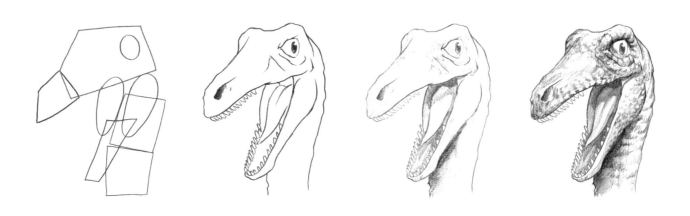

ICHTHYOSAUR (FACE DETAIL)

PTERODACTYL

 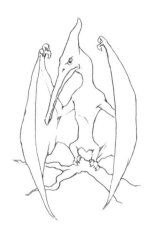 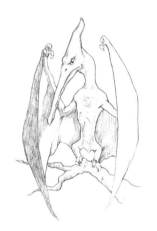 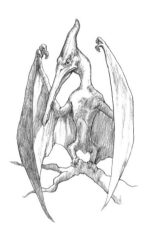

PTERODACTYL (FACE DETAIL)

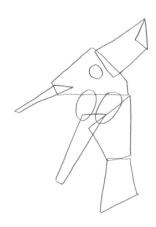

STEGOSAURUS (FACE DETAIL)

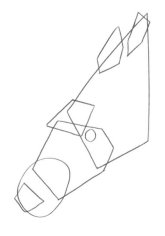 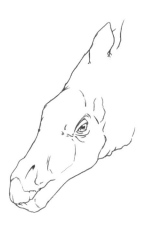 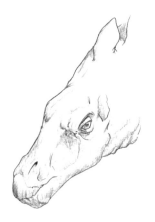 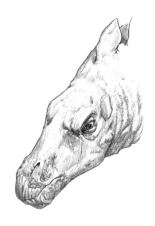

TRICERATOPS (FACE DETAIL)

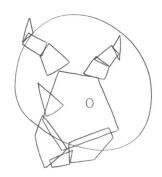

TYRANNOSAURUS REX (FRONT)

 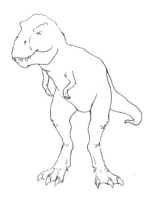 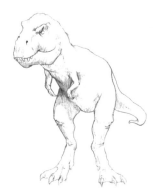 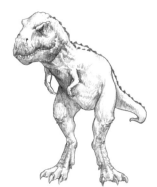

TYRANNOSAURUS REX (FACE DETAIL)

 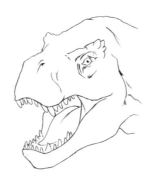 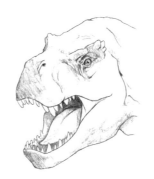 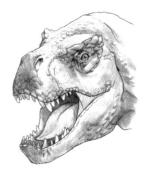

VELOCIRAPTOR

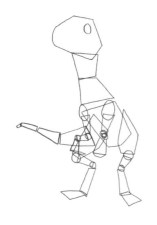 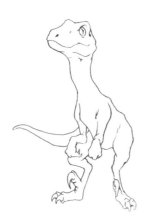 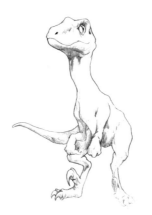 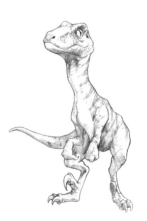

VELOCIRAPTOR (FACE DETAIL)

ANT

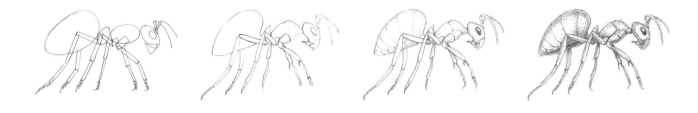

APHID

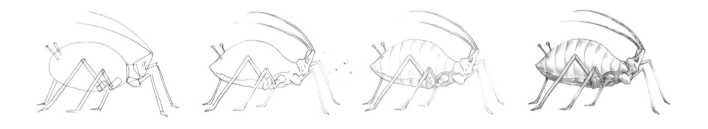

BEE

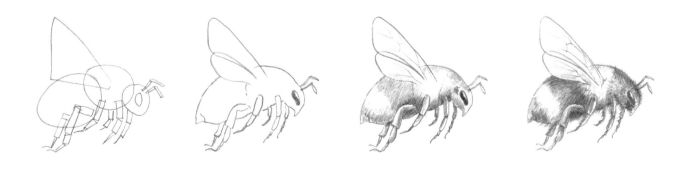

BEETLE

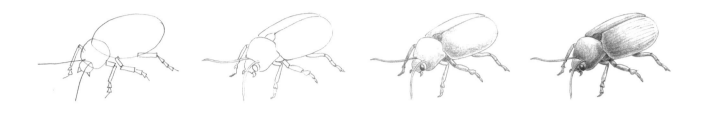

BEETLE (FROM ABOVE)

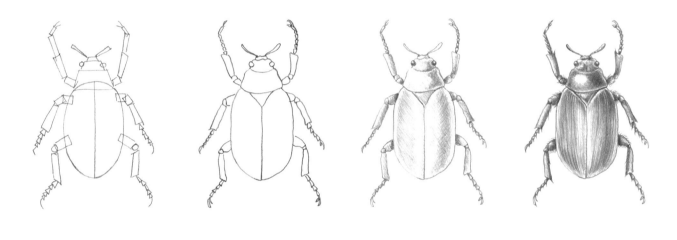

BUTTERFLY

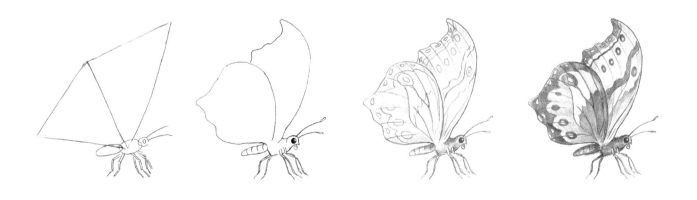

COCKROACH (WINGS CLOSED)

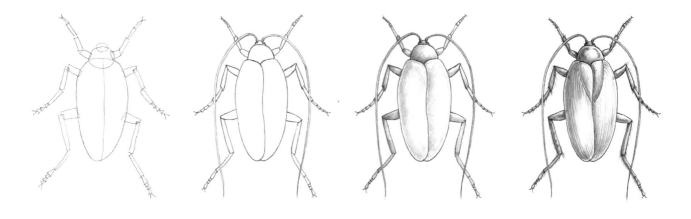

COCKROACH (WINGS RAISED)

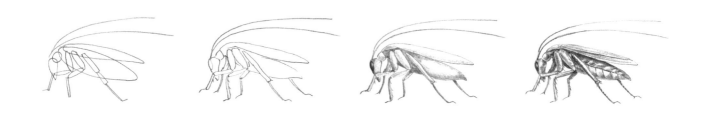

CRANE FLY

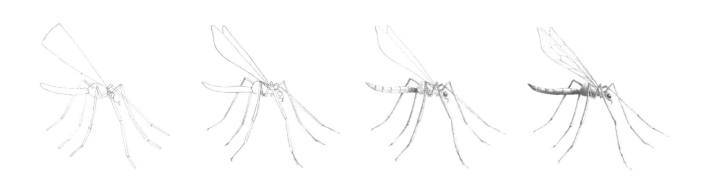

FLEA

FROG

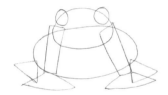 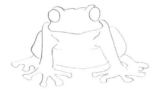 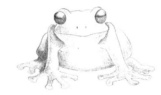 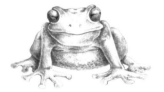

FROG (LEAPING)

GIANT MOTH

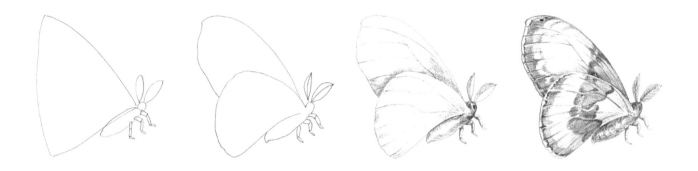

GREEN SHIELD BUG

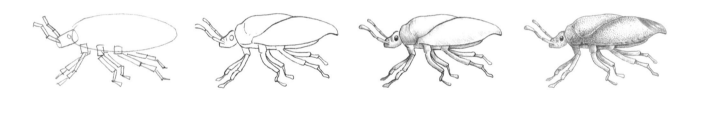

LADYBIRD

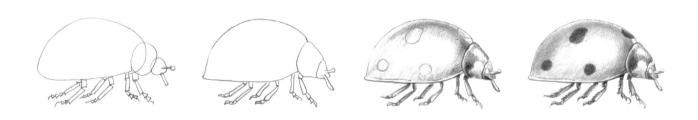

LADYBIRD (FROM ABOVE)

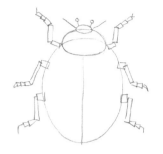

SLUG

SNAIL (FRONT)

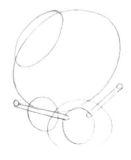

SNAIL (SIDE)

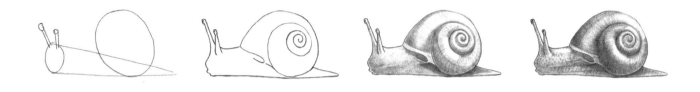

STICK INSECT

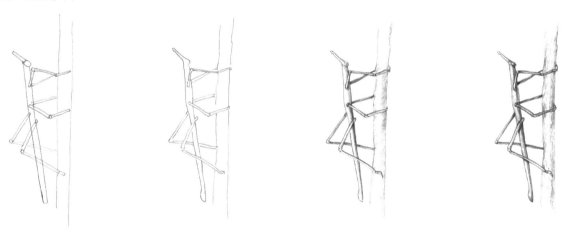

TARANTULA (FROM ABOVE)

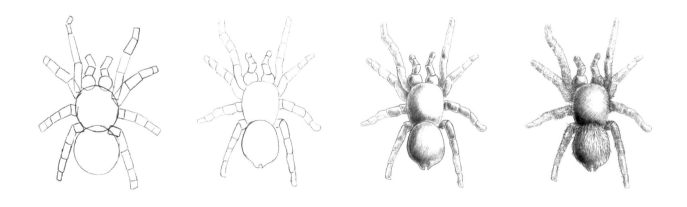

TARANTULA

TOAD

 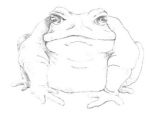 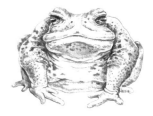

TOAD (SIDE)

 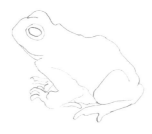 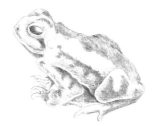 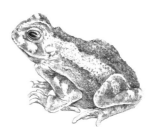

WASP

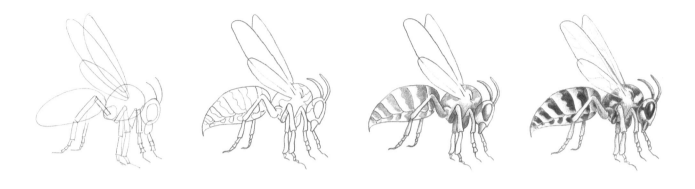

WOODLOUSE

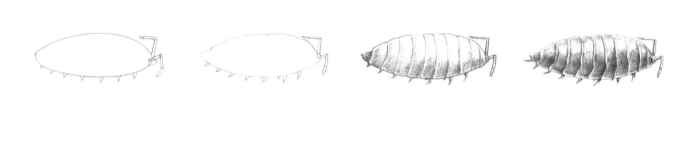

WORM

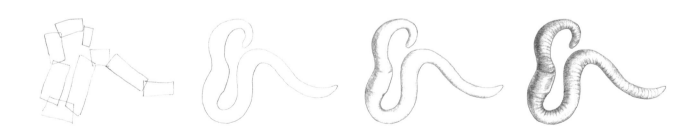

BUTTERFLY

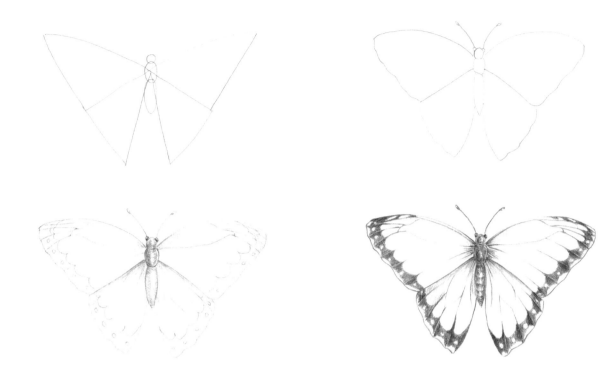

CATERPILLAR

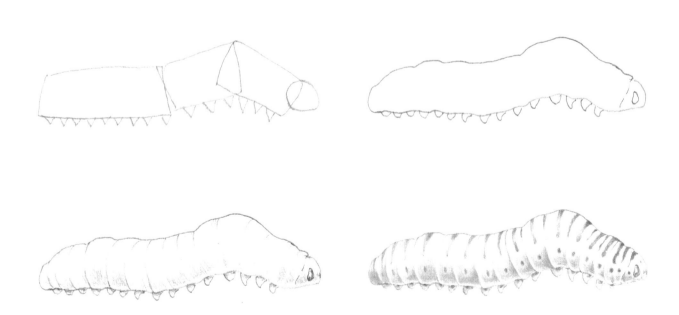

CENTIPEDE

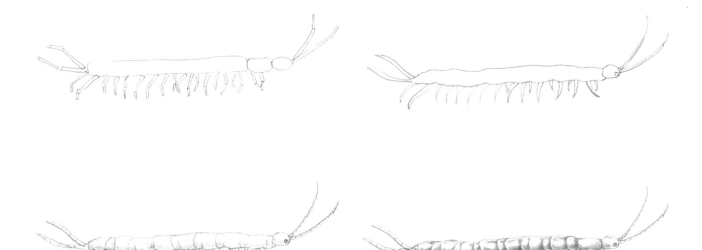

GIANT MOTH

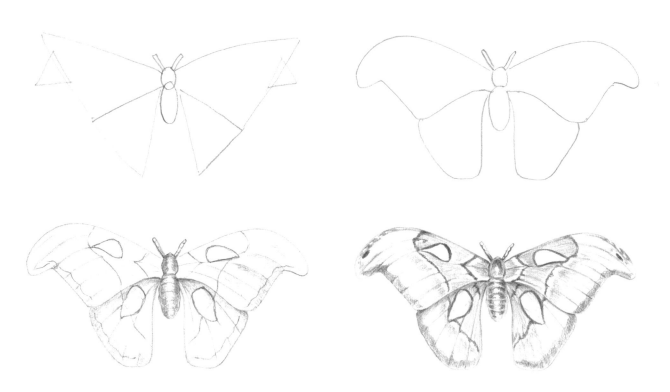

ALPACA

ALPACA (FACE DETAIL)

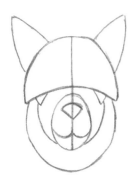 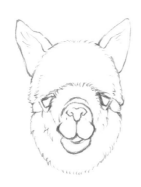 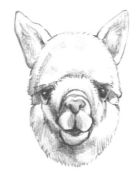

BUSH DOG

 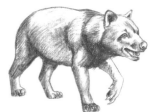

BUSH DOG (FACE DETAIL)

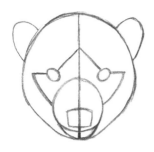 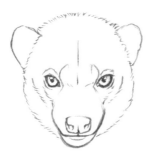 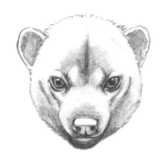

LLAMA

LLAMA (FACE DETAIL)

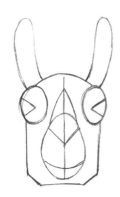 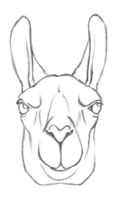 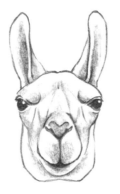 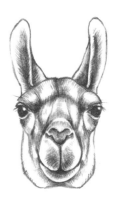

MOUNTAIN LION

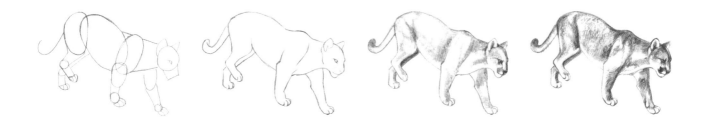

MOUNTAIN LION (FACE DETAIL)

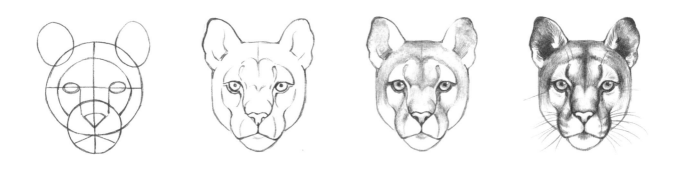

NORTH AMERICAN BISON

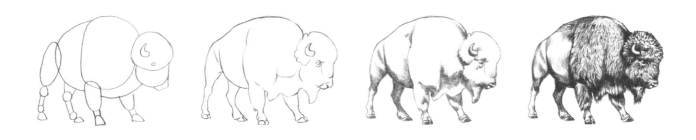

NORTH AMERICAN BISON (FACE DETAIL)

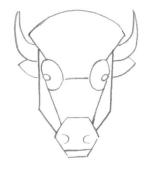 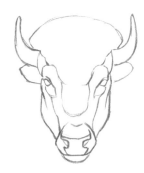 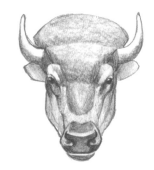 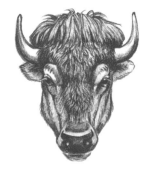

TAPIR

WARTHOG

WARTHOG (FACE DETAIL)

 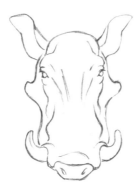 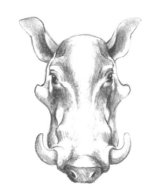 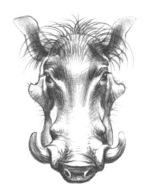

WATER BUFFALO

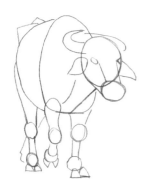 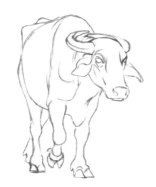 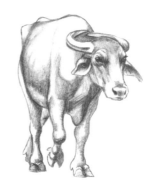 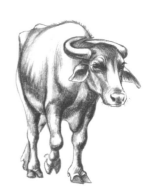

WATER BUFFALO (FACE DETAIL)

BABOON

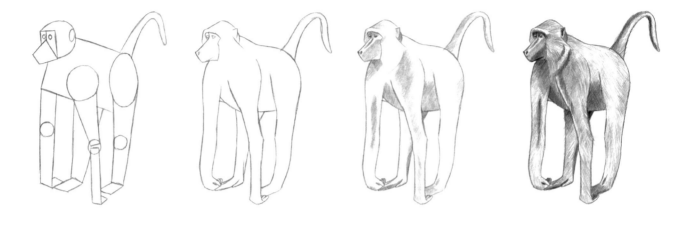

BABOON (FACE DETAIL)

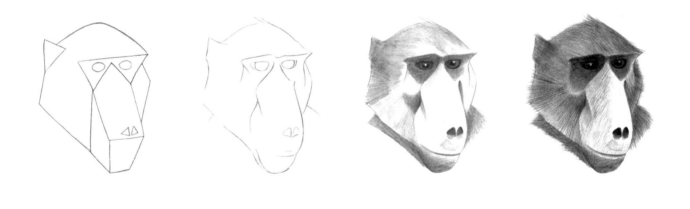

CHIMP

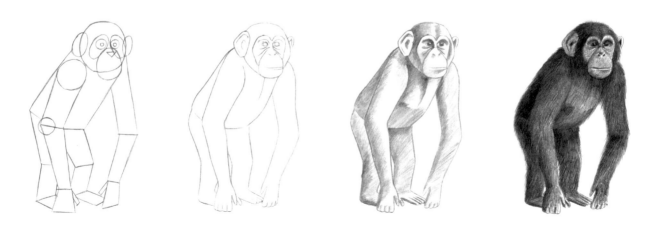

CHIMP (FACE DETAIL)

 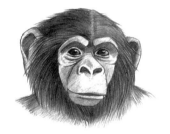

GIBBON

 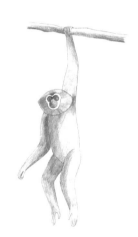 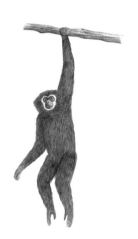

GIBBON (FACE DETAIL)

 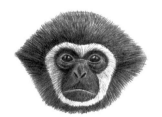

GORILLA (FACE DETAIL)

 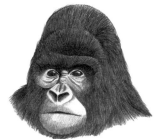

GORILLA BABY

LEMUR

ORANGUTAN

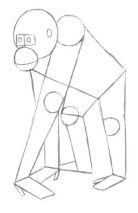

ORANGUTAN BABY

ORANGUTAN BABY (FACE DETAIL)

ALLIGATOR (FACED DETAIL)

CHAMELEON (FACE DETAIL)

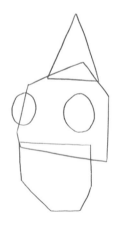

COBRA (COILED)

COBRA (FACE DETAIL)

 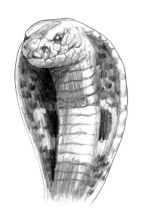

CROCODILE (FACE DETAIL)

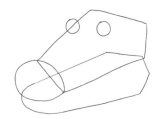

GRASS SNAKE (COILED)

GRASS SNAKE (FACE DETAIL)

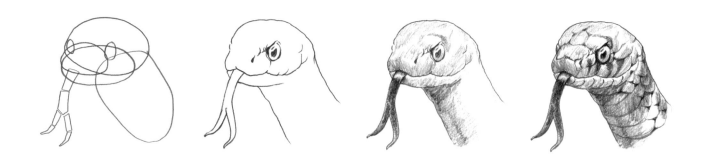

IGUANA (FACE DETAIL)

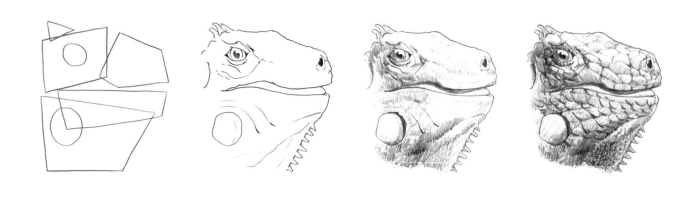

KOMODO DRAGON (FACE DETAIL)

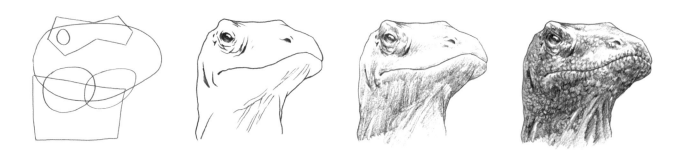

PYTHON (FACE DETAIL)

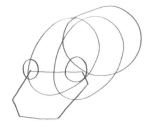 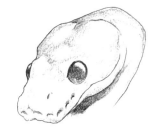 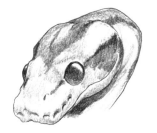

RATTLE SNAKE (COILED)

RATTLE SNAKE (FACE DETAIL)

TORTOISE

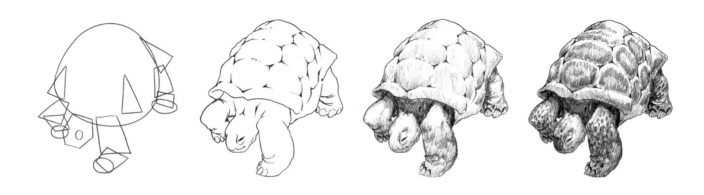

TORTOISE (SHELL DETAIL)

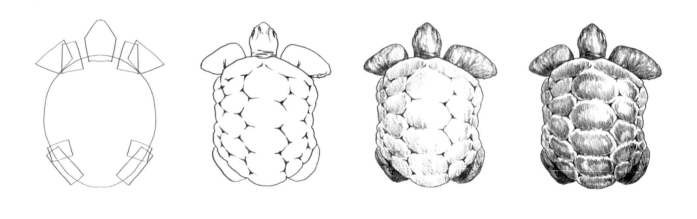

TORTOISE (FACE DETAIL)

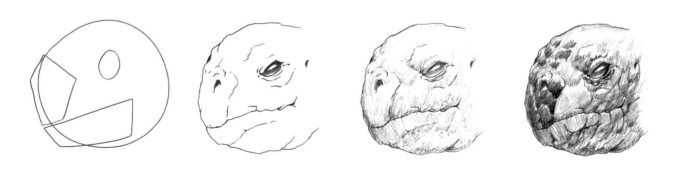

ALLIGATOR

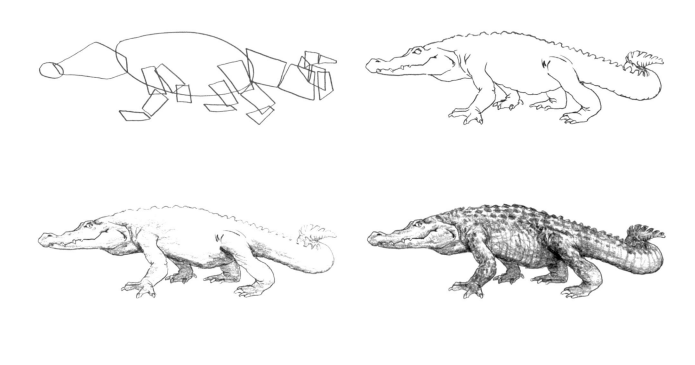

CHAMELEON

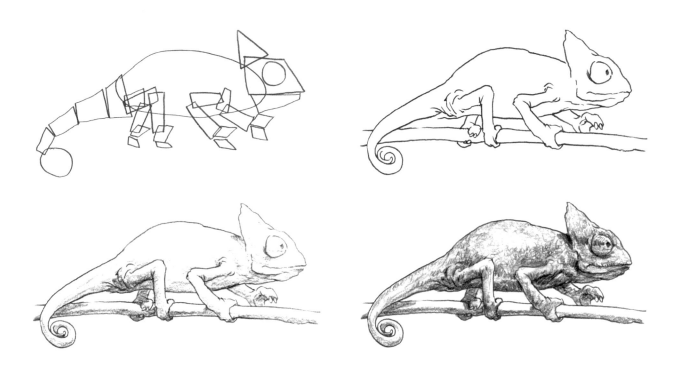

COBRA

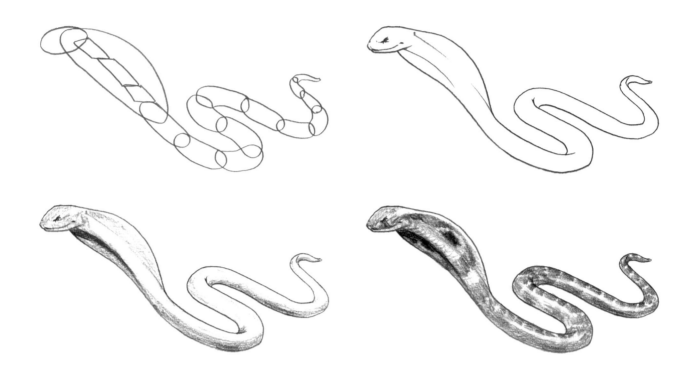

CROCODILE

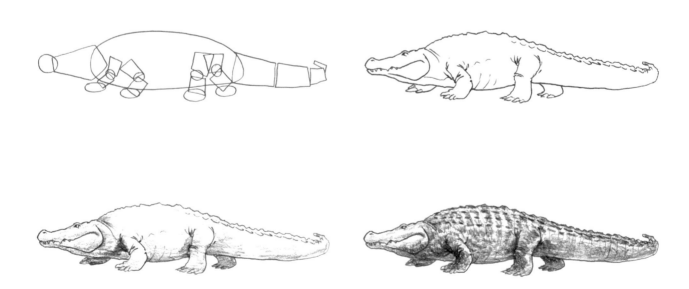

IGUANA

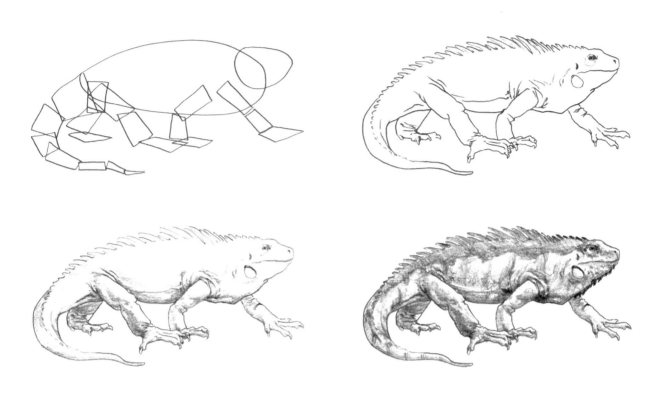

KOMODO DRAGON

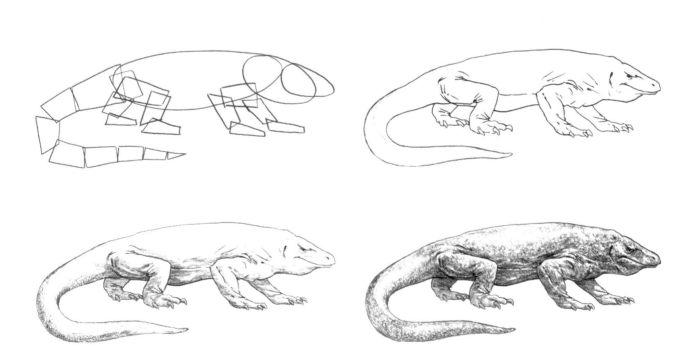

CHINCHILLA

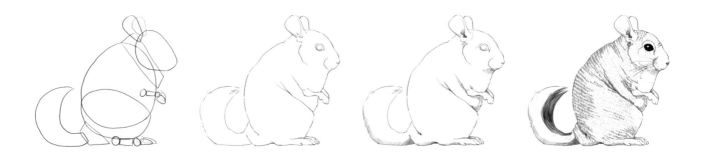

CHINCHILLA (FACE DETAIL)

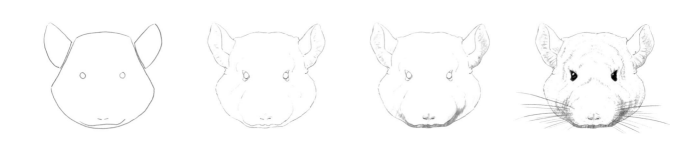

GUINEA-PIG

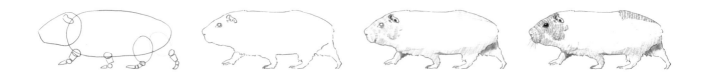

GUINEA-PIG (FACE DETAIL)

HAMSTER

HAMSTER (FACE DETAIL)

MOUSE

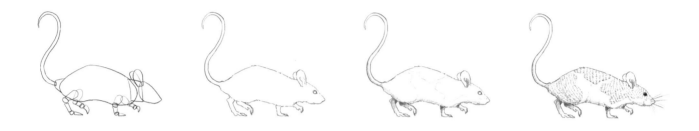

MOUSE (SITTING UP)

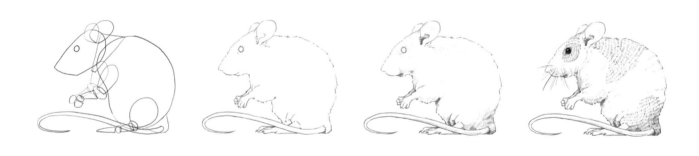

MOUSE (FACE DETAIL)

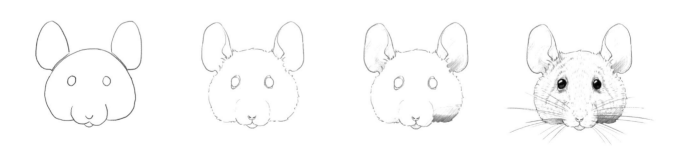

PORCUPINE

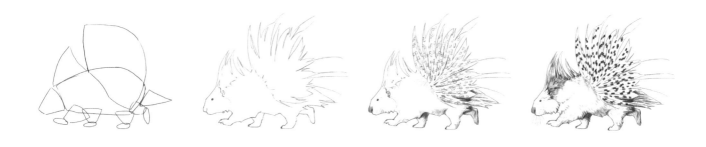

PORCUPINE (FACE DETAIL)

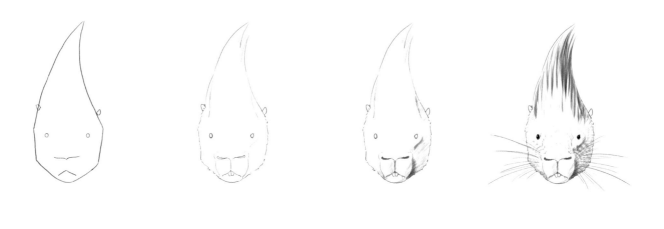

RABBIT

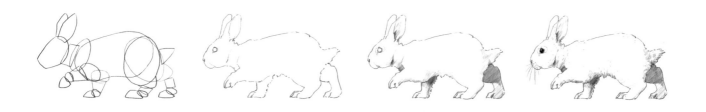

RABBIT (SITTING UP)

RABBIT (FACE DETAIL)

RAT

RAT (FACE DETAIL)

SHREW

SHREW (FACE DETAIL)

AARDVARK

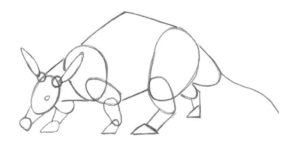
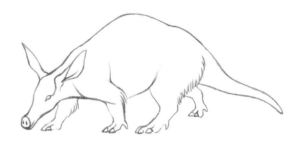
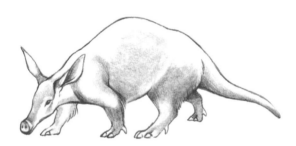
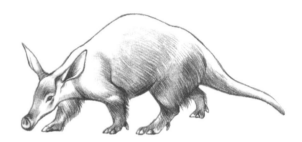

ELEPHANT

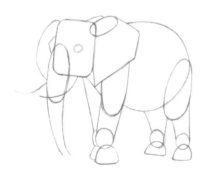
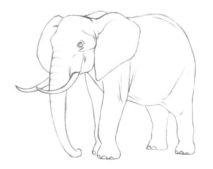
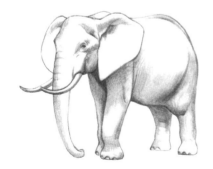
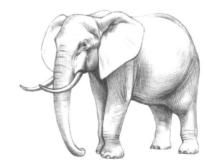

HIPPOPOTAMUS

RHINOCEROS

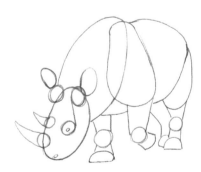
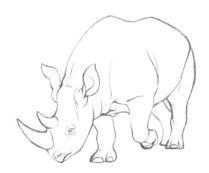
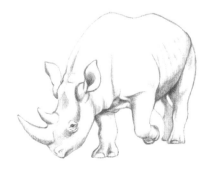
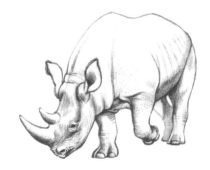

AARDVARK (FACE DETAIL)

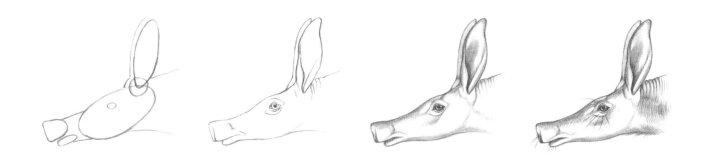

AFRICAN PAINTED DOG

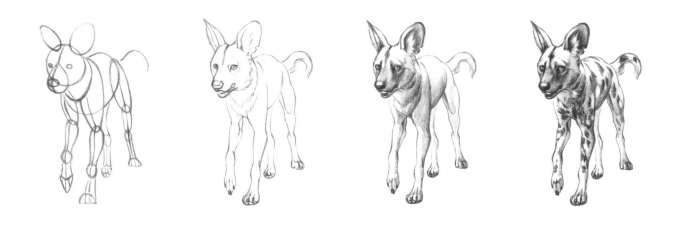

AFRICAN PAINTED DOG (FACE DETAIL)

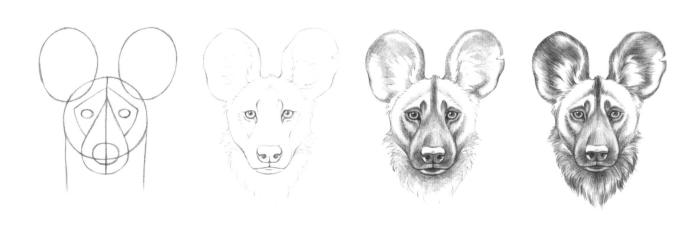

ELEPHANT (FACE DETAIL)

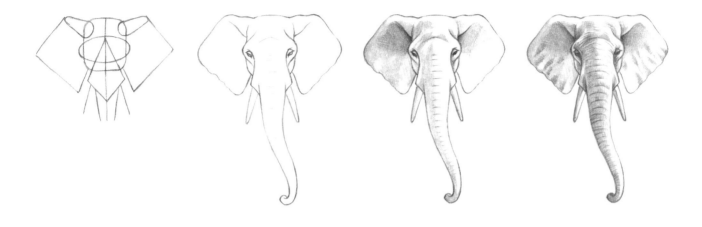

ELEPHANT CALF

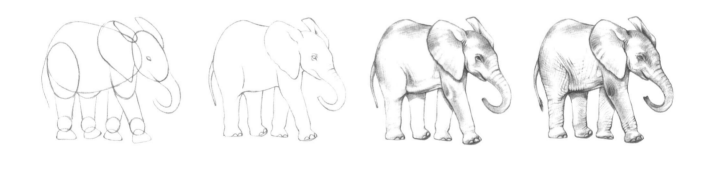

ELEPHANT CALF (FACE DETAIL)

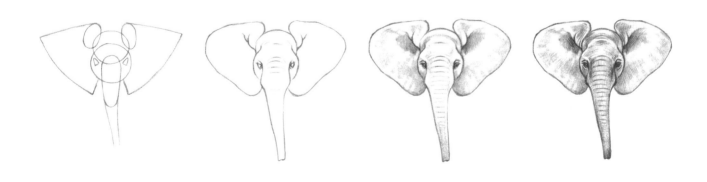

GIRAFFE

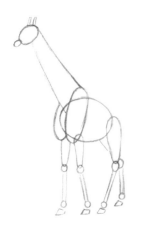 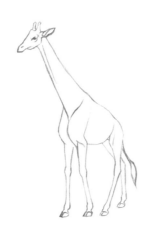

GIRAFFE (FACE DETAIL)

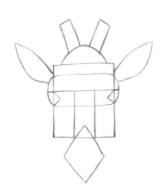 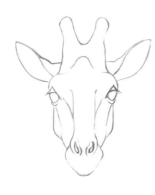 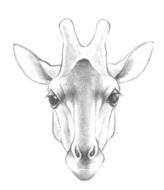 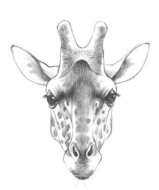

HIPPOPOTAMUS (FACE DETAIL)

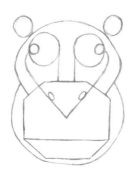 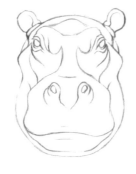 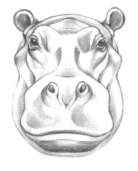 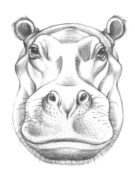

RHINOCEROS (FACE DETAIL)

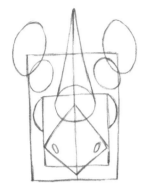 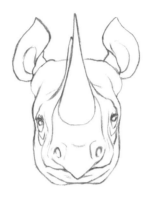 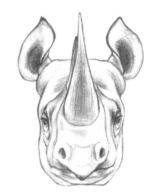 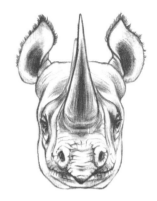

ZEBRA

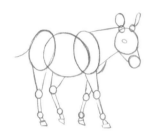 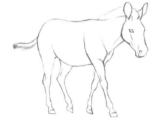 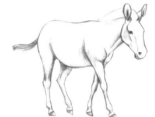 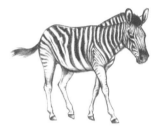

ZEBRA (FACE DETAIL)

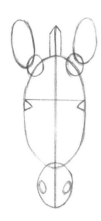 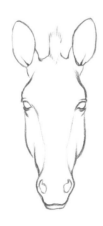 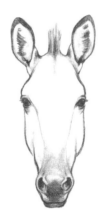 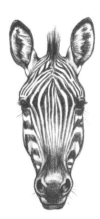

BLUE WHALE

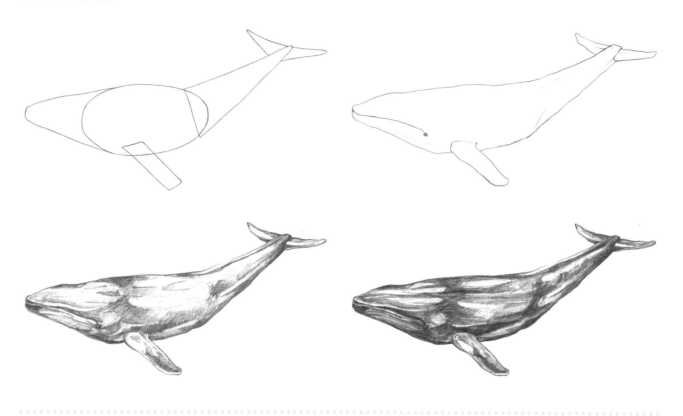

CUTTLEFISH

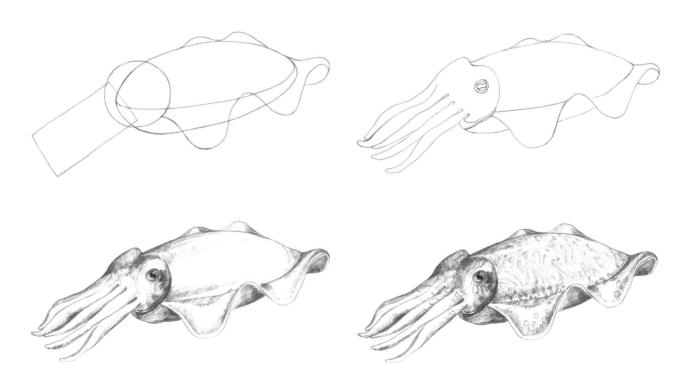

DOLPHIN

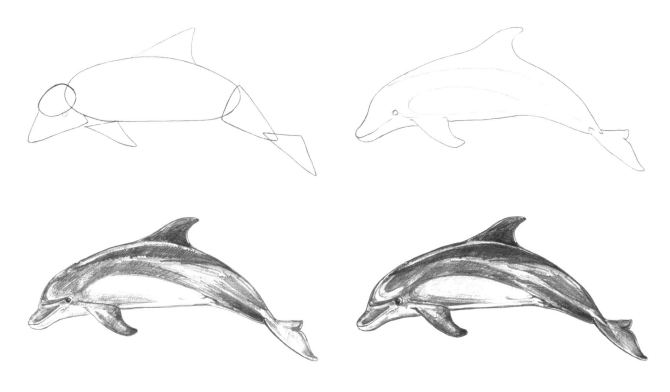

EXOTIC FISH

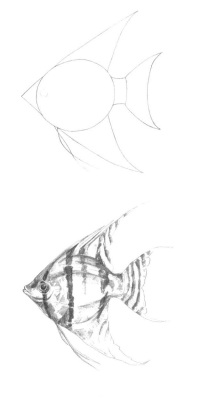
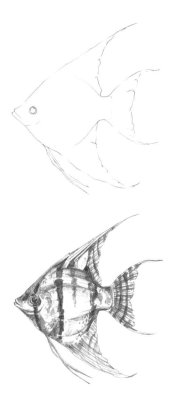

GREAT WHITE SHARK

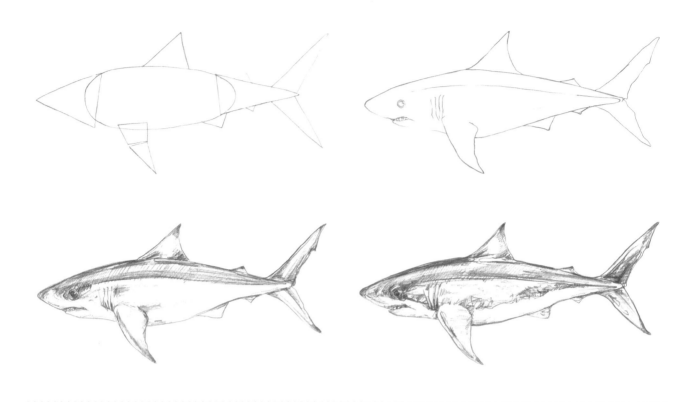

HAMMERHEAD SHARK

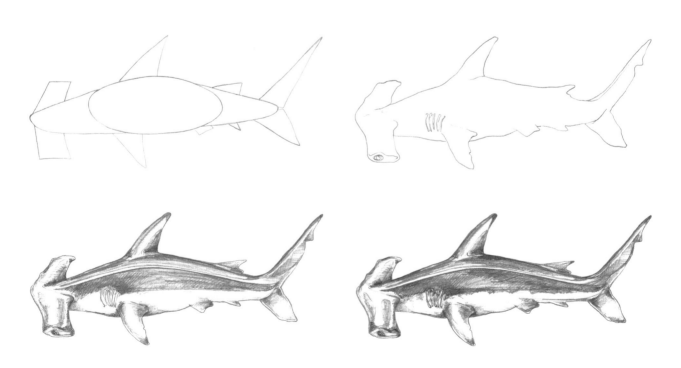

KILLER WHALE

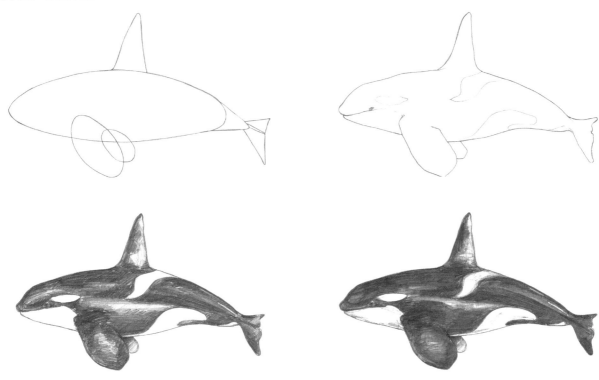

LOBSTER

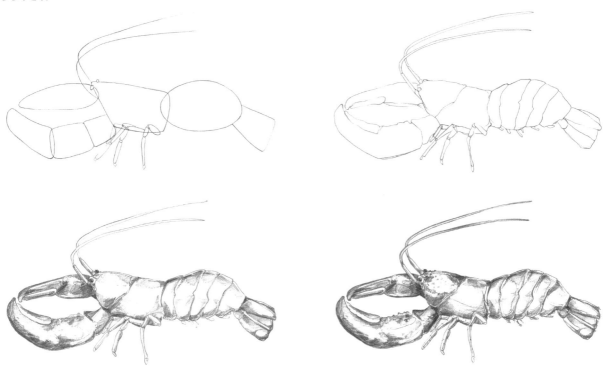

MANATEE

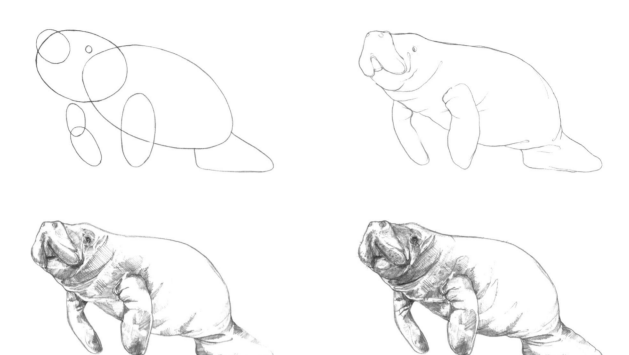

OCTOPUS

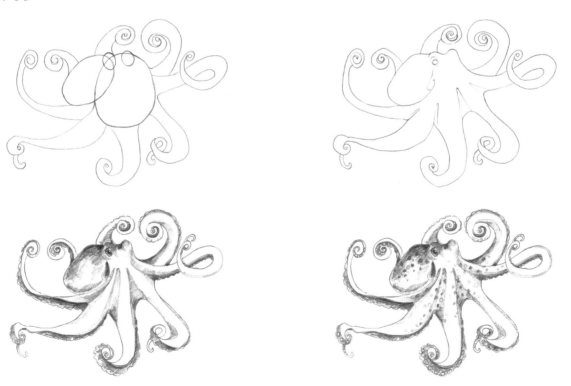

SWORDFISH

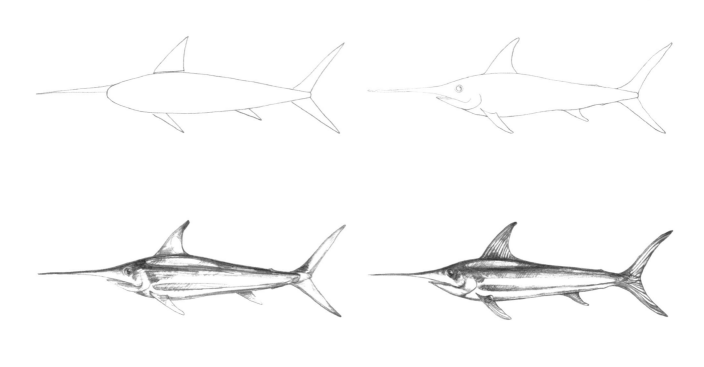

TUNA FISH

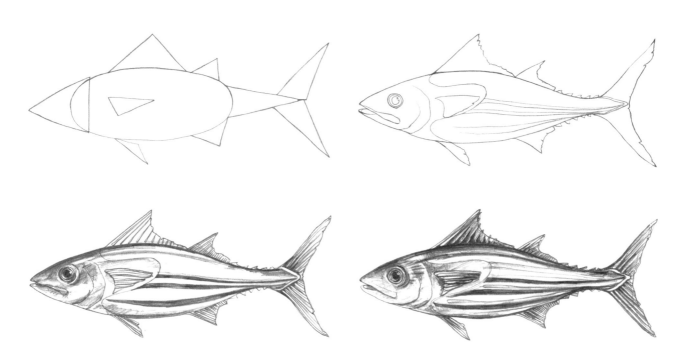

CLOWN FISH

CRAB

GREAT WHITE SHARK

HAMMERHEAD SHARK

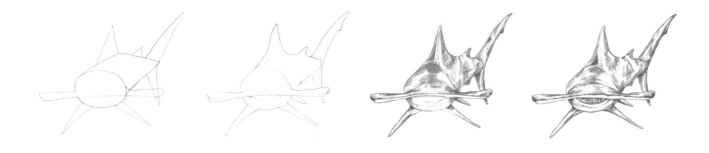

JELLY FISH

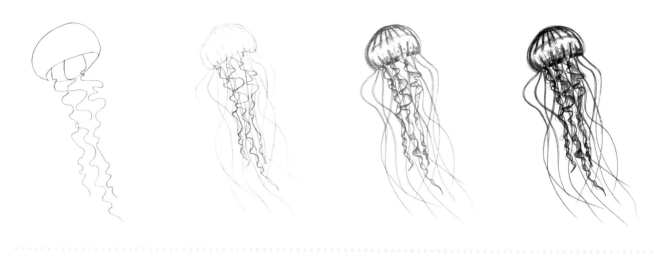

LOBSTER

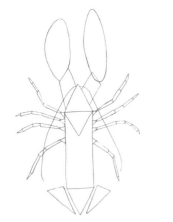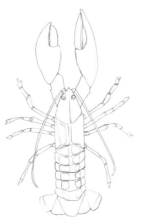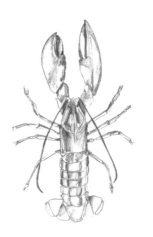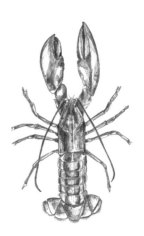

OCTOPUS

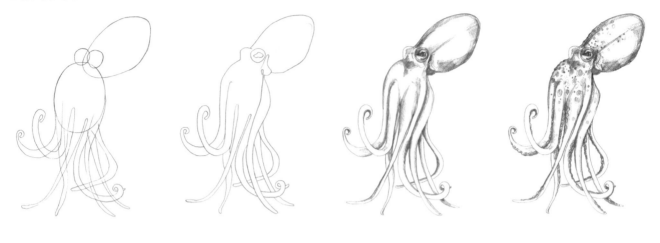

PRAWN

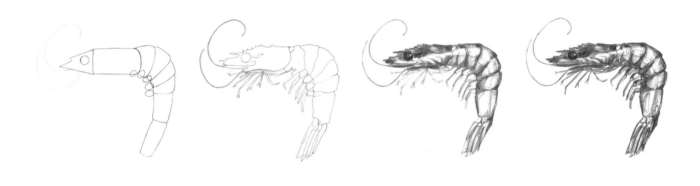

SEAHORSE

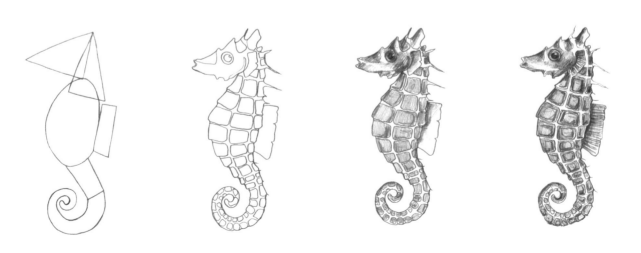

SEA TURTLE

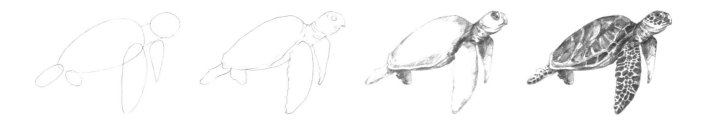

SEA TURTLE (SHELL DETAIL)

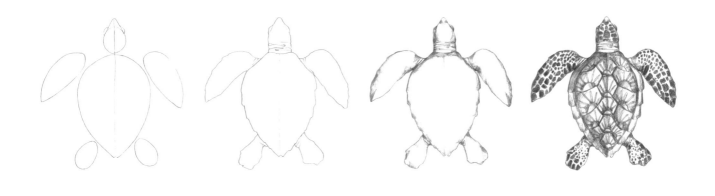

SQUID

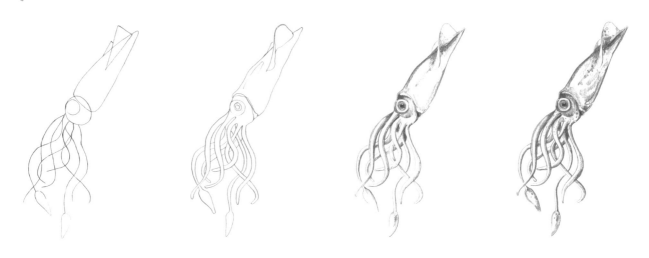

BEAVER

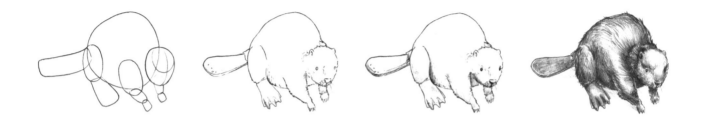

BEAVER (FACE DETAIL)

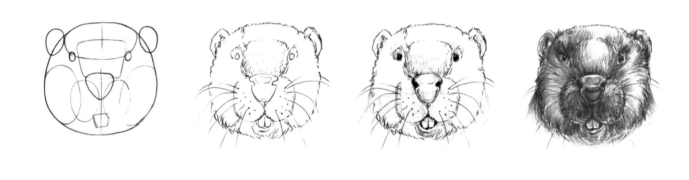

PLATYPUS

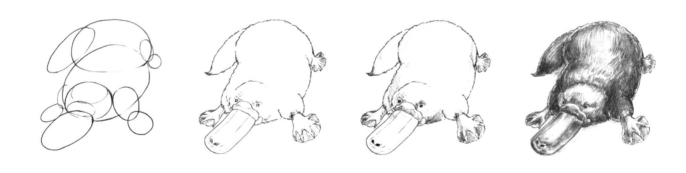

PLATYPUS (FACE DETAIL)

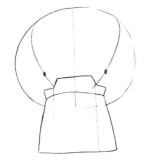 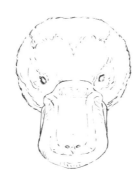

SEA LION (FACE DETAIL)

SEA OTTER (IN WATER)

 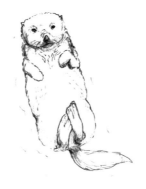 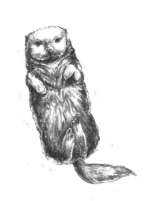

SEA OTTER (FACE DETAIL)

 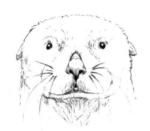 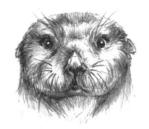

WALRUS

 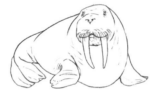

WALRUS (FACE DETAIL)

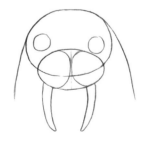 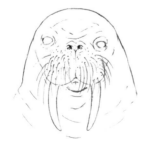

BADGER

BADGER (FACE DETAIL)

 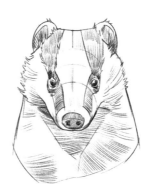 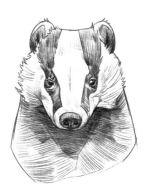

BROWN BEAR

BROWN BEAR (STANDING)

 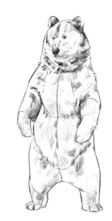 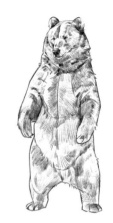

BROWN BEAR (FACE DETAIL)

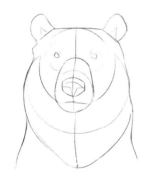 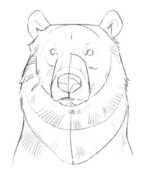 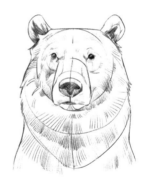 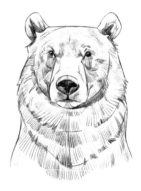

DEER

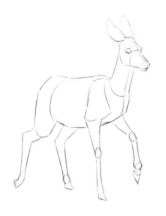 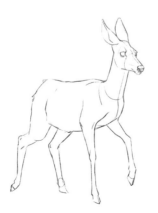 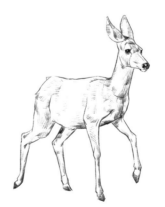 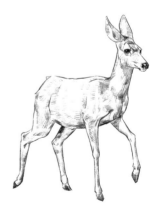

DEER (FACE DETAIL)

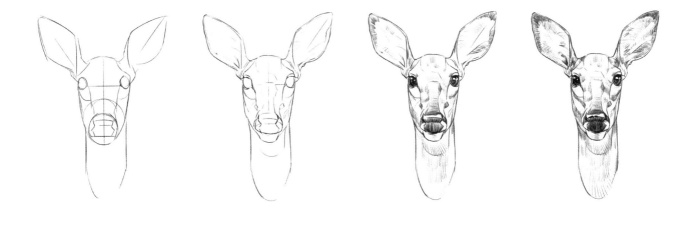

FERRET

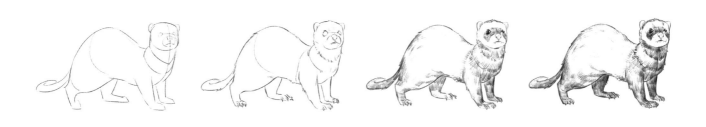

FERRET (FACE DETAIL)

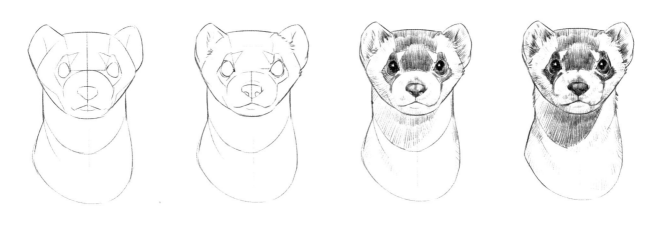

FOX

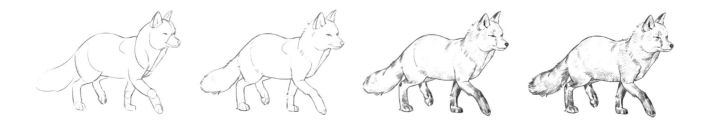

FOX (SITTING)

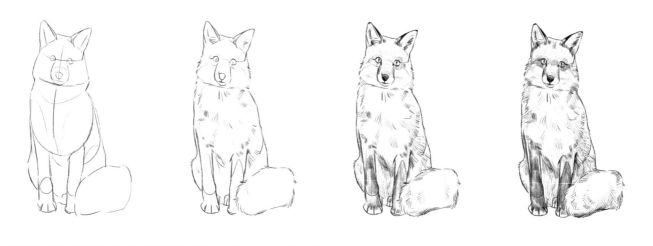

FOX (FACE DETAIL)

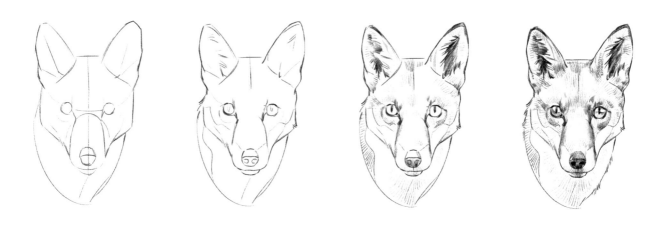

HEDGEHOG

MOOSE (FACE DETAIL)

 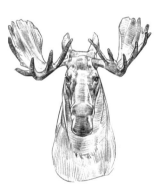

SKUNK

SKUNK (FACE DETAIL)

SLOTH

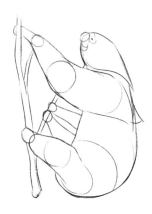 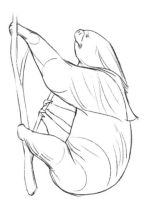 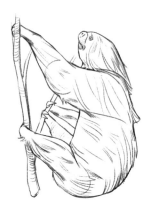 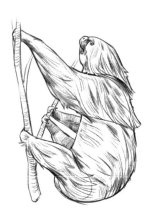

SLOTH (FACE DETAIL)

STAG

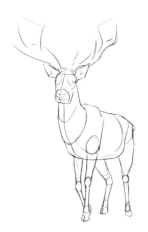 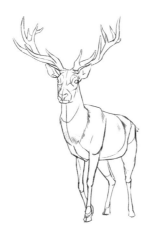 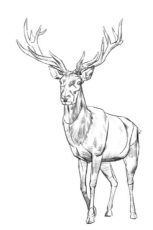 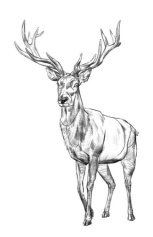

STAG (FACE DETAIL)

 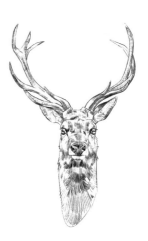

SUN BEAR (FACE DETAIL)

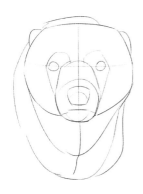 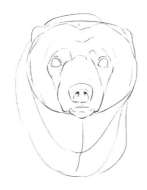 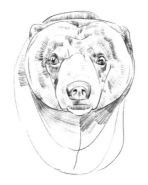 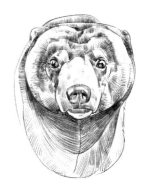

WEASEL

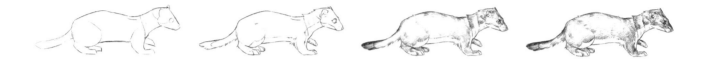

WEASEL (FACE DETAIL)

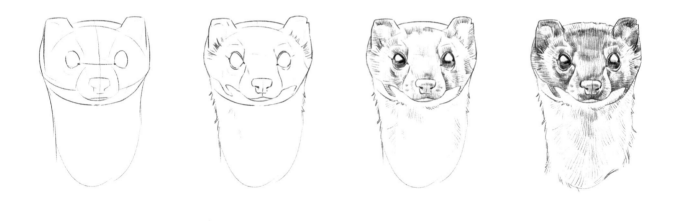

WOLF

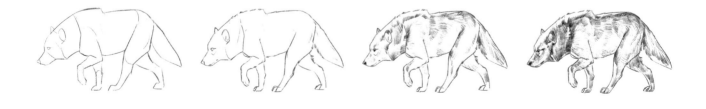

WOLF (SITTING)

 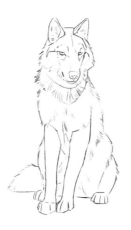 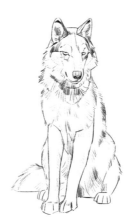 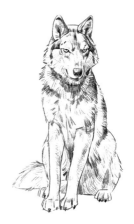

WOLF (FACE DETAIL)

WOLF CUB

WOLF CUB (FACE DETAIL)

WOLVERINE

 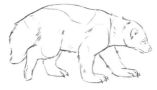 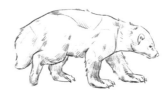 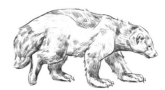

WOLVERINE (FACE DETAIL)

MOOSE

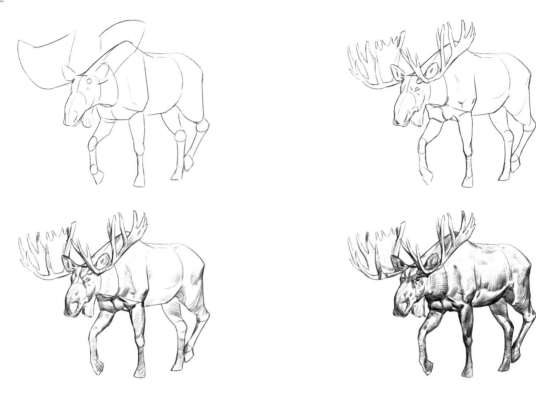

SUN BEAR

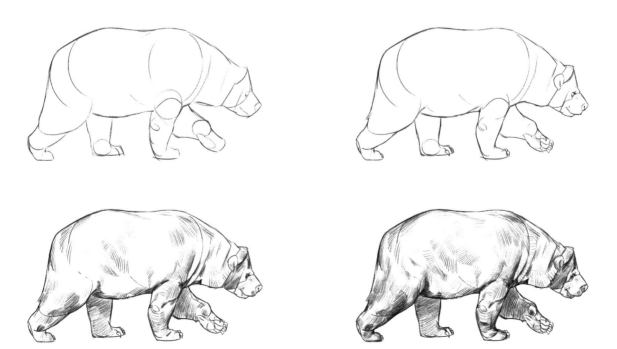

CALF (FACE DETAIL)

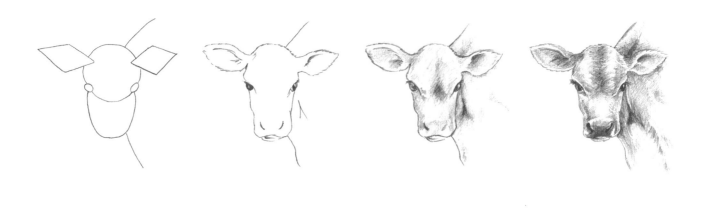

CAT

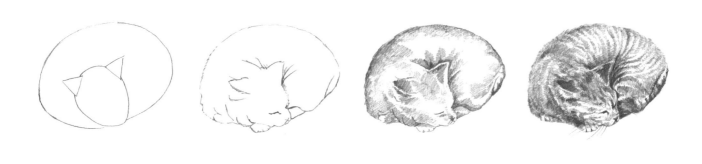

CAT (FACE DETAIL)

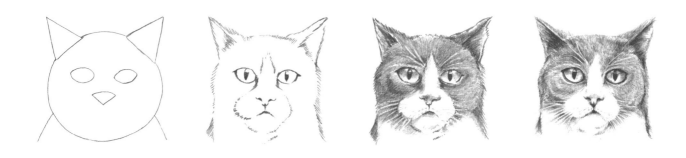

DOG

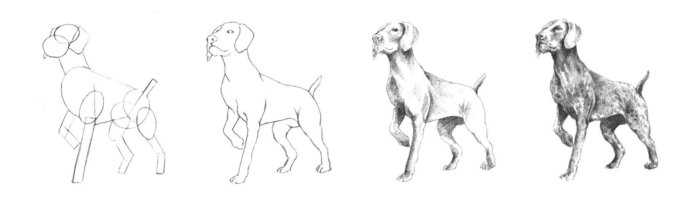

DOG (FACE DETAIL)

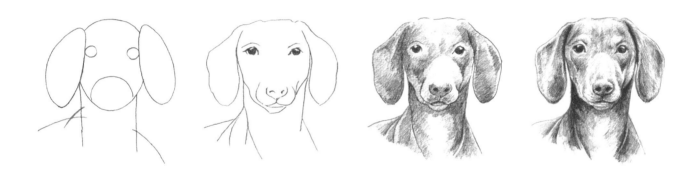

DONKEY (FACE DETAIL)

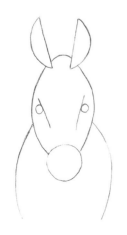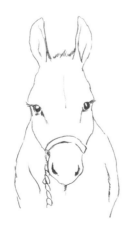

GOAT

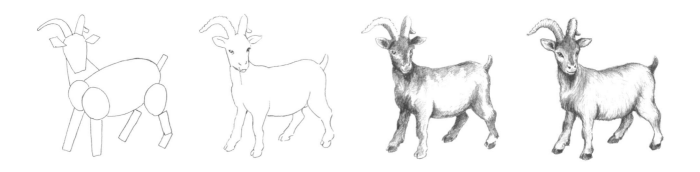

GOAT (FACE DETAIL)

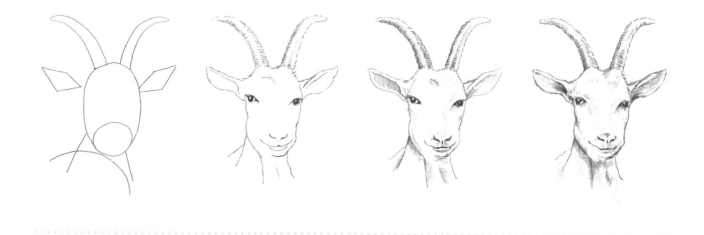

GREYHOUND

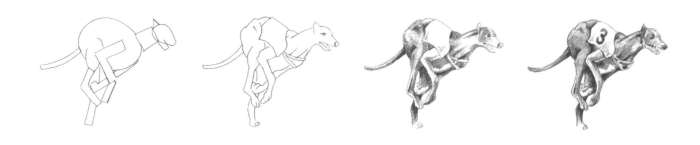

PIG

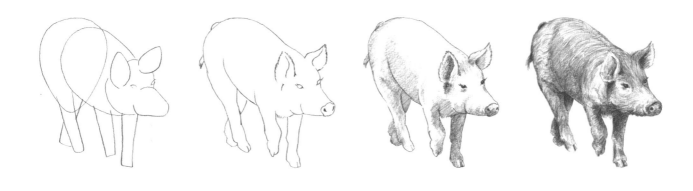

SHEEP (FACE DETAIL)

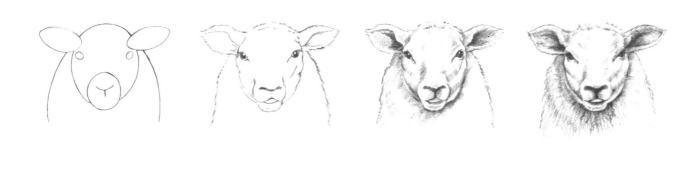

SLED DOG (FACE DETAIL)

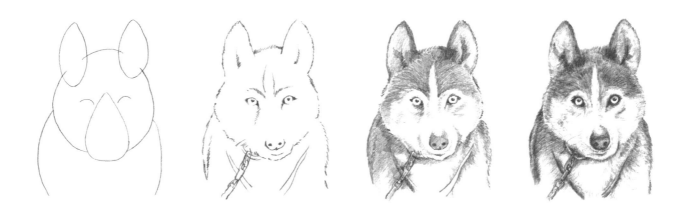

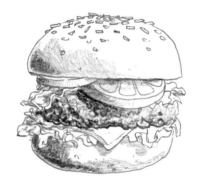

FOOD AND DRINK

...

Still life drawing frequently focuses on food and drink items as these subjects offer a great occasion to practice sketching compositions. A strong still life composition will feature foods and drinks that use a mixture of shapes and textures, so in this chapter you will find a range of liquid and solid forms in a variety of those features. Group these subjects to see what interesting artworks you can create through diversity.

IN THIS CHAPTER

..

ALCOHOL

BREAKFAST FOODS

COLD FOODS

FAST FOOD

FRUITS AND VEGETABLES

HOT FOODS

SOFT DRINKS

SWEET TREATS

BEER BOTTLE

 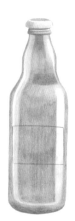

CHAMPAGNE BOTTLE

CHAMPAGNE FLUTE

COCKTAIL

WINE BOTTLE

WINE GLASS

 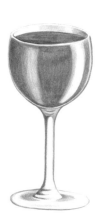

BAGUETTE

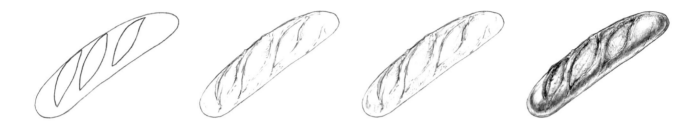

CROISSANT

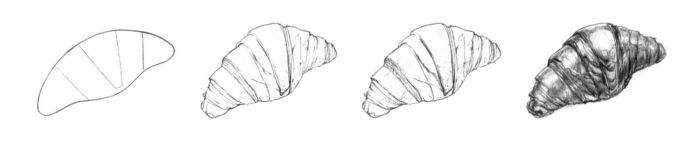

EGGS ON TOAST

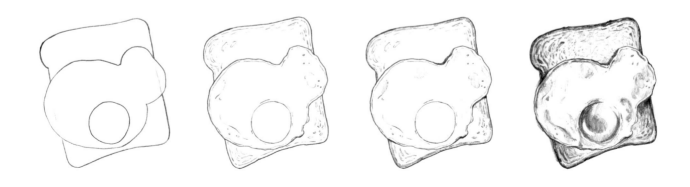

FRIED BREAKFAST

PANCAKES

WAFFLES

BREADSTICKS

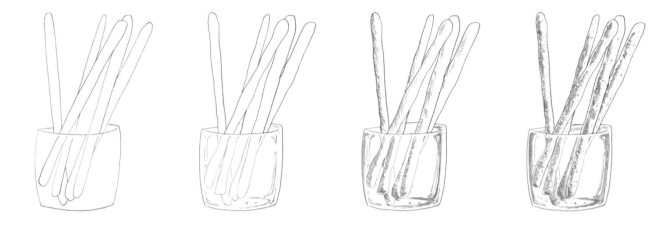

CHEESE

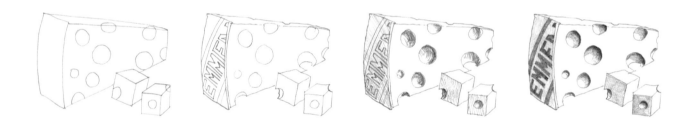

MIXED NUTS

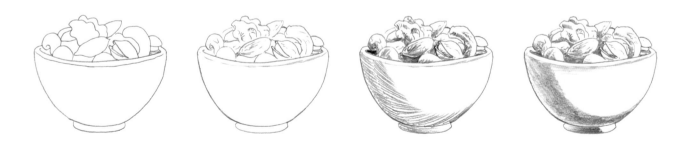

MONKEY NUTS

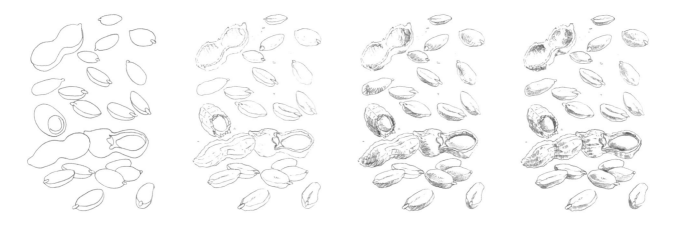

MUSHROOMS

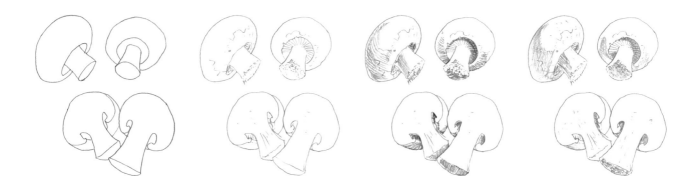

PORK PIE

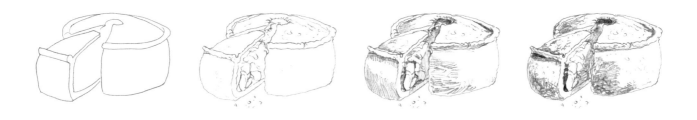

SALAD

SALAMI SAUSAGE

SANDWICH

SCOTCH EGG

SMOKED FISH

 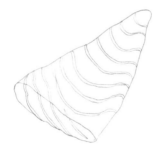

SUSHI

BURGER

BURRITO

CHINESE TAKEAWAY BOX

FRIES

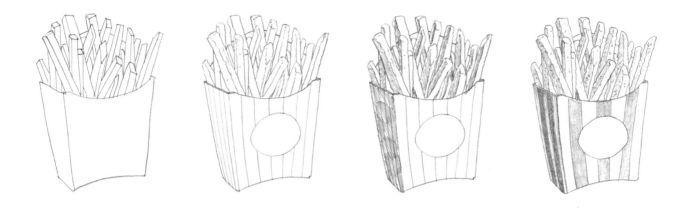

GARLIC BREAD

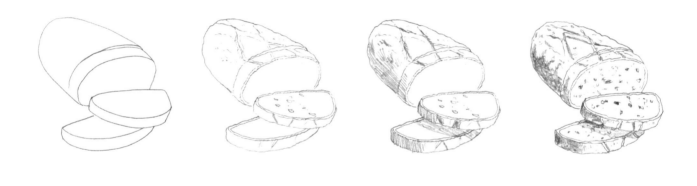

HOTDOG

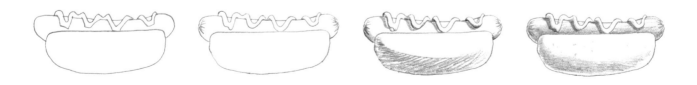

KEBAB

NOODLES

PASTY

 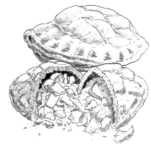

PIZZA

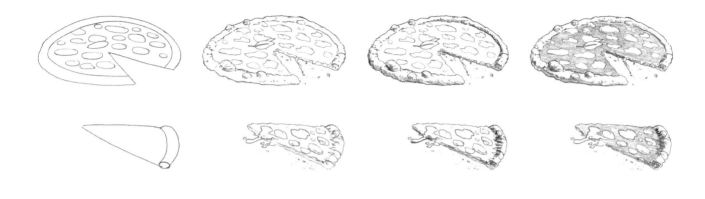

RAMEN

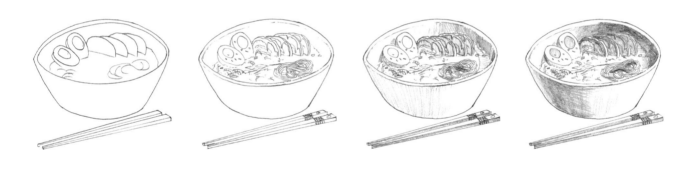

TACO

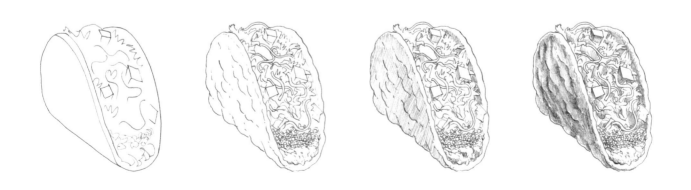

APPLE

AVOCADO

BANANA

BANANA BUNCH

BEETROOT

BELL PEPPER

BLACKBERRY

BROCCOLI

CARROT

CHILI PEPPER

COCONUT

CORN

CUCUMBER

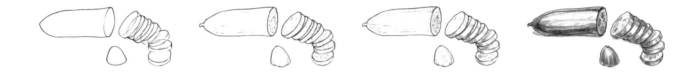

EGGPLANT

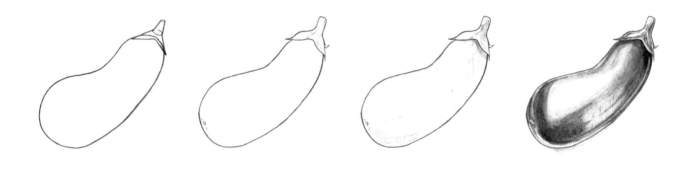

FIG

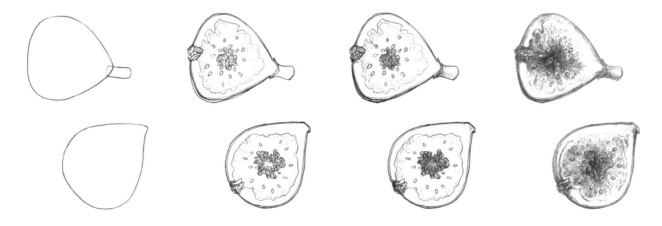

GARLIC BULB

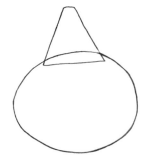

GRAPES

JACKFRUIT

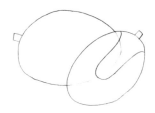

LEEK

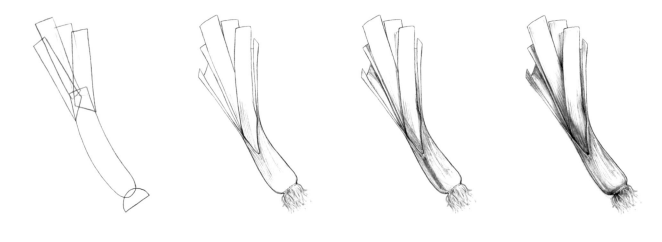

LEMON

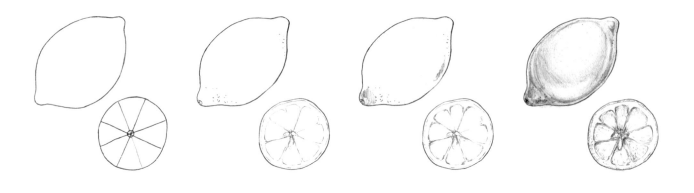

ONION

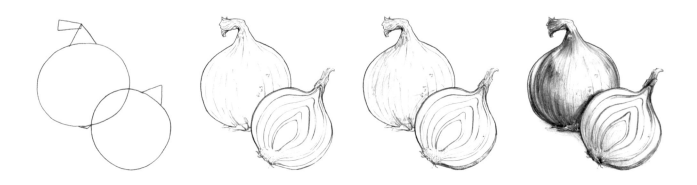

ORANGE

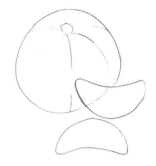 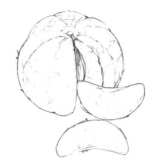

PAPAYA

PEACH

PEA POD

PINEAPPLE

POMEGRANATE

PUMPKIN

RASPBERRY

 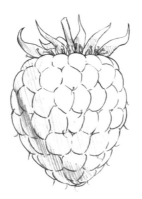 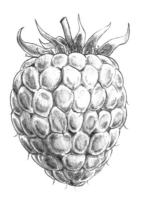

RHUBARB

SAVOY CABBAGE

SCALLIONS

SPROUTS

SQUASH

STRAWBERRY

TARO

TOMATO

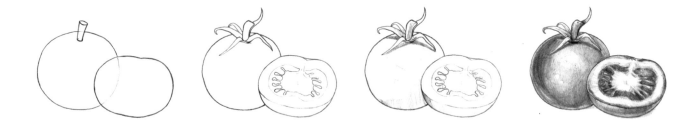

WATERMELON

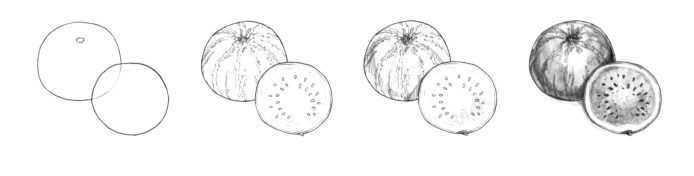

YAM

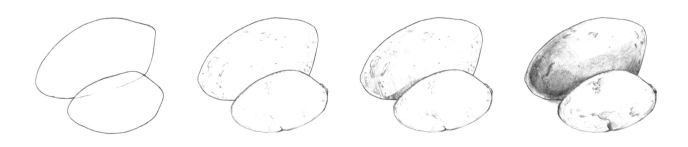

CASSEROLE

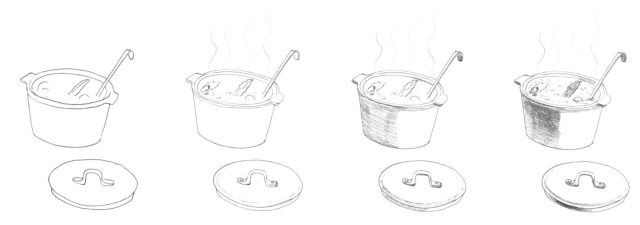

CHICKEN DRUMSTICK

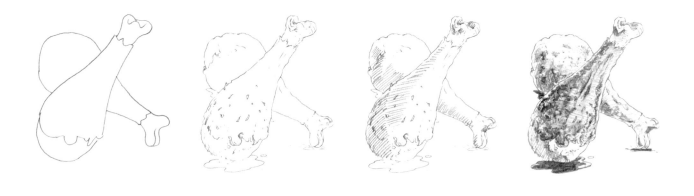

CURRY AND NAAN BREAD

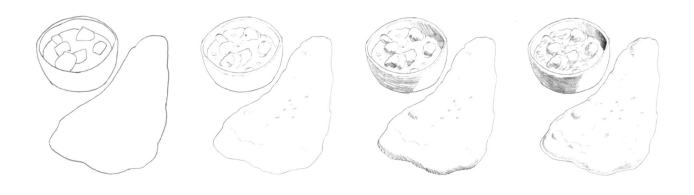

FISH

HAM

PASTA

RICE

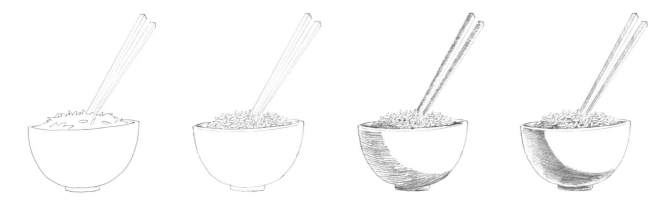

ROAST CHICKEN

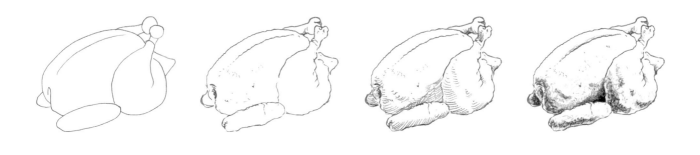

SAUSAGES

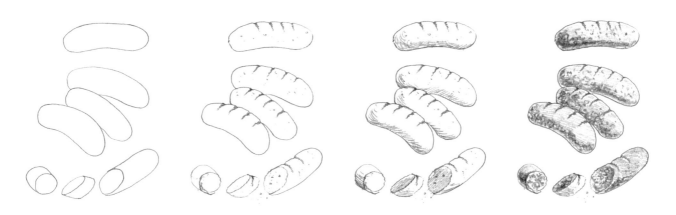

SHRIMP

SPAGHETTI AND MEATBALLS

STEAK

COFFEE

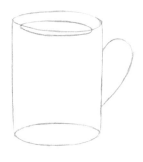

FRAPPE

 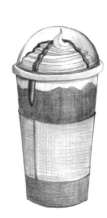

ICED DRINK

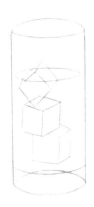

JUICE BOX

MILK CARTON

SODA

SODA BOTTLE

TEA CUP

TEAPOT

CAKE

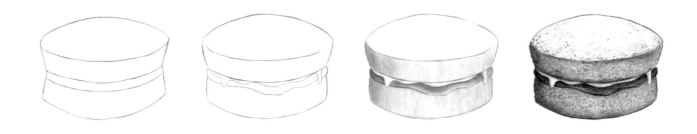

CAKE (SLICE)

CHEESECAKE

CUPCAKE

DANISH PASTRIES

DOUGHNUT

ICE CREAM

ICE CREAM CONE

ICE CREAM SUNDAE

JELLY

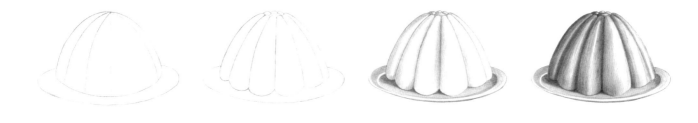

PIE (SLICE)

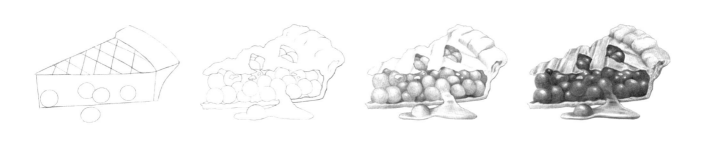

SCONE WITH JAM AND CREAM

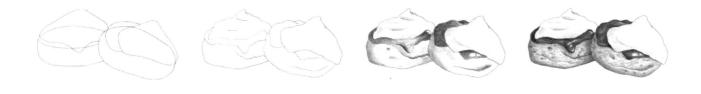

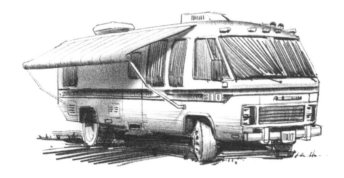

VEHICLES AND TRANSPORTATION

The vehicles and transportation devices included in this chapter appear in the form of both hard surface textures, such as metals and glass, but also as organic textures such as wood. However, the subjects are largely united by the use of basic angular shapes, which can be built up to create complex objects. When drawing these subjects pay close attention to the existence and placement of reflections and intricate design elements.

IN THIS CHAPTER

··

AIR AND SPACE VEHICLES

CARS, BIKES, AND TRUCKS

MILITARY VEHICLES

PROFESSIONAL VEHICLES

PUBLIC TRANSPORT

PUSH OR PULL VEHICLES

WATER VEHICLES

AIRPLANE

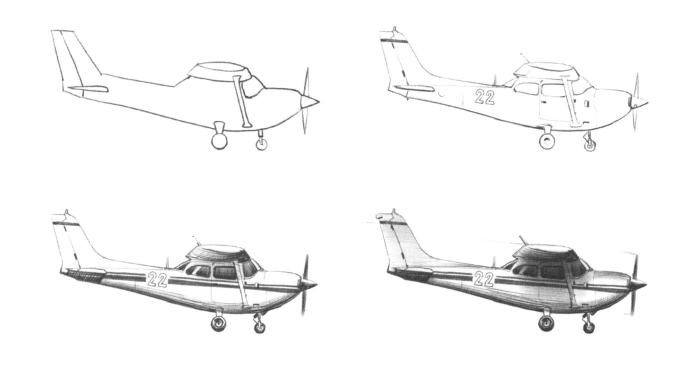

HELICOPTER

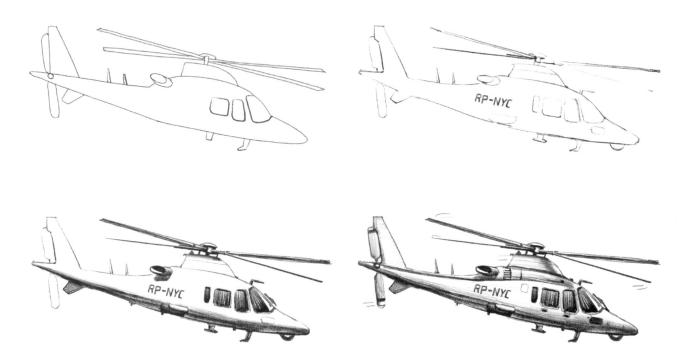

PASSENGER JET

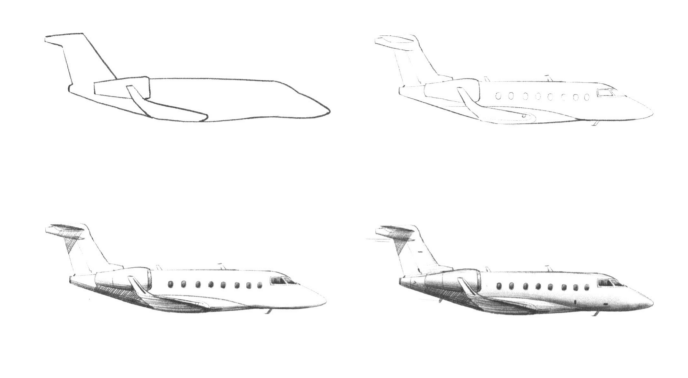

ROCKET

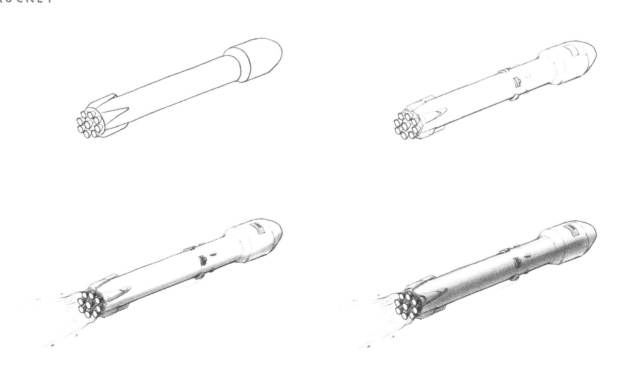

SPACESHIP

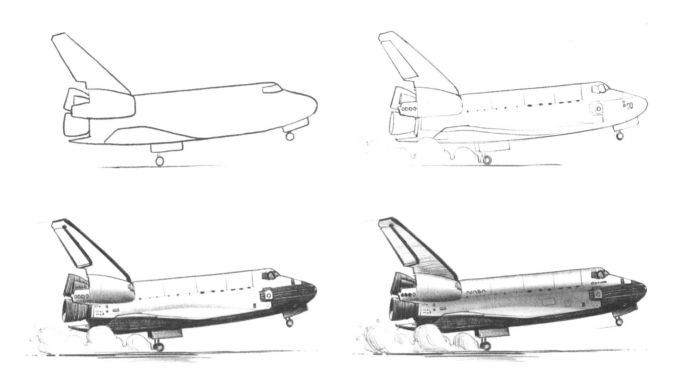

ZEPPELIN

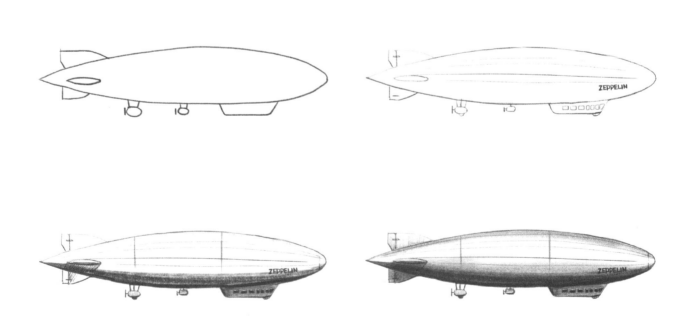

ALL-TERRAIN VEHICLE

CAMPER VAN

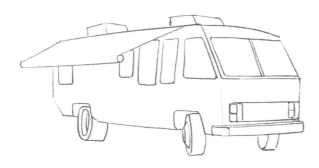

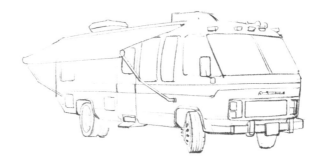

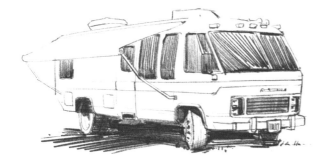

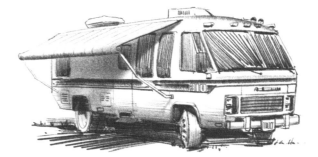

CARAVAN

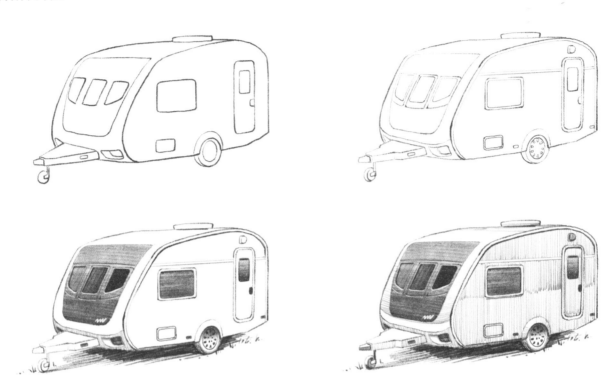

ELECTRIC CAR

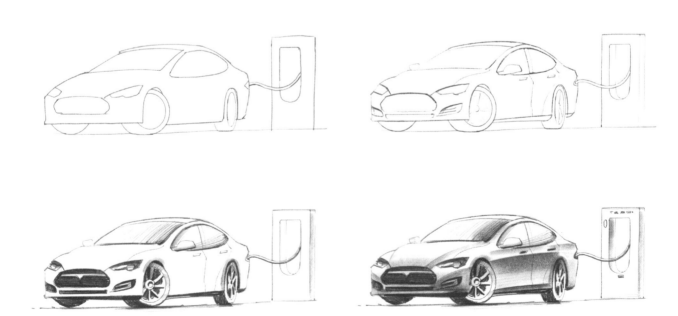

GOLF CART

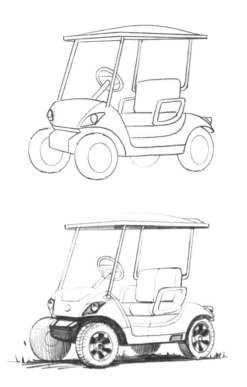
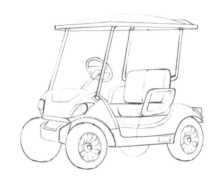
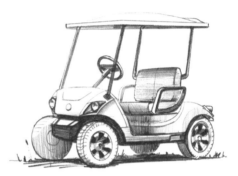

HATCHBACK

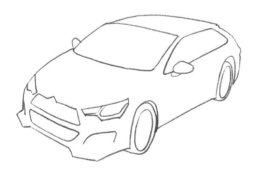
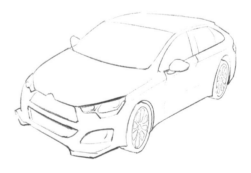
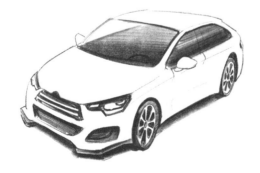

LORRY

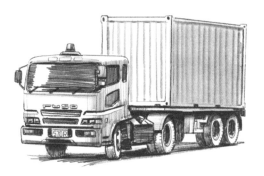

MINIBUS

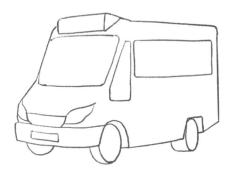
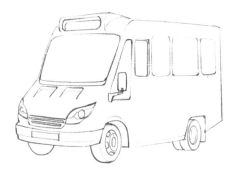
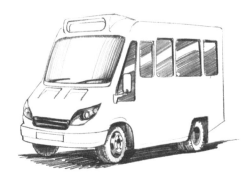
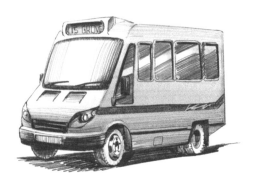

MONSTER TRUCK

MOON BUGGY

MOTORBIKE

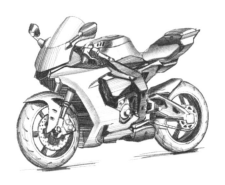

MOTORBIKE AND SIDECAR

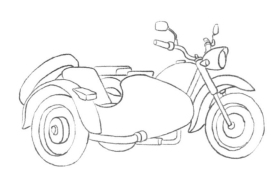
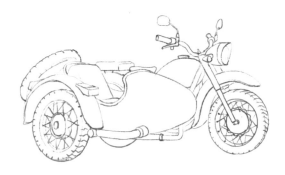
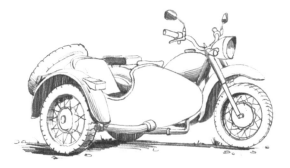
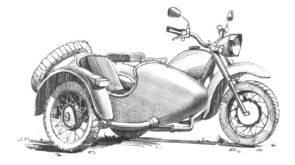

OIL TANKER

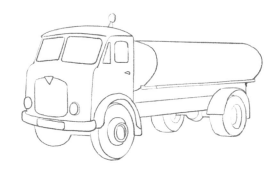
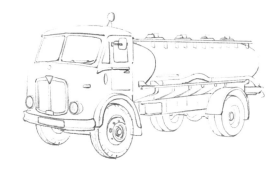

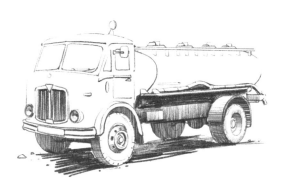
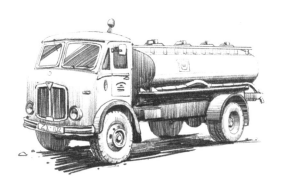

OLD-FASHIONED CAR

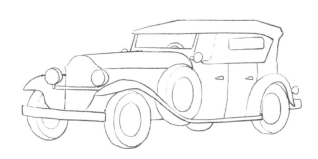
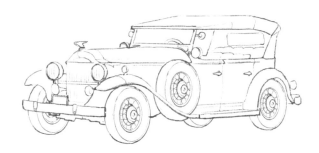

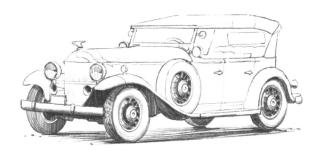

QUAD BIKE

RACING CAR

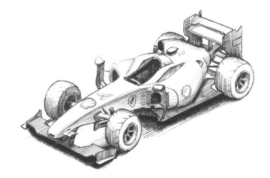

SUPERCAR

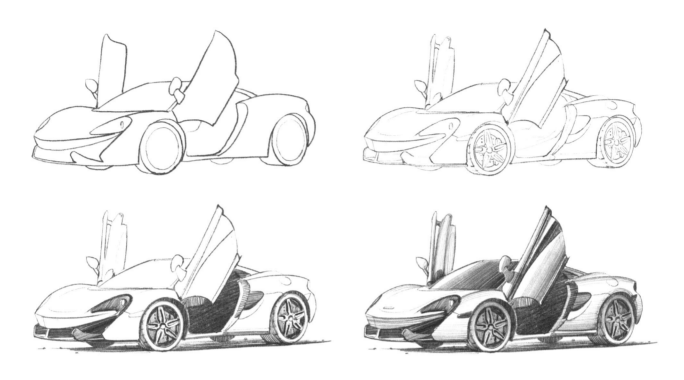

TRANSPORTER LORRY

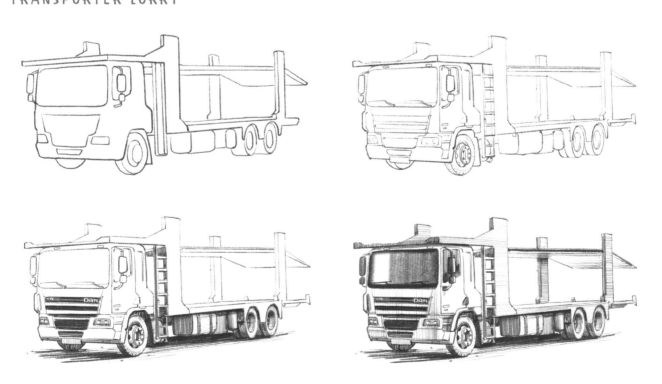

TRUCK

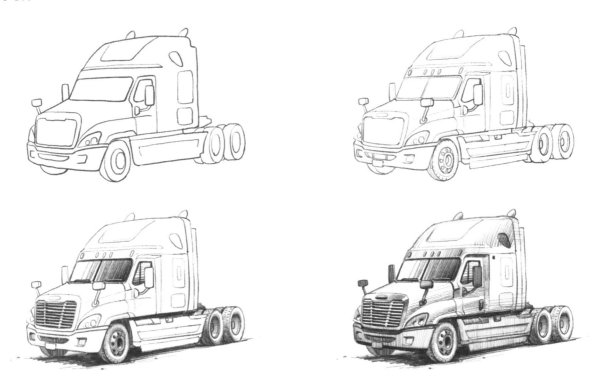

VAN

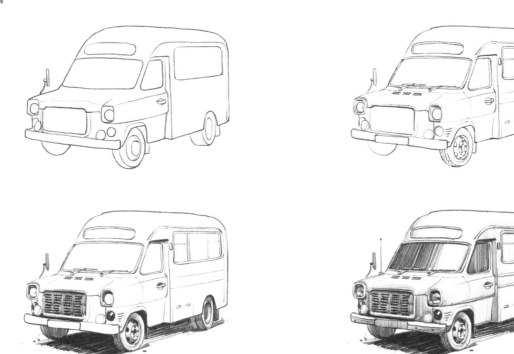

ARMORED CAR

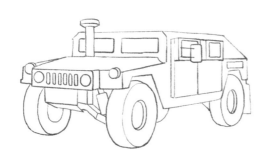

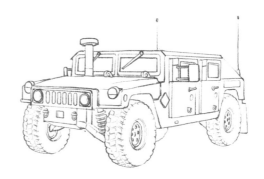

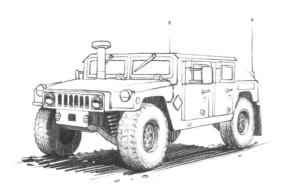

DROP SHIP

FIGHTER JET

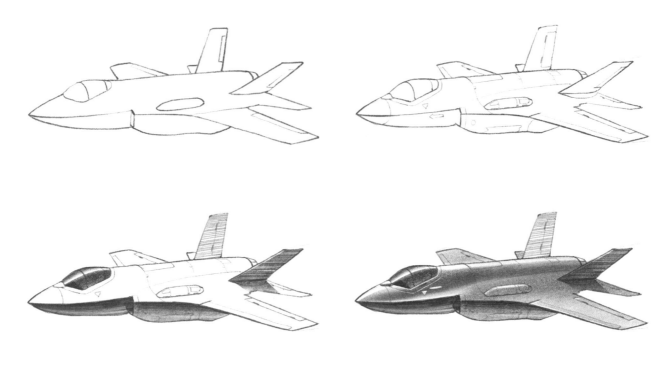

TANK

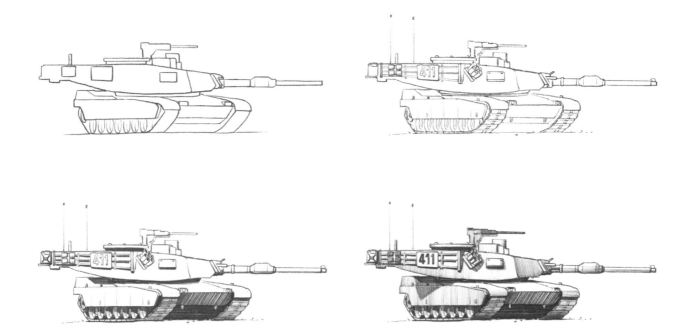

AMBULANCE

CEMENT MIXER LORRY

DIGGER

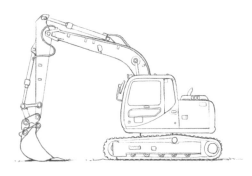
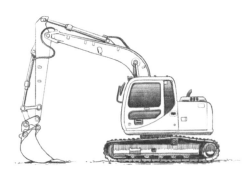
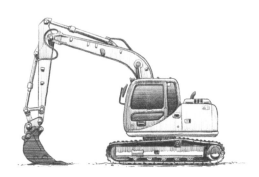

FIRE ENGINE

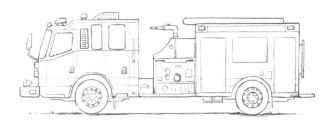
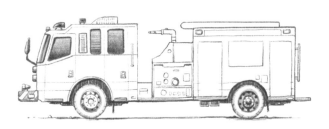
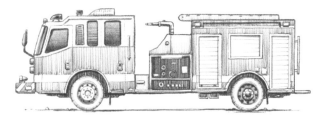

ICE CREAM TRUCK

MILK FLOAT

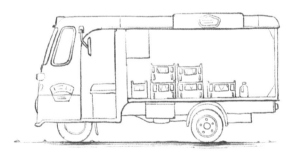

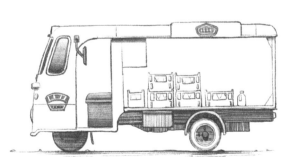
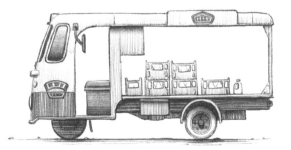

POLICE CAR

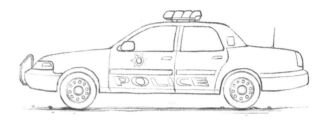

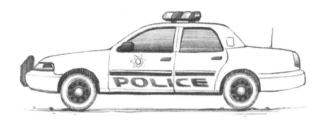
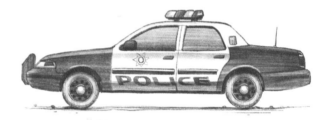

PRISON VAN

STEAM ROLLER

 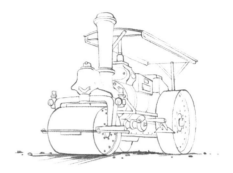

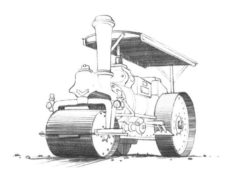 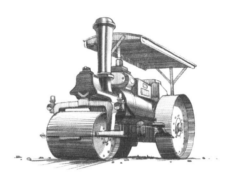

TRACTOR

BUS

DOUBLE-DECKER BUS

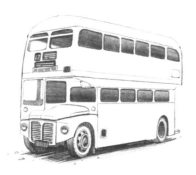 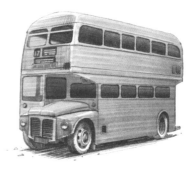

LONDON TAXI

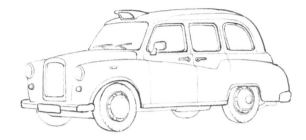
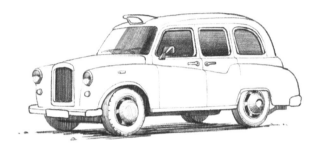
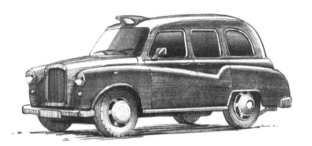

STEAM TRAIN

TAXI CAB

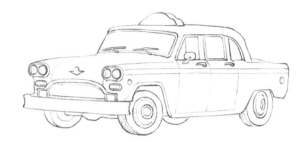
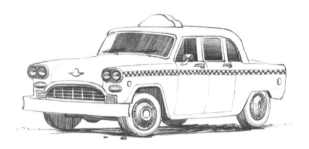
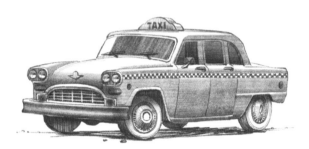

TRAIN (AGED)

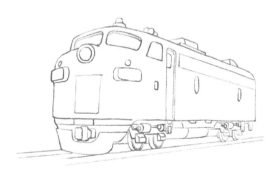
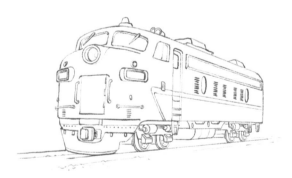
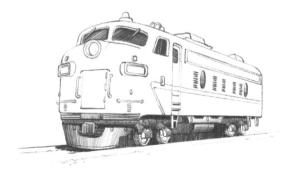
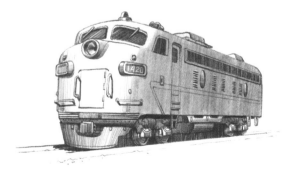

TRAIN (MODERN)

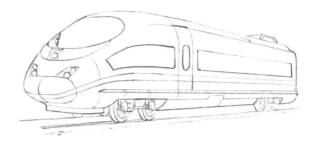

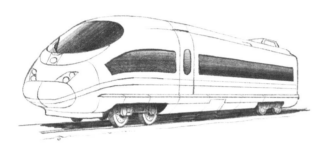
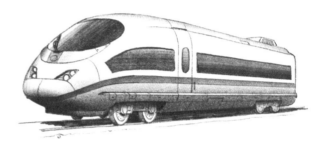

TRAM

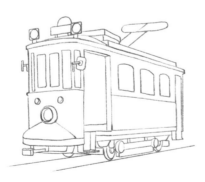
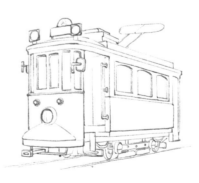

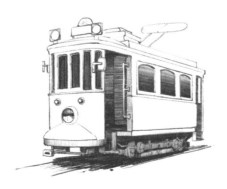
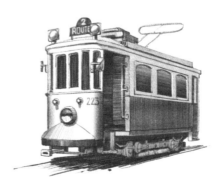

ARCTIC SLEDGE

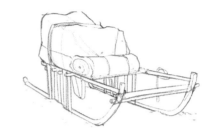

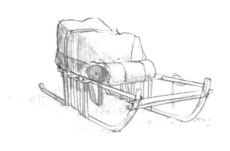

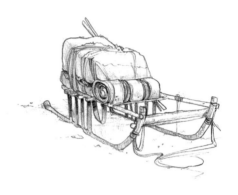

BABY CARRIAGE (MODERN)

BABY CARRIAGE (OLD)

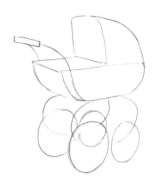 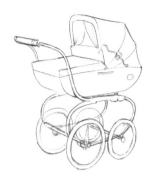

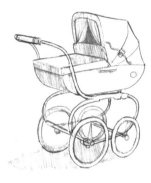 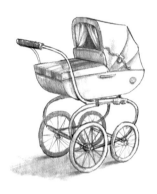

BICYCLE

CARRIAGE

CHILDREN'S BICYCLE

CHILDREN'S TRICYCLE

GO CART

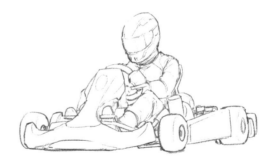
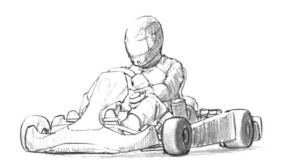
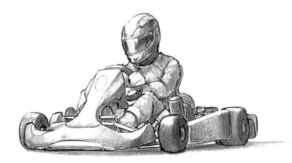

PENNY-FARTHING

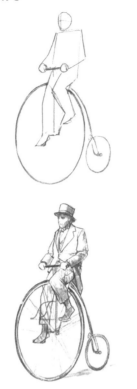

RACING BICYCLE

ROLLER SKATES

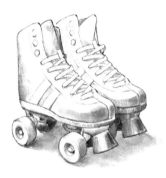

ROLLERBLADES

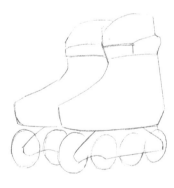

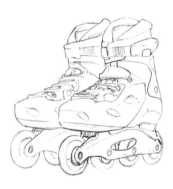

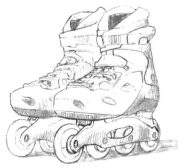

ROMAN CHARIOT

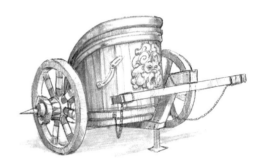

SCOOTER

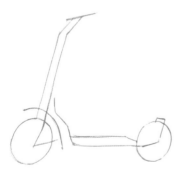
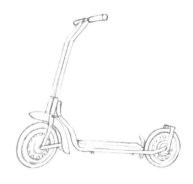
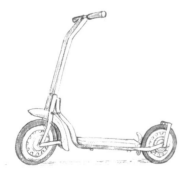
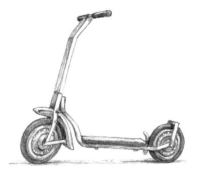

SKATEBOARD

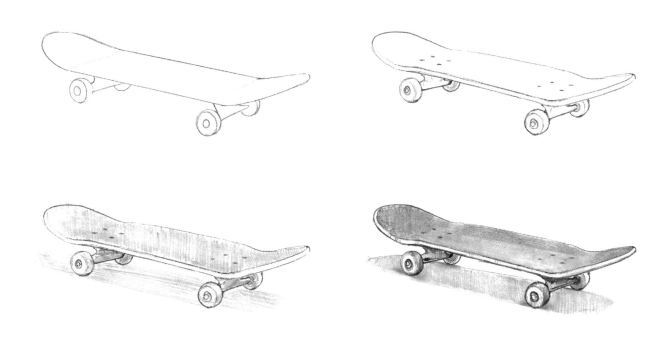

SOAPBOX RALLY CAR

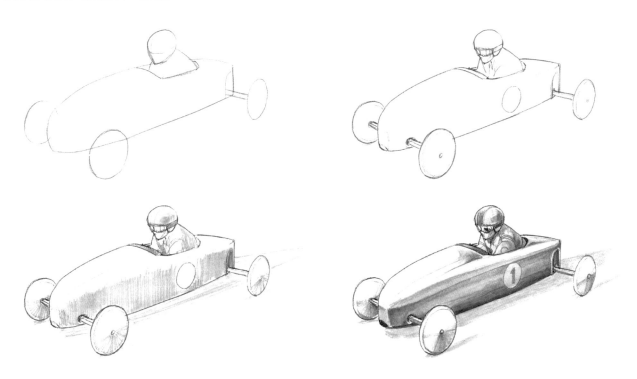

TUK TUK

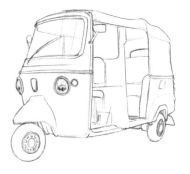

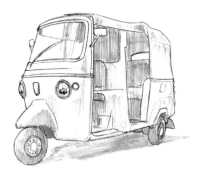

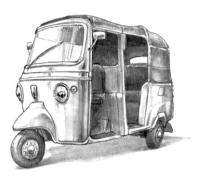

TWIN STROLLER

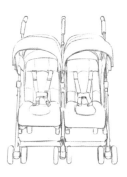

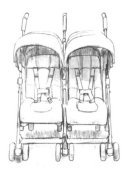

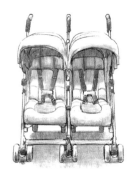

UNICYCLE

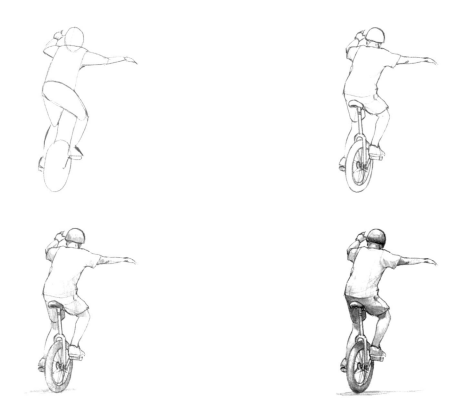

YAK-PULLED CART

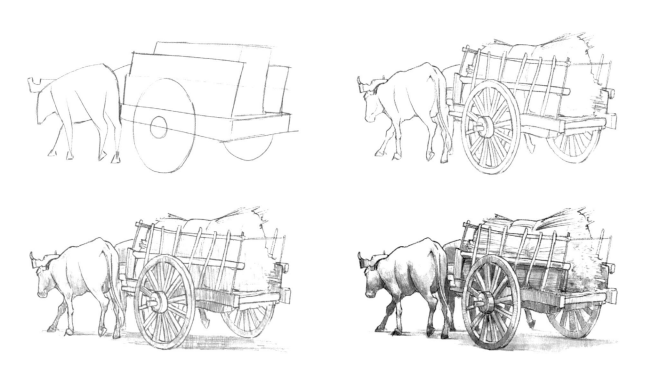

BARGE

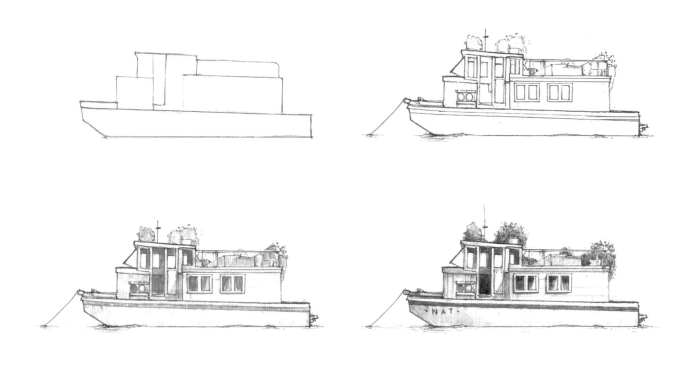

CANAL BOAT

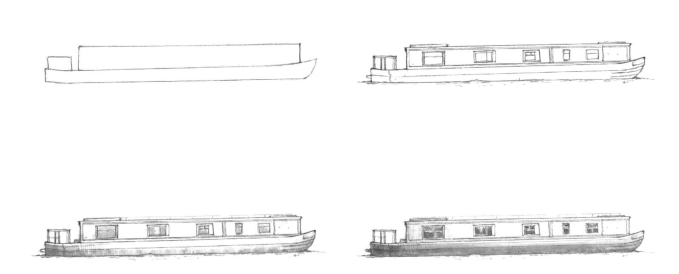

CORACLE

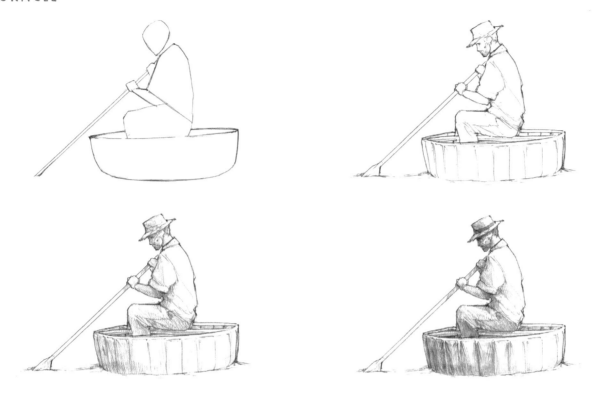

CRUISE LINER

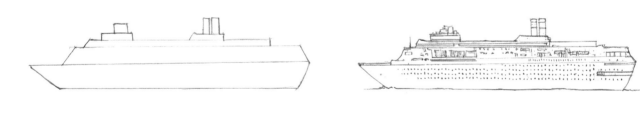

DINGHY

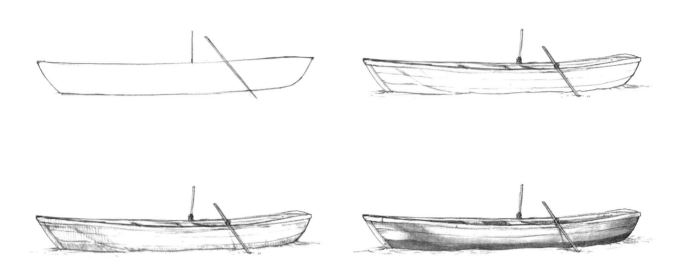

FERRY

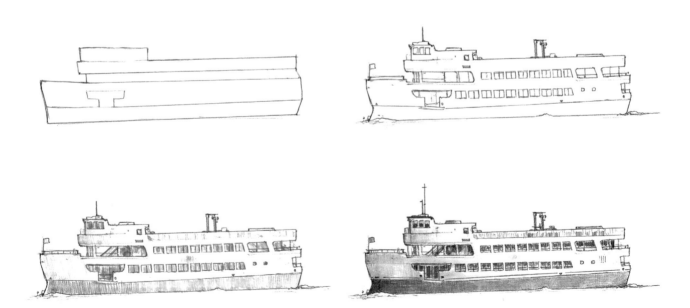

JET SKI

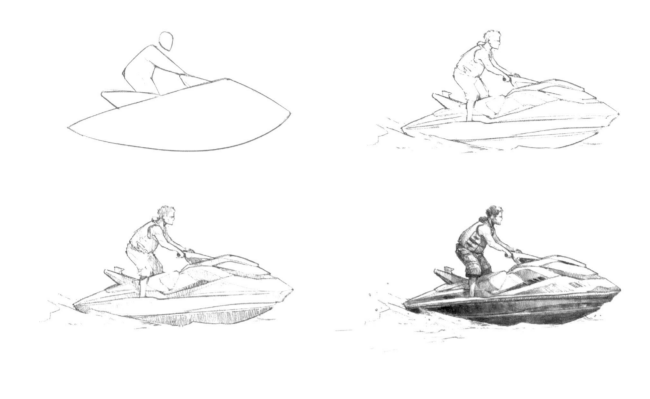

LUXURY YACHT

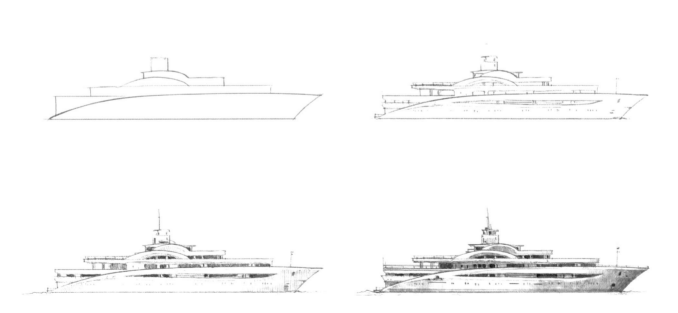

PADDLEBOAT

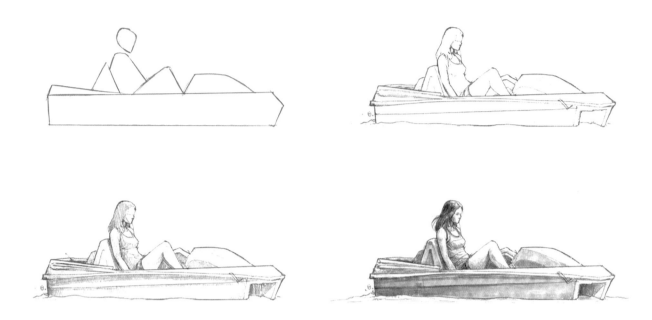

ROWING BOAT

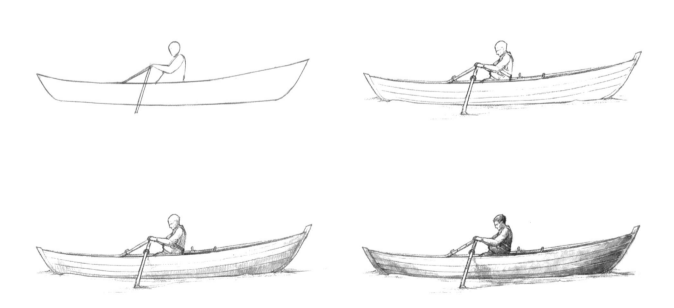

RUSTIC TRADING SHIP

SAILING BOAT

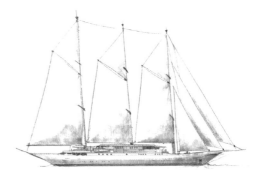

SPEED BOAT

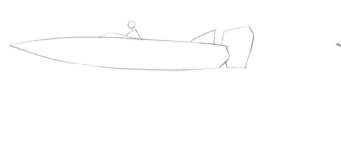
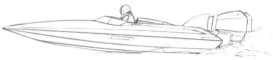
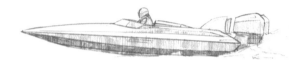
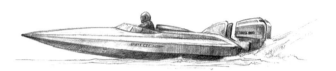

VENETIAN GONDOLA

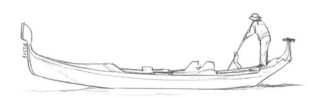
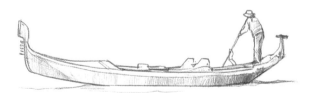
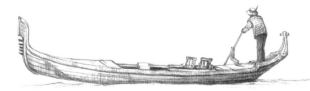

VIKING LONGSHIP

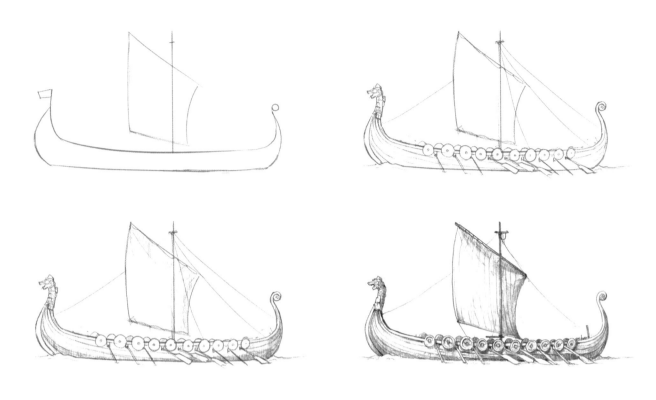

WOODEN RAFT

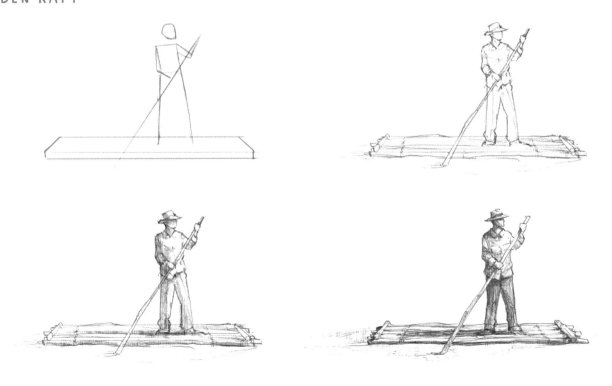

HOBBIES

······································

Most hobby activities, and especially musical and sporting activities, require a prop or item of equipment. The subjects included in this chapter are particularly useful for providing your characters and environment scenes with context. As still life subjects with a great range of shapes and textures, these objects also offer the perfect opportunity to practice any area of sketching that you are struggling with.

IN THIS CHAPTER

································

MUSICAL INSTRUMENTS

SPORTS EQUIPMENT

ACOUSTIC GUITAR

AFRICAN DRUM

BAGPIPES

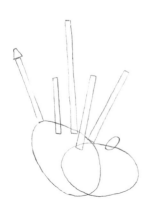 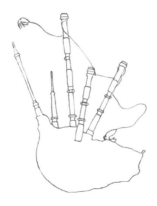 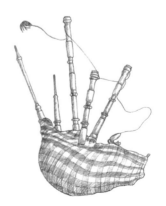 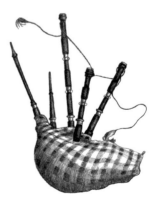

CELLO

ELECTRIC GUITAR

HARP

RECORDER

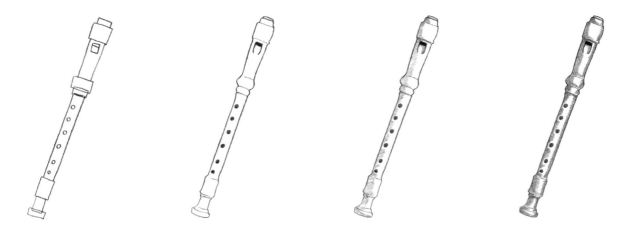

SAXOPHONE

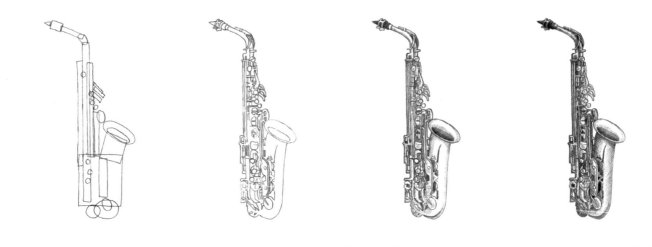

SITAR

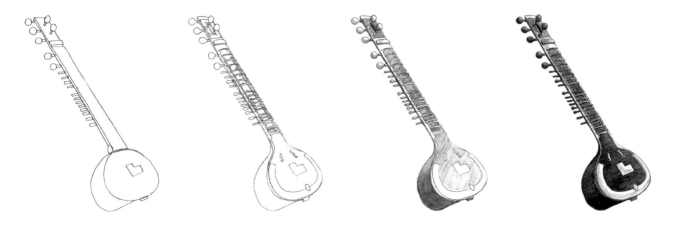

TAMBOURINE

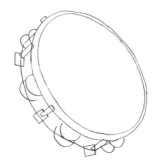

UKULELE

 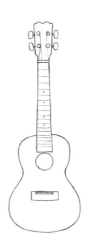 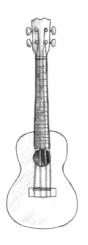 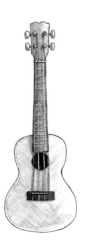

VIOLIN

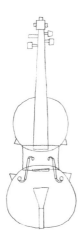

ACCORDION

DRUM SET

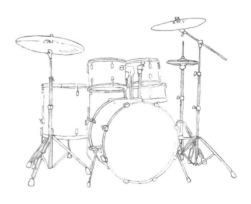
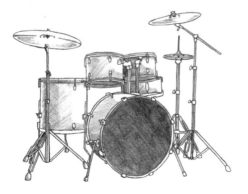
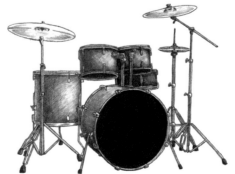

FLUTE

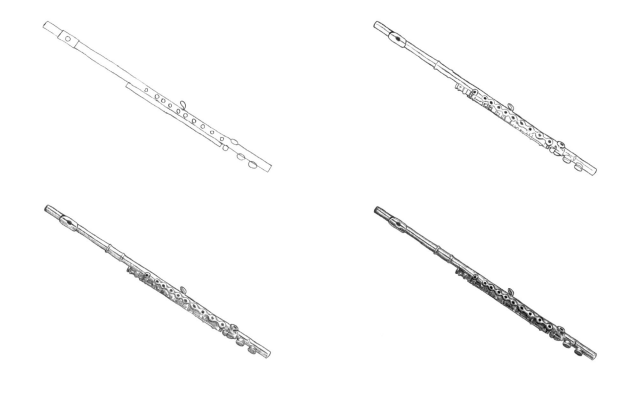

FRENCH HORN

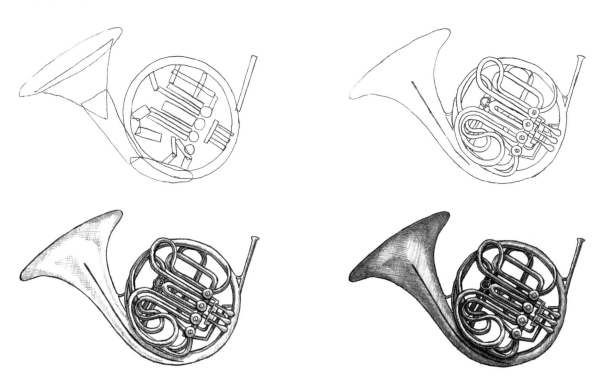

PIANO (GRAND)

PIANO (UPRIGHT)

 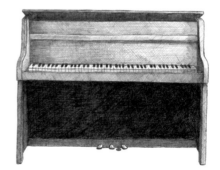

TRUMPET

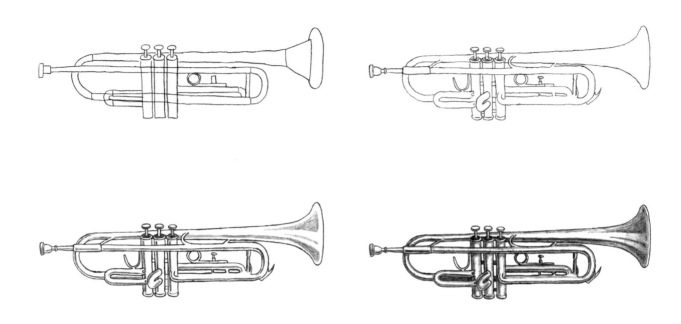

XYLOPHONE

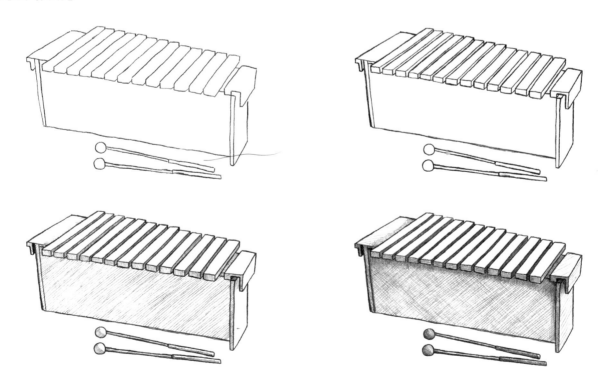

BADMINTON SET

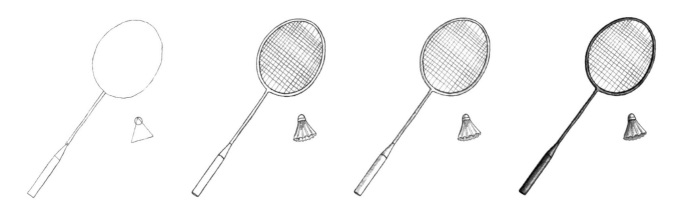

BALLET PUMPS

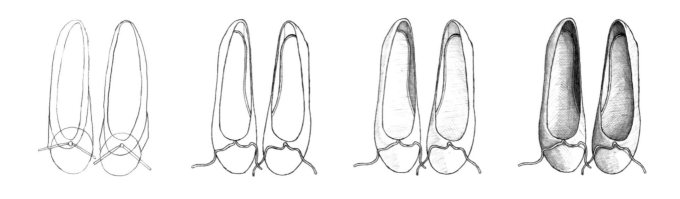

BASEBALL AND BAT

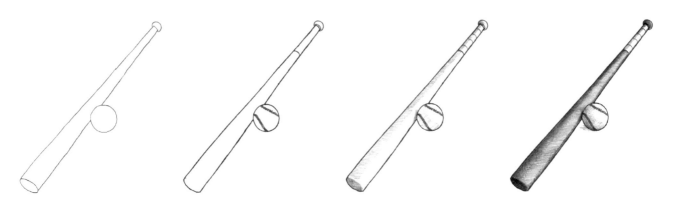

BASEBALL GLOVE

BASEBALL HELMET

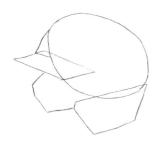 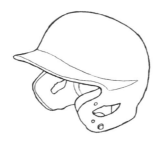

BASKETBALL

BASKETBALL HOOP

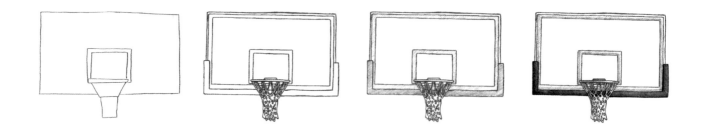

CRICKET BALL AND BAT

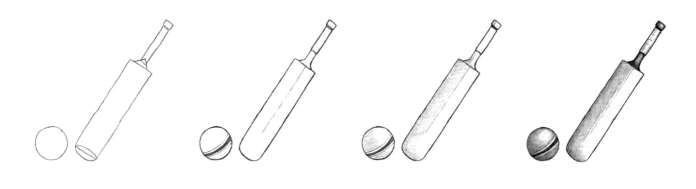

CRICKET WICKETS

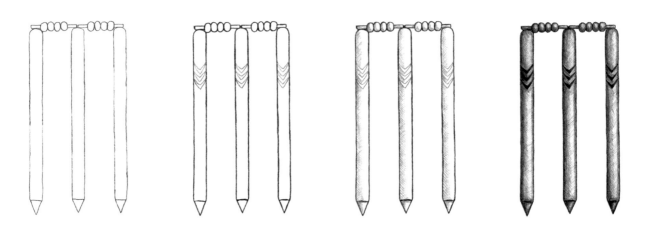

DARTS AND DARTBOARD

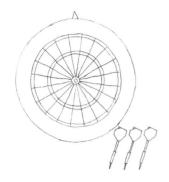 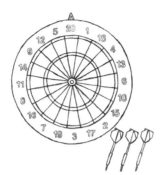 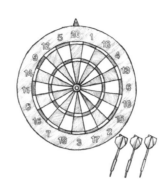

DISCUS

GOLF BAG

GOLF STICK AND BALL

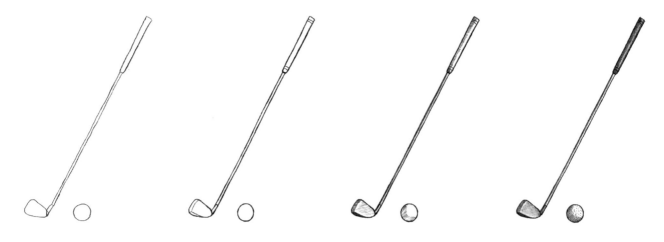

HOCKEY STICK AND BALL

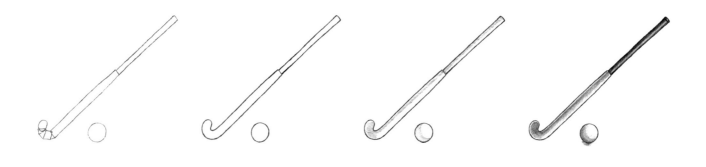

ICE HOCKEY STICK AND PUCK

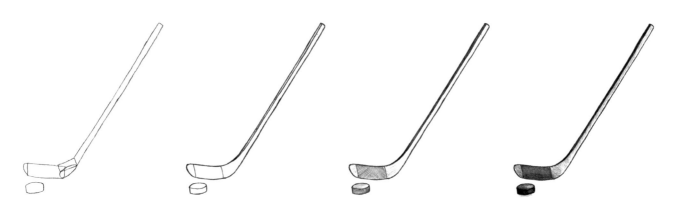

JAVELIN

MEDAL

ROSETTE

SHOT PUT HAMMER

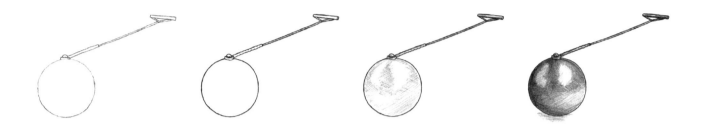

SOCCER BALL

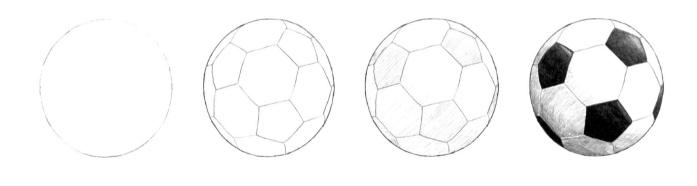

TABLE-TENNIS PADDLE AND BALL

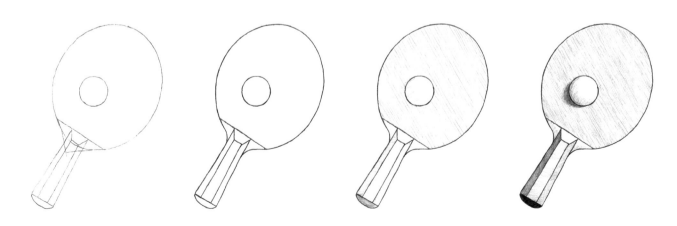

TENNIS RACKET AND BALL

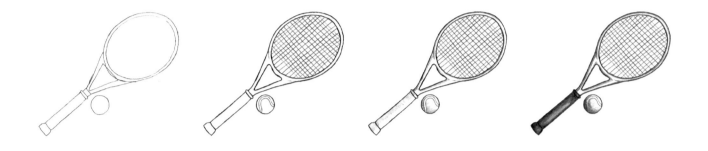

TROPHY (LARGE)

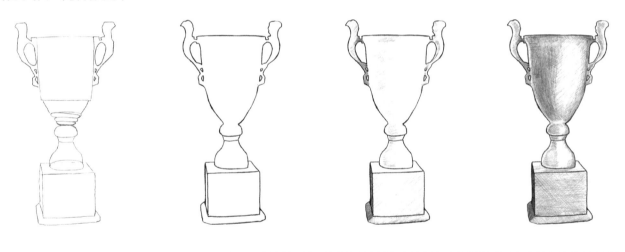

TROPHY (SMALL)

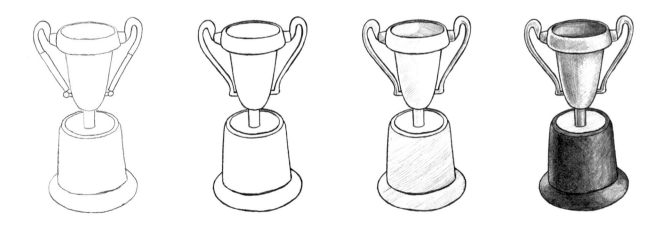

BARBELL

BOWLING PINS AND BALL

CROSS TRAINER

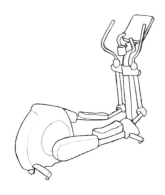

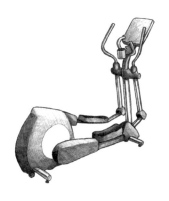

DUMBBELL WEIGHT

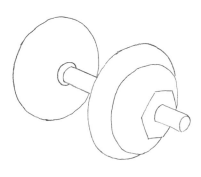

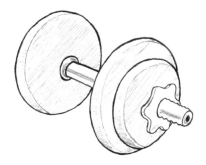

EXERCISE BIKE

FOOTBALL BOOT

RUGBY BALL

RUNNING SHOES

SNOOKER TABLE

SWIMMING GOGGLES AND ARM BANDS

TRAMPOLINE

TREADMILL

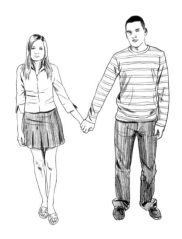

PEOPLE

People and characters are often the main focus of an image, but they are notoriously difficult to capture successfully. For very rough work you can practice capturing human movements by sketching in public and observing through life. For more detailed sketches however, pay close attention to the type of person you are drawings, their pose, facial expression, and their clothing materials.

IN THIS CHAPTER

..

ABSEILING

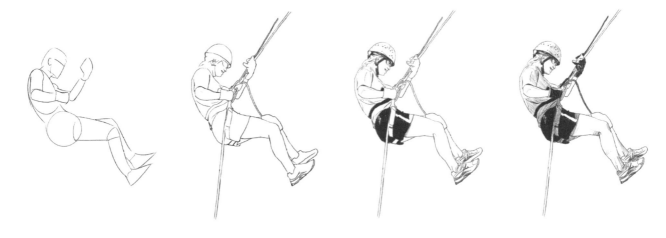

BALLROOM DANCING

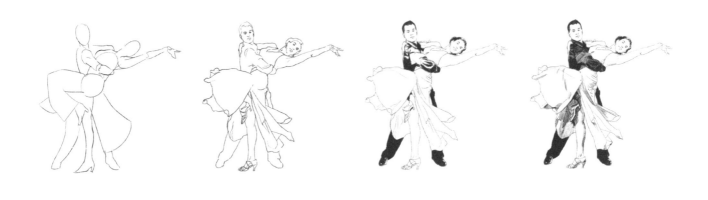

CRYING (BABY)

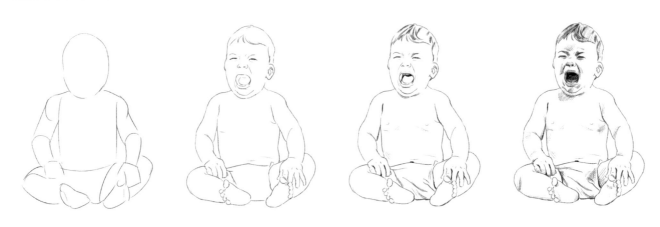

DRINKING

EATING

FIGHTING

FIST RAISED

HOLDING HANDS

HUGGING

JUGGLING

JUMPING (ADULT)

JUMPING (CHILD)

KICKING

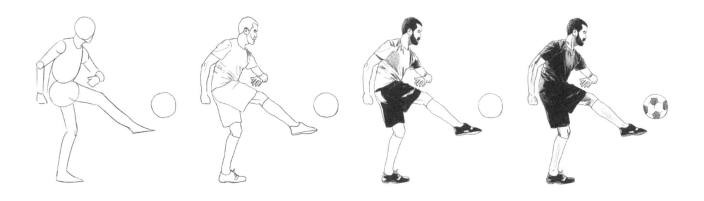

KISSING

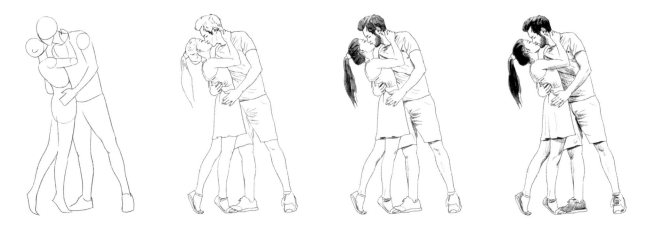

PRAYING

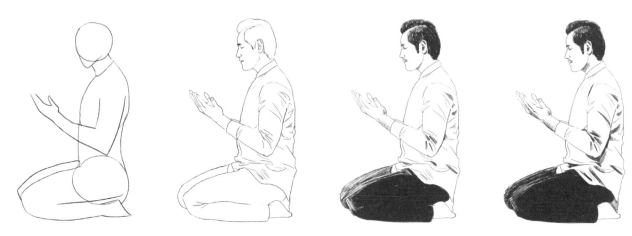

ROCK CLIMBING

ROLLER-SKATING

 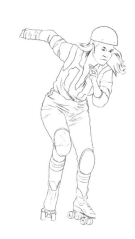 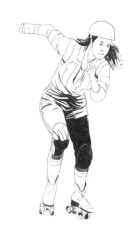 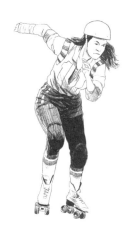

RUNNING (CHILD)

RUNNING (MAN)

RUNNING (WOMAN)

 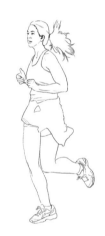 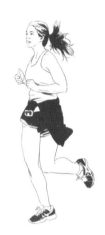 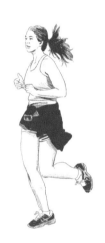

SINGING

SITTING

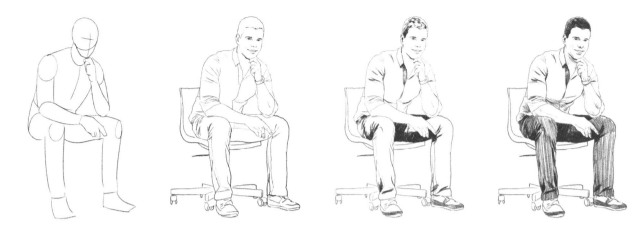

SKATEBOARDING

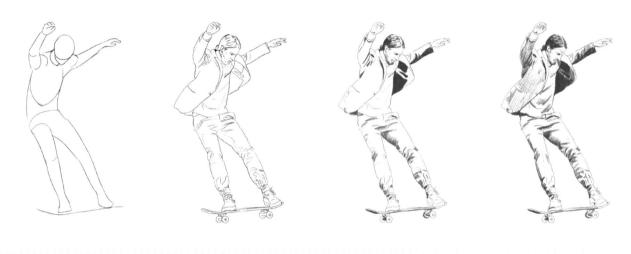

SKIING

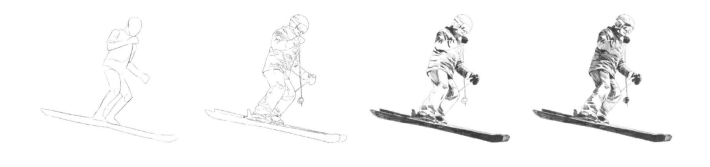

SKIPPING

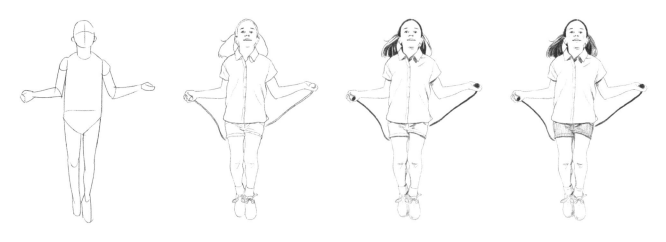

SNORKELING

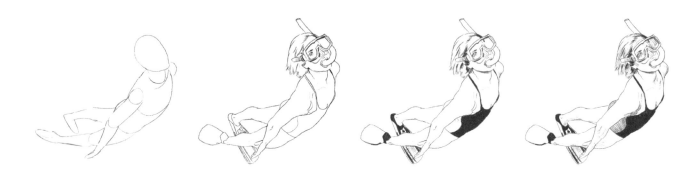

SNOWBOARDING

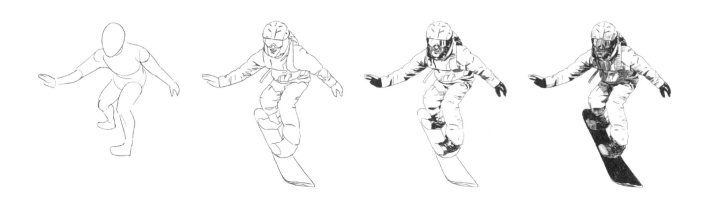

STUMBLING

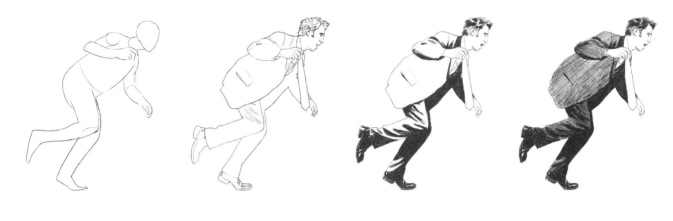

SURFING

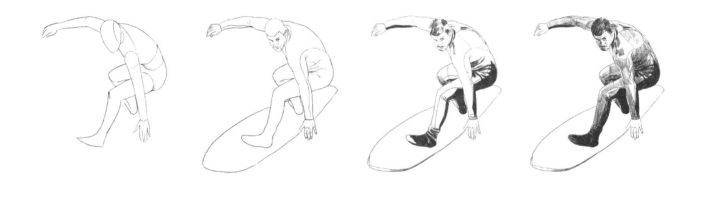

THROWING

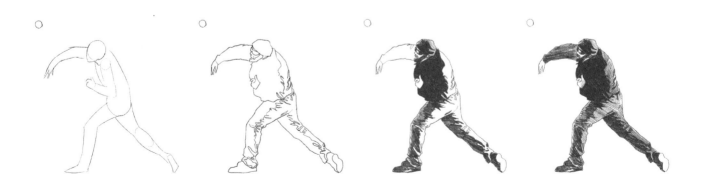

TODDLING (CHILD)

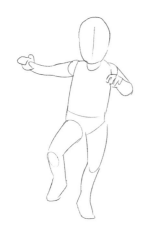 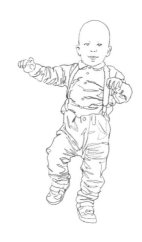 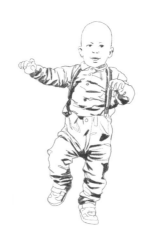 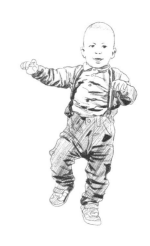

WAVING

ZIP WIRE RIDING

CRAWLING (BABY)

HIGH-KICKING

RIDING BICYCLE (MAN)

RIDING BICYCLE (WOMAN)

ROWING

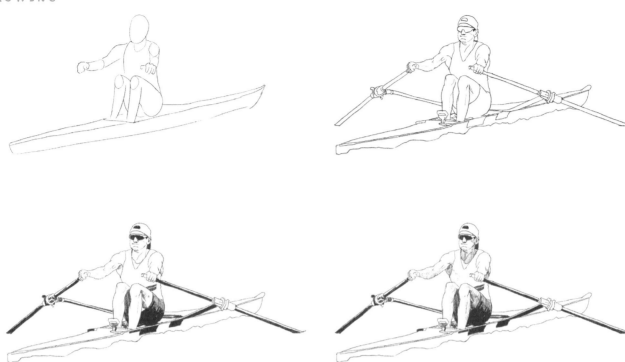

SKYDIVING

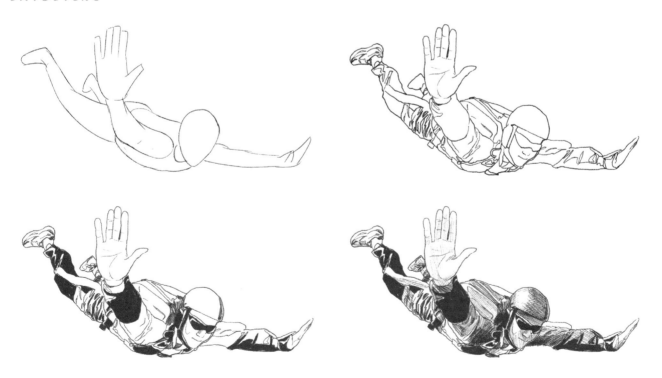

SLEEPING (BABY)

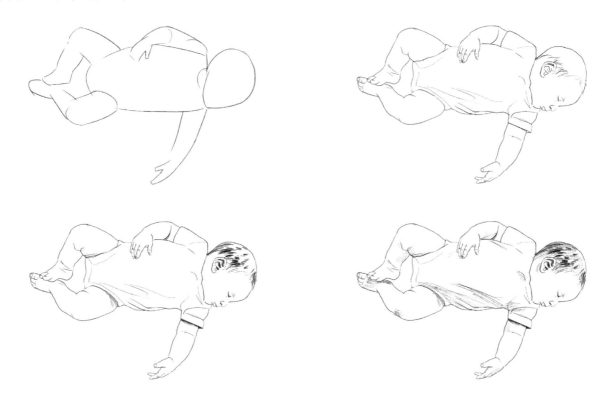

SWIMMING

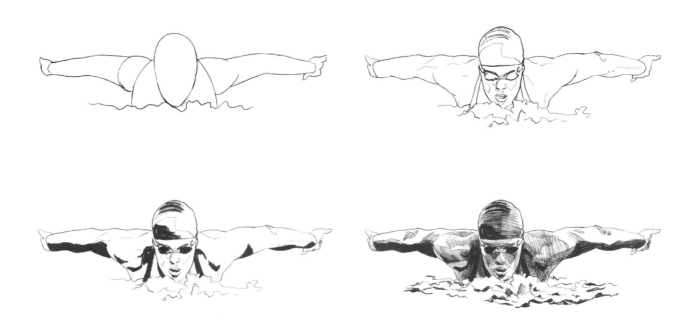

ADULT MAN

ADULT WOMAN

BABY

 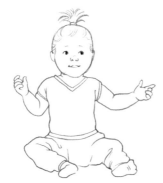 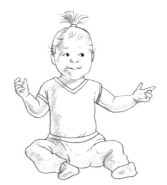 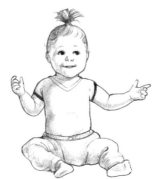

OLD MAN

OLD WOMAN

TEENAGER

WHEELCHAIR USER

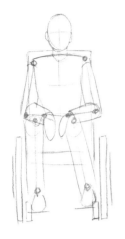 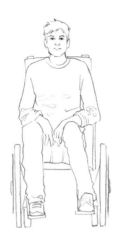 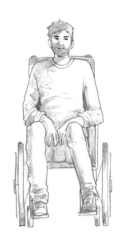 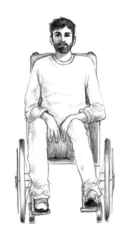

YOUNG BOY

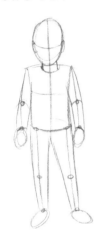 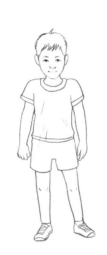 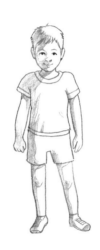 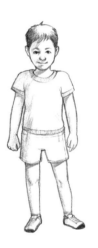

YOUNG GIRL

ANGRY

BOOING

CHEERING

CRYING

LAUGHING (BOY)

LAUGHING (GIRL)

LAUGHING (ADULT)

PLAYFUL

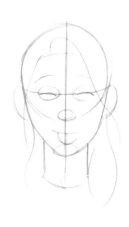 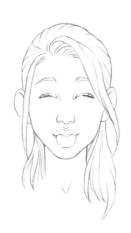 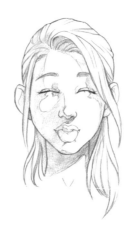 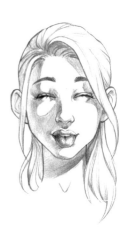

SCOWLING (TEENAGER)

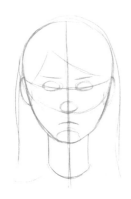 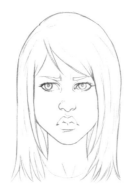 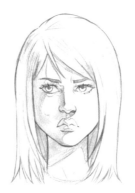 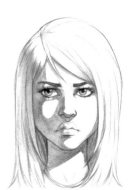

SHOUTING

SILLY FACE (BOY)

SILLY FACE (GIRL)

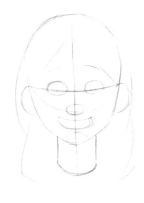 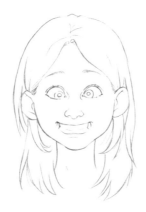 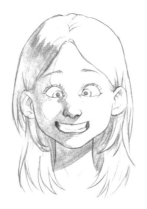 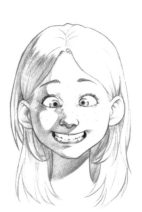

GRECIAN EMPEROR

GRECIAN EMPRESS

KING

KNIGHT

 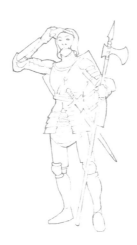 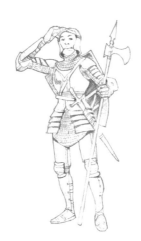 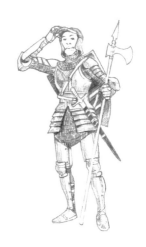

QUEEN

ROCOCO STYLE (MAN)

ROCOCO STYLE (WOMAN)

ROMAN CENTURION

VIKING

 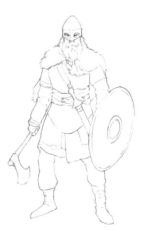 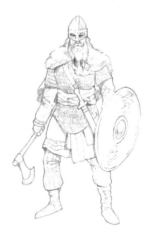 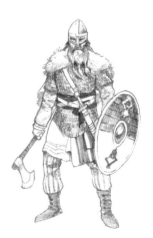

AMERICAN FOOTBALL PLAYER

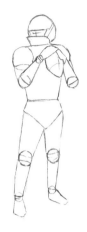 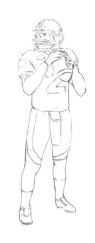 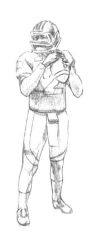 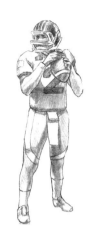

ARTIST

ASTRONAUT

BALLET DANCER

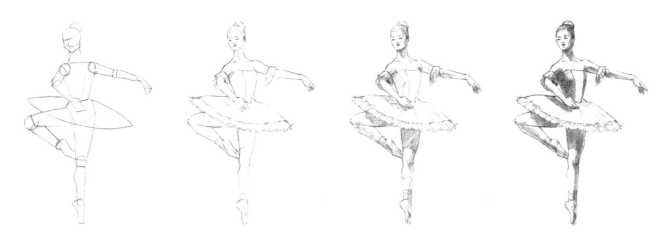

BASEBALL PLAYER

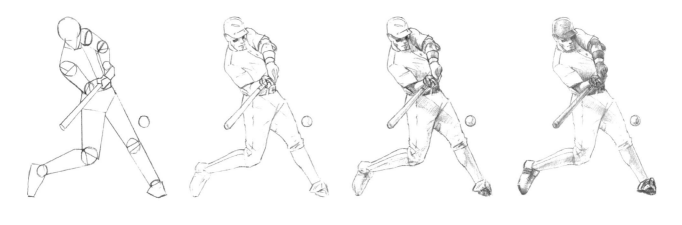

BASKETBALL PLAYER

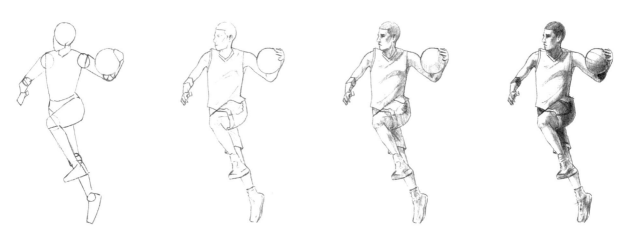

BOLLYWOOD DANCER

BUILDER

BUTCHER

347

CANADIAN MOUNTY

CHEF

CHIMNEY SWEEP

 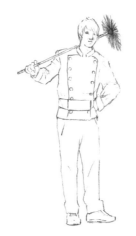 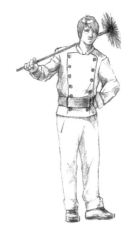 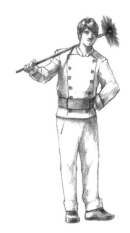

CLOWN

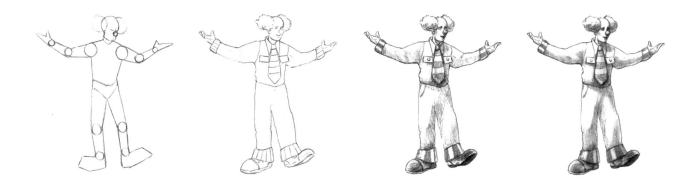

CRICKETER

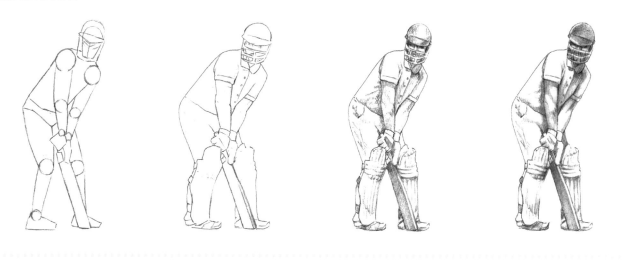

CROSSING GUARD

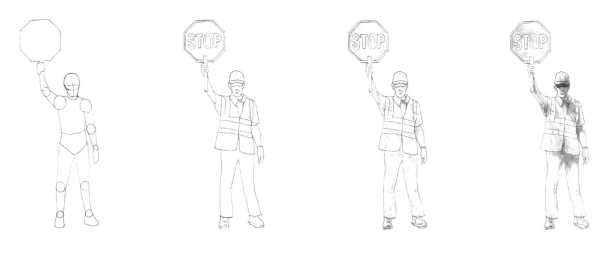

DEEP SEA DIVER

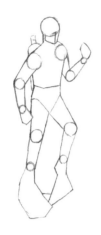 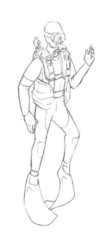

DELIVERY PERSON

DOCTOR

EXPLORER

FARMER

 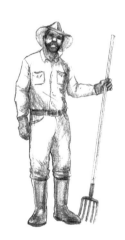 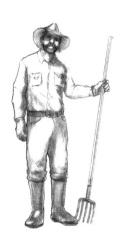

FENCER

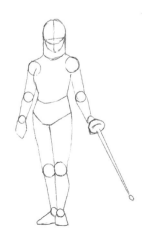 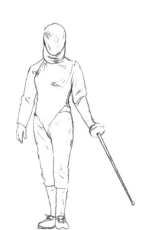

FIGURE SKATER

FIREFIGHTER

 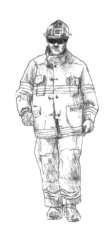 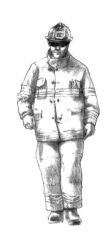

FLAMENCO DANCER

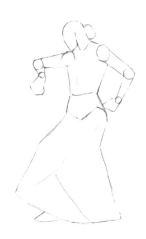 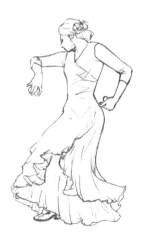

FLOWER SELLER

GOLFER

HORSE RIDER

HUNTER

HUNTRESS

 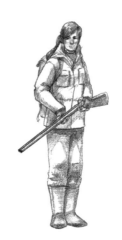 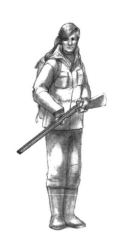

IRISH DANCER

 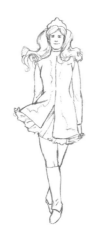 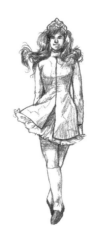 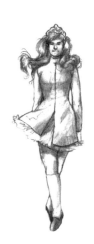

JESTER

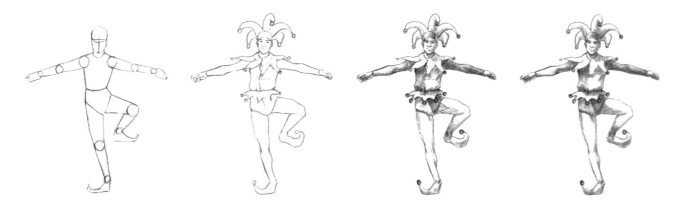

LIFEGUARD

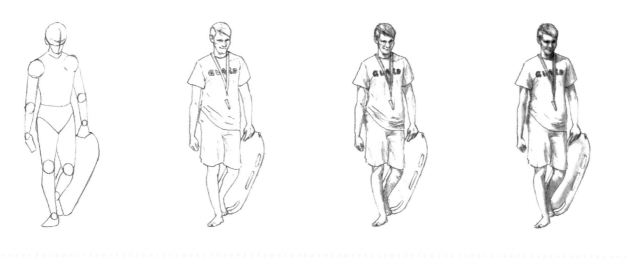

MAILMAN

MATADOR

MILITARY PERSONNEL (CAMOUFLAGE)

MILITARY PERSONNEL (UNIFORM)

MIME

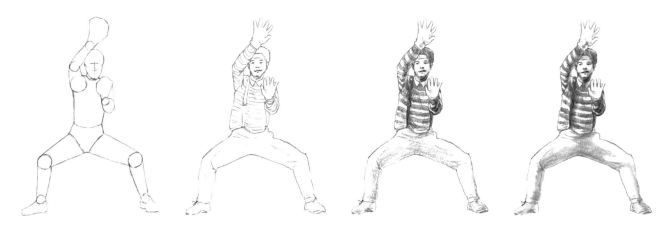

MINER

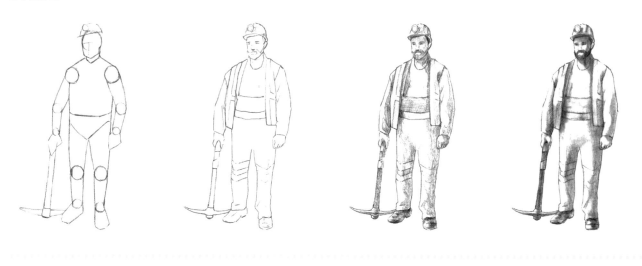

NINJA

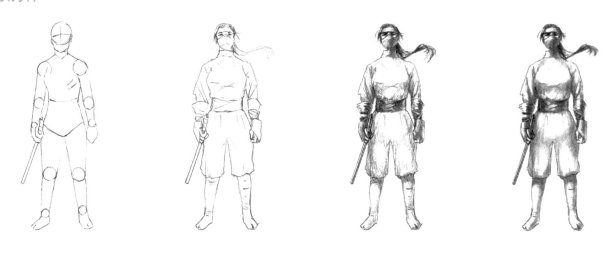

NURSE

OPERA SINGER

PAPER GIRL

PHOTOGRAPHER

POLICE OFFICER

PUNK

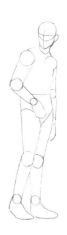

RACING CAR DRIVER

ROAD SWEEPER

ROAD WORKER

ROYAL GUARD (UK)

RUSSIAN GUARD

SCIENTIST

SHEPHERD

SPACEMAN

SPACEWOMAN

SUMO WRESTLER

SURGEON

TENNIS PLAYER

 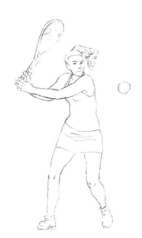 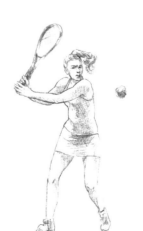 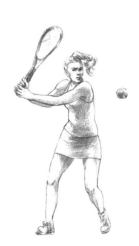

TRAIN DRIVER

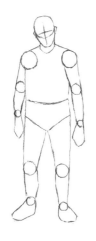

TRAPEZE ARTIST

WEIGHT LIFTER

BRIDAL GOWN

BUSINESS SUIT (MAN)

BUSINESS SUIT (WOMAN)

ESKIMO GARMENTS

 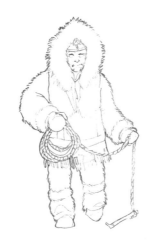 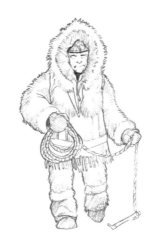 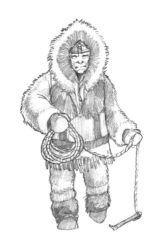

GEISHA DRESS

KASAYA ROBES

MONK'S HABIT

MORNING SUIT

NUN'S HABIT

RASTAFARI STYLE

SARI

SCOTTISH KILT

 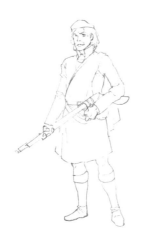 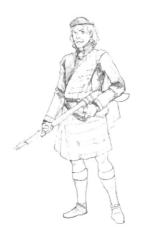 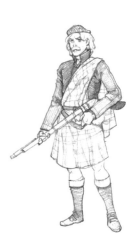

SHALWAR KAMEEZ

SIKH CEREMONIAL ATTIRE

 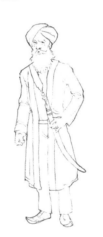 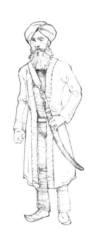 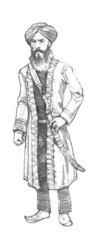

TRADITIONAL AFRICAN DRESS

 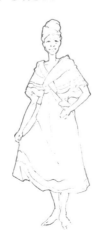 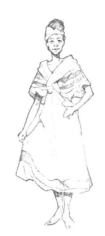 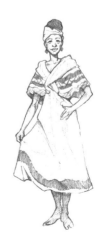

BUILDINGS AND STRUCTURES

Often used in urban sketching and landscape drawing, buildings and structures provide a fantastic opportunity to explore perspective and scale in your sketches. These structures can be made from a variety of organic and human-made materials which also allow for experimentation with different textures and light effects. In this chapter there are buildings and structures from many different countries and eras for you to explore sketching different locations and settings.

IN THIS CHAPTER

·······························

FAMOUS LANDMARKS

HOMES

PUBLIC BUILDINGS

RURAL BUILDINGS

URBAN FEATURES

CHRIST THE REDEEMER, RIO DE JANEIRO, BRAZIL

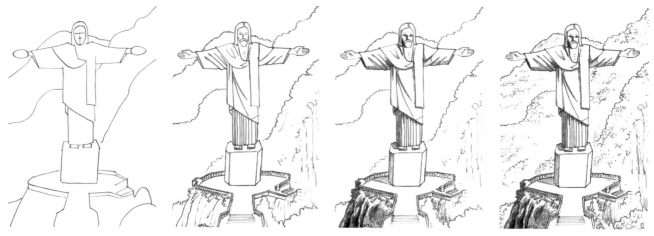

EASTER ISLAND HEAD, CHILE

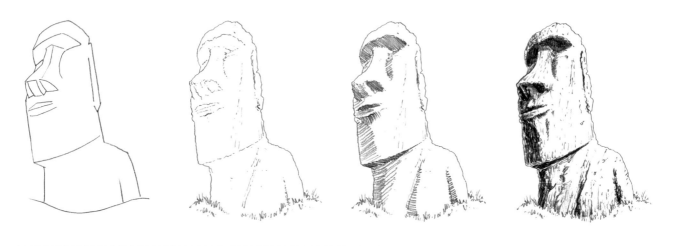

EIFFEL TOWER, PARIS, FRANCE

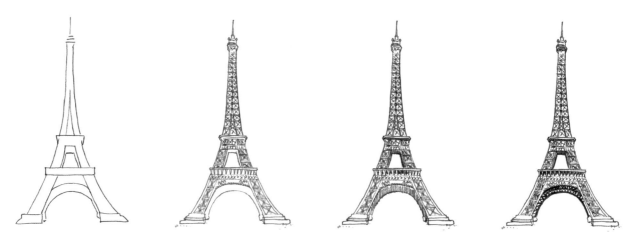

EMPIRE STATE BUILDING, NEW YORK, USA

GOLDEN GATE BRIDGE, SAN FRANCISCO, USA

GREAT SPHINX OF GIZA, EGYPT

HOOVER DAM, NEVADA, USA

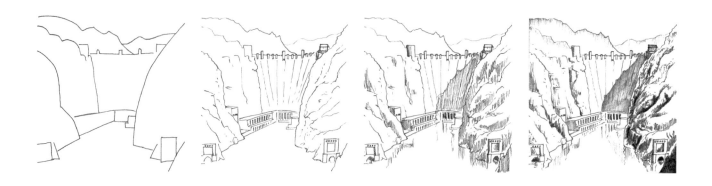

KELPIES SCULPTURE, FALKIRK, SCOTLAND

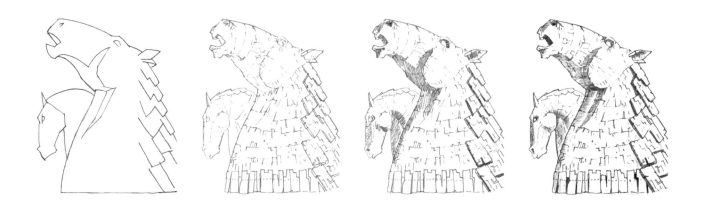

LEANING TOWER OF PISA, ITALY

PYRAMIDS, GIZA, EGYPT

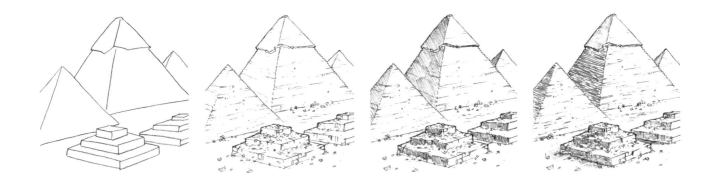

ST BASIL'S CATHEDRAL, MOSCOW, RUSSIA

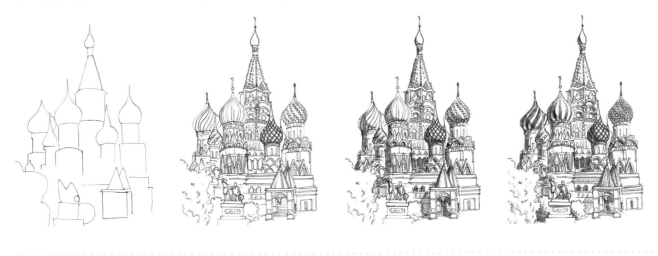

STATUE OF LIBERTY, NEW YORK, USA

TAJ MAHAL, AGRA, INDIA

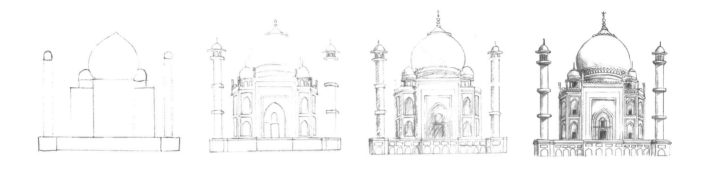

TOWER BRIDGE, LONDON, UK

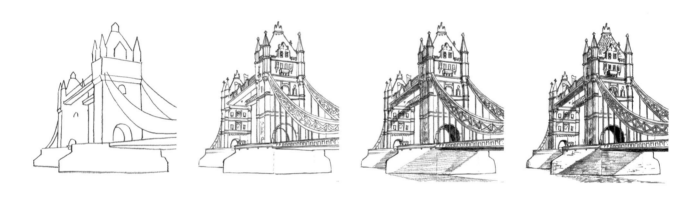

WELLINGTON ARCH, LONDON, UK

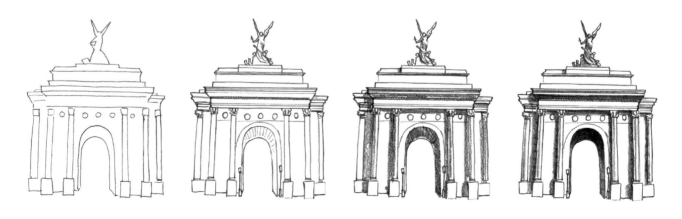

ANGKOR WAT, CAMBODIA

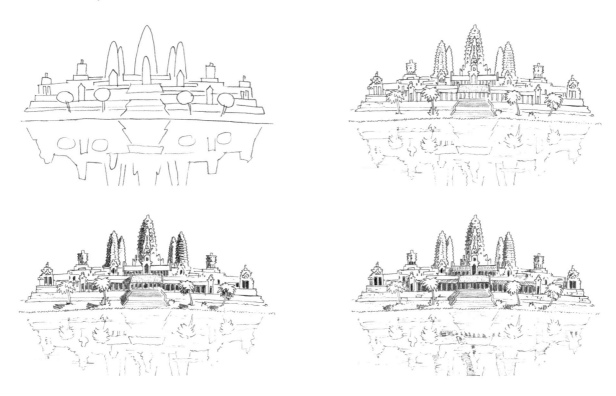

BABYLONIAN RUINS, IRAQ

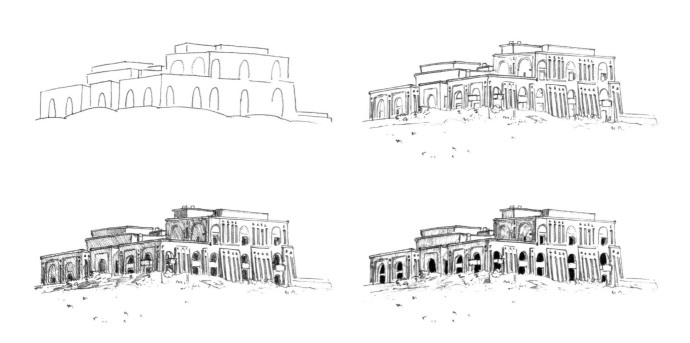

COLOSSEUM, ROME, ITALY

GRAND CENTRAL STATION, NEW YORK, USA

GREAT WALL OF CHINA

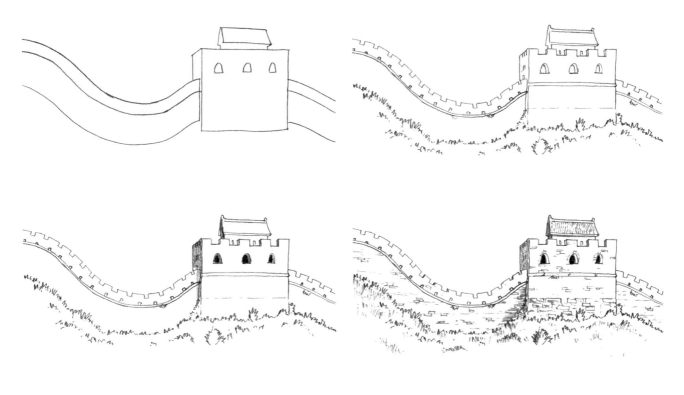

GUGGENHEIM MUSEUM, NEW YORK, USA

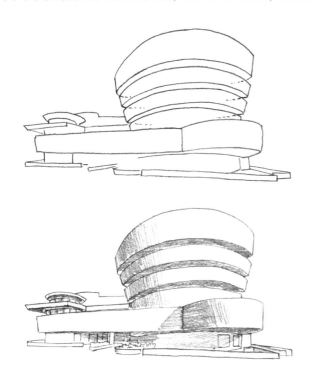 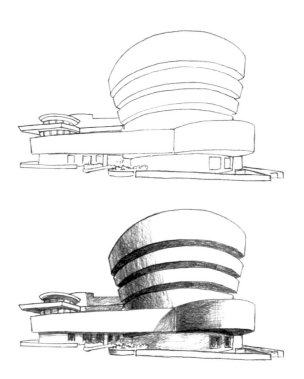

MOUNT RUSHMORE, SOUTH DAKOTA, USA

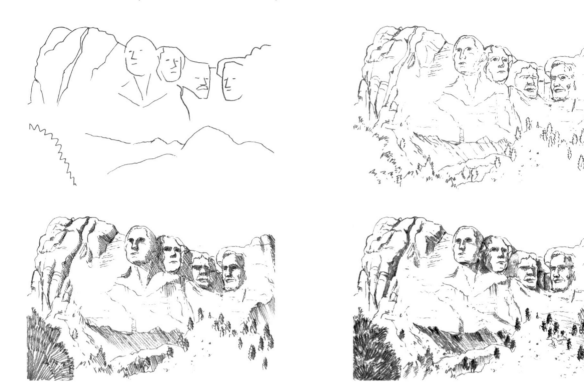

PARTHENON, ATHENS, GREECE

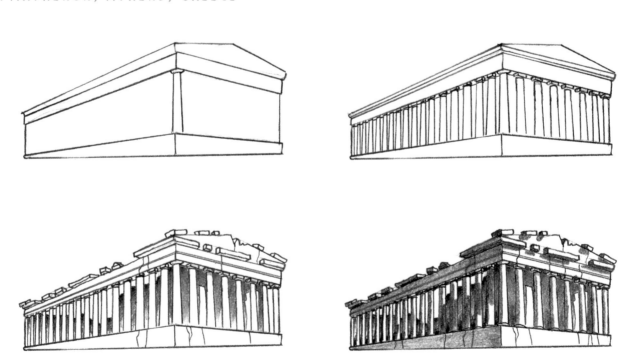

SKELLIG ISLAND BUILDINGS, IRELAND

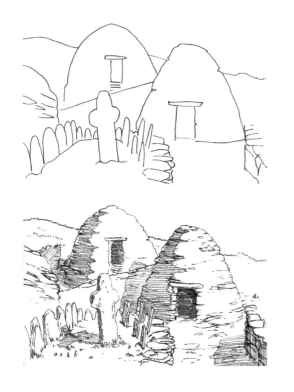
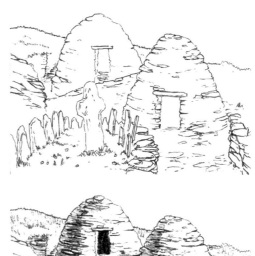

WEMBLEY STADIUM, LONDON, UK

APARTMENT BLOCK (MODERN)

APARTMENT BLOCK (RUSTIC)

 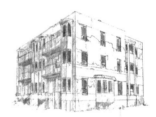 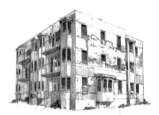

CHATEAU

 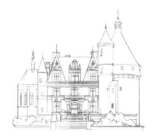

GOTHIC CASTLE

HAUNTED HOUSE

NORMAN-STYLE CASTLE

RUSSIAN-STYLE PALACE

RUSTIC CASTLE

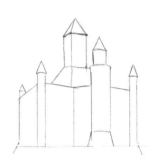 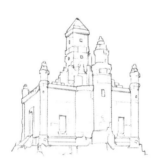 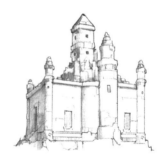 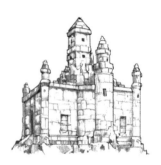

STICK HOUSE

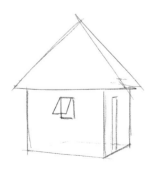

ADOBE BUILDING

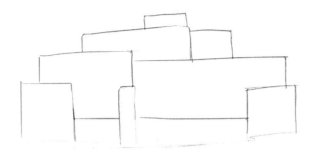

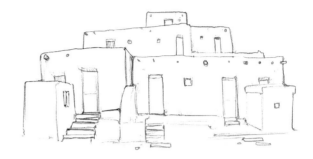

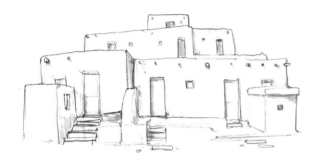

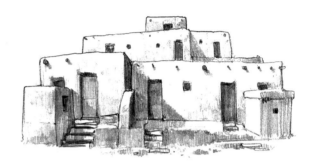

AMERICAN RANCH

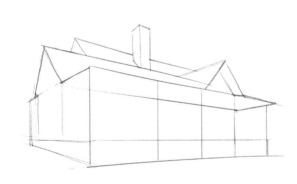

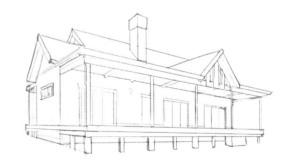

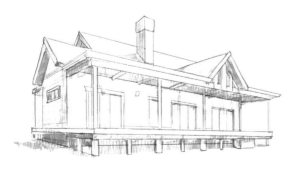

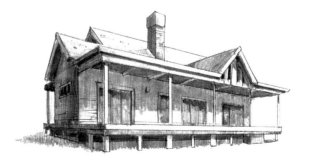

BRICK HOUSE

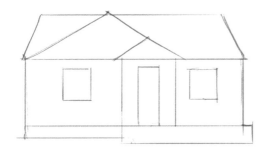
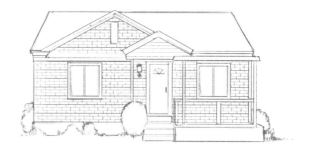

BURNT-OUT BUILDING

CAVE DWELLING

IGLOO

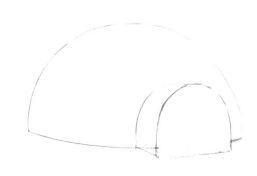
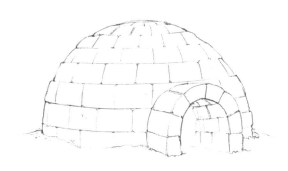
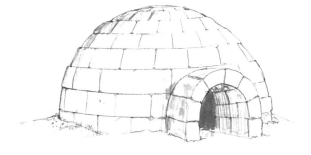
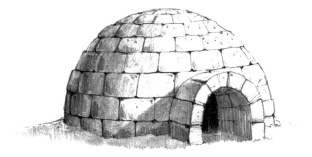

LAKE HOUSE

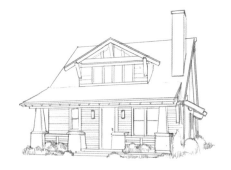

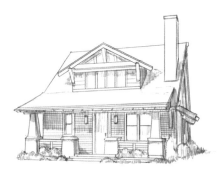

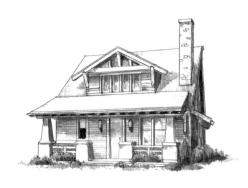

NOMADIC TENT

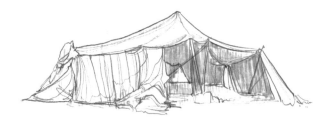

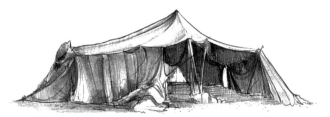

NORDIC COTTAGE

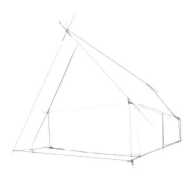

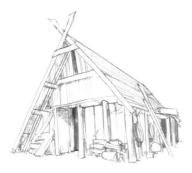

SCANDINAVIAN STAVEKIRKE

THATCHED COTTAGE

TUDOR MANOR

AIRPORT

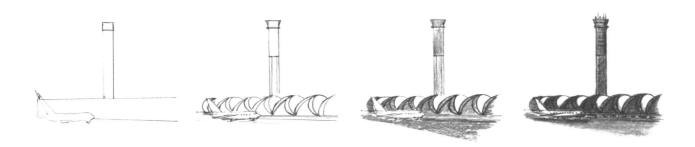

CATHEDRAL

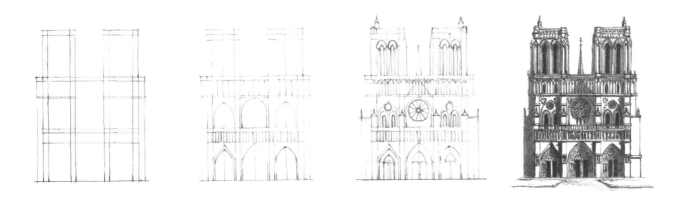

CITY SKYLINE

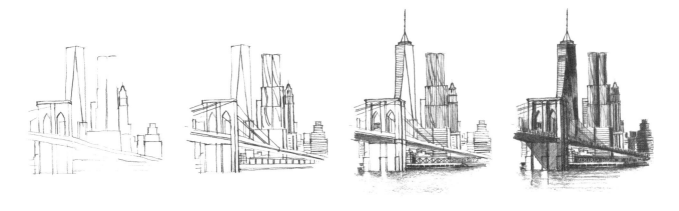

CLOCK TOWER

EASTERN TEMPLE

GAUDI-STYLE BUILDING

GAZEBO

MAYAN TEMPLE

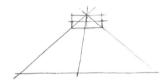

MOSQUE

RUSTIC TEMPLE

SKYSCRAPERS

SYNAGOGUE

COCKTAIL BAR

DOCK YARD

EUROPEAN CHURCH

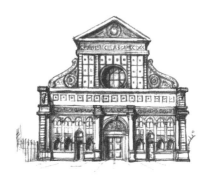

FIRE STATION

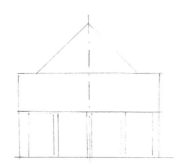
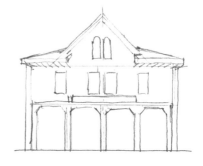
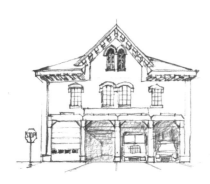

GROCERY STORE

HOSPITAL

MUSEUM

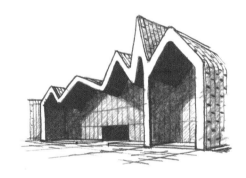

FUEL STATION

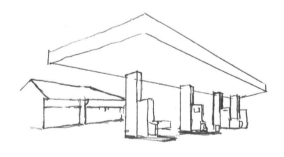
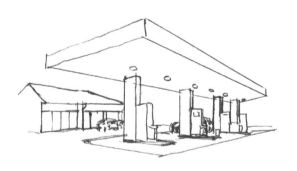

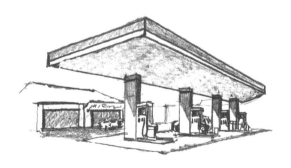

PUB

SAUNA

SCHOOL

SUPERMARKET

THEATRE STAGE

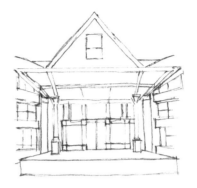
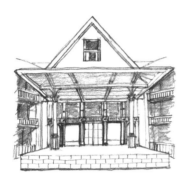

UNIVERSITY

VILLAGE MEETINGHOUSE

WESTERN SALOON

BARN

 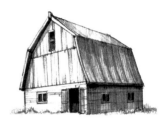

RUIN

TREE HOUSE (BASIC)

 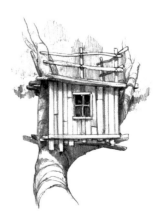

TREE HOUSE (ELABORATE)

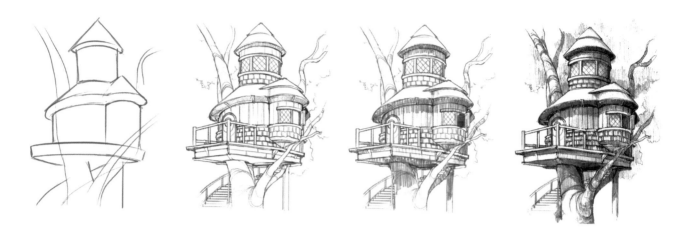

WINDMILL

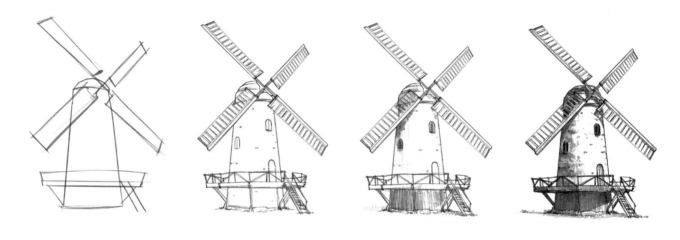

WOODEN CABIN

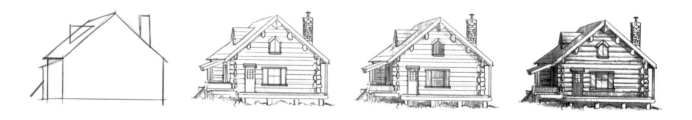

GREENHOUSE

JETTY

ROPE BRIDGE

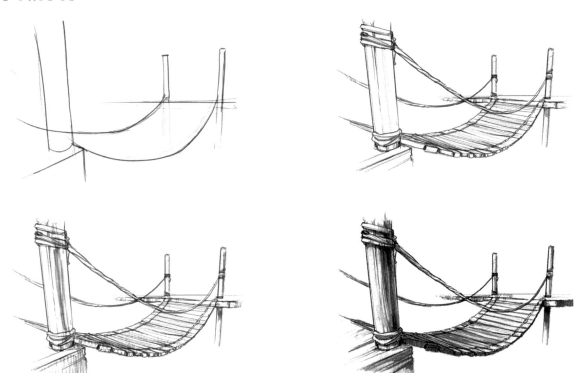

RUSTIC HUT

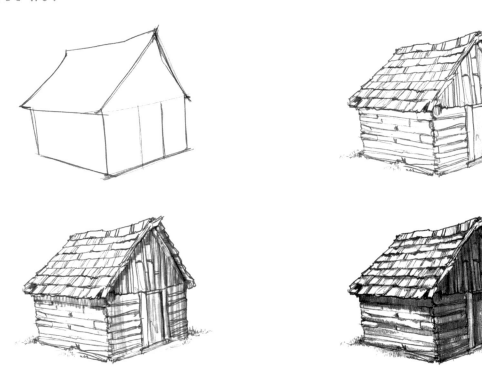

SHANTY BUILDING

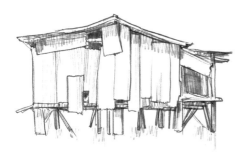
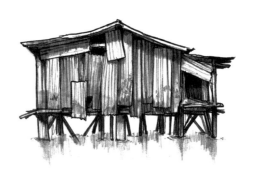

STABLE

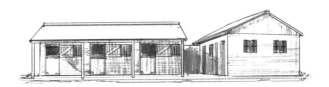
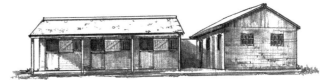

VIKING LONGHOUSE

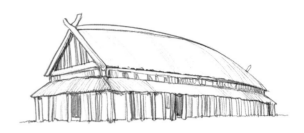

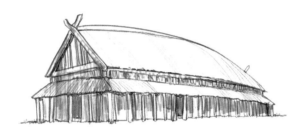
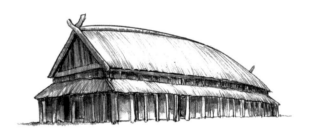

WATTLE AND DAWB ROUNDHOUSE

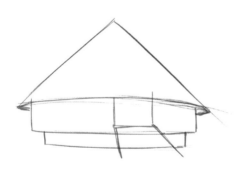
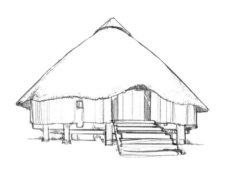

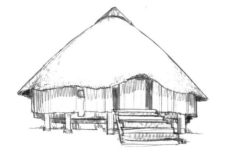
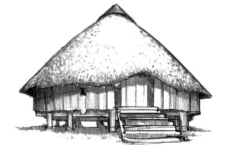

ATM

FOUNTAIN

GATE (ORNATE)

GATE (MANOR STYLE)

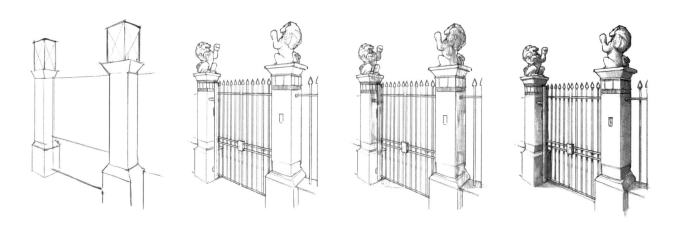

IRON BRIDGE (LARGE)

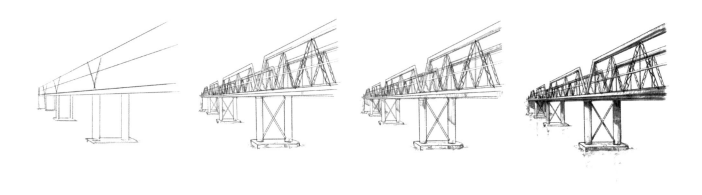

MAILBOX

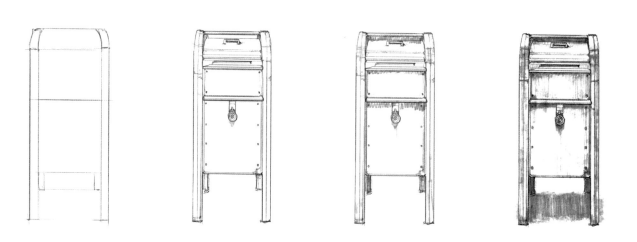

PHONE BOX

 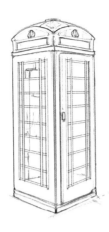 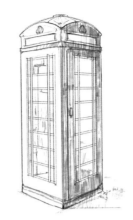

POSTBOX (UK)

PYLON

 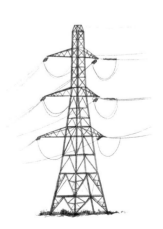

STREET LIGHT (BASIC)

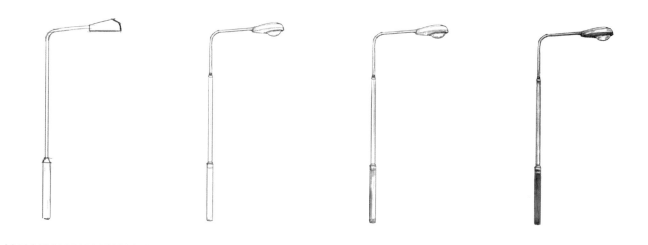

STREET LIGHT (ORNATE)

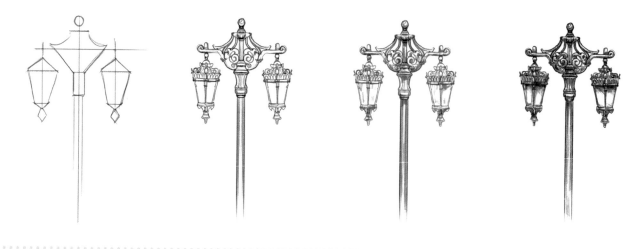

SUSPENSION BRIDGE

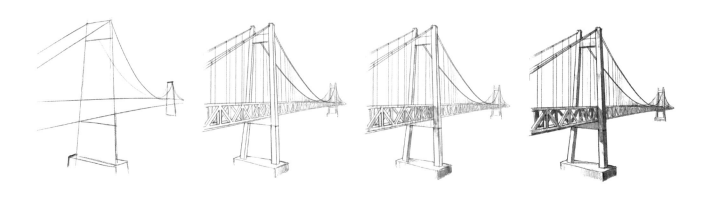

TELECOM TOWER

TRAFFIC LIGHTS

WIND TURBINE

BUS SHELTER

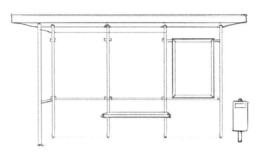
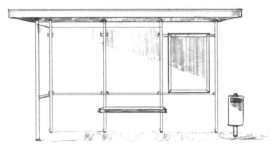
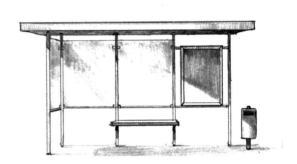

DUMPSTER

FESTIVAL STAGE

NEON SIGN

NEWSSTAND

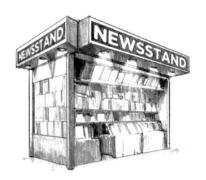

STONE BRIDGE (ORNATE)

STONE BRIDGE (RUSTIC)

WATERMILL

CONTRIBUTORS

INTRODUCTION TO SKETCHING

Pages 10–63
All images © Bobby Rebholtz
unless otherwise stated

BOBBY REBHOLTZ
instagram.com/bobbyrebholz

RICHARD TILBURY
richardtilburyart.com

THE ARTISTS

Pages 64–417
All images © the artists as listed below

ASHLINE ILLUSTRATIONS
artstation.com/ashline

· Archetypes
· Facial expressions

PIP ABRAHAM
pipabraham.com

· Desert animals and marsupials
· Mountain and grassland animals
· Safari animals

HAZEM AMEEN
artstation.com/caninebrush

· Historic dress
· Traditional dress

CYNTHIA CANADA
instagram.com/paintgirlpaint

· Professions and character types

RACHEL CARD
artistrachelcard.com

· Primates
· Alcohol
· Soft drinks
· Sweet treats

ALI ELLY
aliellydesign.com

· Sea life

ALEXANDRA FASTOVETS
behance.net/Hanukafast

· Creatures introduction page
· Arctic animals
· Woodland and jungle animals

BOTI HARKO
harkoart.com

· Dinosaurs
· Reptiles

ANNA HOWLETT
annahowlettartwork.co.uk

· Birds

GARETH HUGHES
harebit.co.uk

· Working and farm animals

EVGENY KASHIN
gr1n.artstation.com

· Vehicles and transportation introduction page
· Air and space vehicles
· Cars, bikes, and trucks
· Military vehicles
· Professional vehicles
· Public transport

ZORA KASTNER
artstation.com/zoraka

· Big cats
· Rodents

DEJVID KNEZEVIC
dejvid.net

· Hobbies introduction page
· Musical instruments
· Sports equipment

IRENE LASCHI AND ANDREA LONGHI

behance.net/irenelaschi
behance.net/andrealonghisketch

- Nature introduction page
- Flowering plants
- Fruiting and edible plants
- Greenery
- Trees
- Sea elements
- Natural structures
- Weather

ANDREA LONGHI

behance.net/andrealonghisketch

- Food and drinks introduction page
- Cold foods
- Fast food
- Hot foods
- Famous Landmarks
 (except those by Maxwell Tilse)

SANDRA MASSAZZA

sandramassazza.com.ar

- Public buildings

MIGUEL MEMBREÑO

behance.net/mgue

- Buildings and structures
 introduction page
- Push or pull vehicles
- Water vehicles
- Homes
- Rural buildings
- Urban features

GINA NELSON

ginanelsonart.com

- Waterside animals
- Breakfast foods
- Fruit and vegetables

JOSEPH QIU

artstation.com/josephqiuart

- People introduction page
- Actions

POLLY SUTHERLAND

instagram.com/pollysutherlandart

- Insects and minibeasts

MAXWELL TILSE

maxwellillustration.com

- Famous landmarks:
 Notre Dame
 Statue of Liberty
 Taj Mahal
 Parthenon

INDEX OF SUBJECTS

Sketching from the Imagination

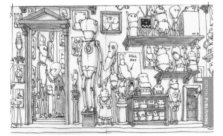

In each book of the *Sketching from the Imagination* series, 50 talented traditional and digital artists have been chosen to share their sketchbooks and explain the reasons behind their design decisions. Visually stunning collections packed full of useful tips, these books offer inspiration for everyone.

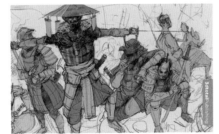

beginner's guide to sketching:
characters, creatures & concepts

Embark on a sketching journey with the inspirational *Beginner's Guide to Sketching: Characters, Creatures and Concepts*.

From gesture drawing and finding simple shapes to mastering line quality and shading, *Beginner's Guide to Sketching: Characters, Creatures and Concepts* is a fantastic companion that will teach you to sketch confidently while helping you improve the way you design. Your journey will begin with a look at drawing materials and techniques, before moving on to essential warm-up exercises to help you become familiar with the fundamental basics. Four master projects by seasoned professional artists will then take you from concept to final illustration, walking you step by step through poses, designs, and costumes before culminating in a final scene. Featured artists include Justin Gerard, Brun Croes, and Sylwia Bomba.

3dtotalpublishing.com | 3dtotal.com | shop.3dtotal.com

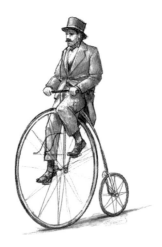

3dtotalPublishing

3dtotal Publishing is a leading independent publisher specializing in trailblazing, inspirational, and educational resources for artists.

Our titles feature top industry professionals from around the globe who share their experience in skillfully written step-by-step tutorials and fascinating, detailed guides. Illustrated throughout with stunning artwork, these best-selling publications offer creative insight, expert advice, and essential motivation.

Fans of digital art will find our comprehensive volumes covering Adobe Photoshop, Pixologic's ZBrush, Autodesk Maya, and Autodesk 3ds Max must-have references to get the most from the software. This dedicated, high-quality blend of instruction and inspiration also extends to traditional art. Titles covering a range of techniques, genres, and abilities allow your creativity to flourish while building essential skills.

Well-established within the industry, we now offer over 50 titles and counting, many of which have been translated into multiple languages the world over. With something for every artist, we are proud to say that our books offer the 3dtotal package:

TECHNIQUE • CONFIDENCE • INSPIRATION

Visit us at 3dtotalpublishing.com

3dtotal Publishing is an offspring of 3dtotal.com, a leading website for CG artists founded by Tom Greenway in 1999